INSPIRED BY THE WORD

J. Sage Elwell, PhD

Foreword by
Corinna Ricasoli, PhD

CONTENTS

FOREWORD

This book is written for those who wish to learn about the wide impact the Bible has had on art. Indeed, it is difficult to deny that the Bible has had an influence on countless aspects of our life, culture, and history.

This is particularly true for the visual arts, which have always been a fundamental means to educate and communicate the biblical narratives. In an era in which illiteracy was widespread, images could teach biblical stories and encourage devotion by helping people feel closer to God. The fundamental role that art had in terms of education, devotion, and evangelization resulted in the production of innumerable artworks, the subject matter of which was drawn from the Bible or from the lives of saints. In many instances, these artworks were the result of the client's devotion and wish to have an artwork in their private home or chapel. They hired an artist who would carry out a painting or a sculpture on a specific subject matter dear to them, which would encourage and assist prayer and meditation. In other words, it was often the client who was "inspired by the Word."

It should be noted, however, that the aim of this book is not to prove that all artists dealing with biblical art were religious. What we hope to accomplish is to demonstrate how both the Old and New Testaments have received wide "coverage" by artists over the past centuries. Each illustration is followed by a brief biography of the artist (when known). A biblical passage and a reflection follow the biography in order to highlight and explain the connection between the Word and the art and to recreate the biblical fabric around the imagery.

One may wonder what is the present book's significance, especially within secularized societies. Indeed, the numerous references to the Bible, which we come across almost daily, often go unnoticed and in many cases have lost their original meaning. We can be moved by the beauty of a cathedral, the power of Dante's verses, of Bach's sacred music, or of Caravaggio's religious paintings, but could we enjoy such things with the awareness that, without the Bible, none of the above would exist? Can we really *understand* Dante, Bach, or Caravaggio without knowing what the sources—or, in fact, *the* main source—that inspired their work was?

In terms of the arts, the Bible should be considered as one of the most important books of all time because of the impact it has had on creativity. This book wishes to showcase some of the outstanding art inspired by the Bible in the hopes of contributing to an increased understanding and awareness of the cultural context that nurtured the great minds of the past. This understanding and awareness is crucial, and not just because such knowledge contributes to our general education and critical thought, but also because such masterpieces of literature, music, and art *still* have an influential impact on us today.

Corinna Ricasoli, PhD
Consultant Curator of Fine Arts, Museum of the Bible
corinna.ricasoli@mbible.org

About the Museum of the Bible

Located in Washington, DC, Museum of the Bible is an innovative, global, educational institution whose purpose is to invite all people to engage with the history, narrative, and impact of the Bible. This 430,000-square-foot museum is the most technologically advanced museum in the world, providing guests with an immersive and personalized experience as they see the Bible in a whole new light. State-of-the-art handheld navigation systems guide guests through seven floors of exhibits. Among those are:

The Narrative Floor shares the stories of the Bible by engaging all of guests' senses. The adventure and drama of the Bible will come to life in riveting presentations. Visitors will walk through the narratives of the Hebrew text from Genesis to Chronicles and then through first-century Nazareth, ending with the story of the New Testament. This floor intertwines immersive experiences with artifacts, executed in highly creative ways.

The History Floor showcases archaeological discoveries through modern cinematic storytelling to bring the biography of the book we call the Bible to life. The History Floor will feature more than 500 world-class artifacts that document the Bible's preservation, translation, and transmission across centuries and cultures. This floor features many of the greatest biblical discoveries, including writings dating to the time of Abraham, fragments of the Dead Sea Scrolls, early New Testament writings, and more.

The Impact Floor will explore the Bible's impact over time on cultures, civilization, and daily life, including its profound influence on fine arts, science, government, and more. The Impact Floor will be modern, technologically advanced, visually stimulating, and interactive. It will tell stories of the Bible's impact and invite visitors to share their own stories.

Museum of the Bible's Collection is an aggregation of several of the world's most prominent private collections of biblical objects and artifacts. The Collection provides guests an unrivaled opportunity to engage with artifacts and materials related to the Bible.

Museum of the Bible
409 3rd Street SW
Washington, DC 20024
museumoftheBible.org

*T*his image is from a Bible **moralisée** ("moralized Bible") known as *Vienna Codex 2554 (possibly the oldest surviving Bible **moralisée**). Popular in thirteenth-century France and Spain, a Bible **moralisée** was lavishly illustrated and accompanied by a commentary that typically included moral allegories. These books contained thousands of delicately handcrafted and ornate images and were extremely expensive to create. They were commissioned by royal families to be used as instructional tools and priceless decorative objects. Only seven Bible **moralisées** remain in existence today.*

*This image, from the back side of folio 1, features God as the divine architect engaged in the primordial act of creation. The image does not bear a title and has alternately been called **God as Cosmic Architect**, **God the Geometer**, and **God the Designer of the Universe**.*

It depicts God, in the Byzantine tradition of the image of Jesus, circumscribing the cosmos with a compass. Written above the frame (but cropped from this image) is the following inscription: "Here God creates the heavens and the earth, the sun and the moon, and all of the elements."

GOD AS COSMIC ARCHITECT (1220–1230)

artist unknown

Current location: Austrian National Library, Vienna

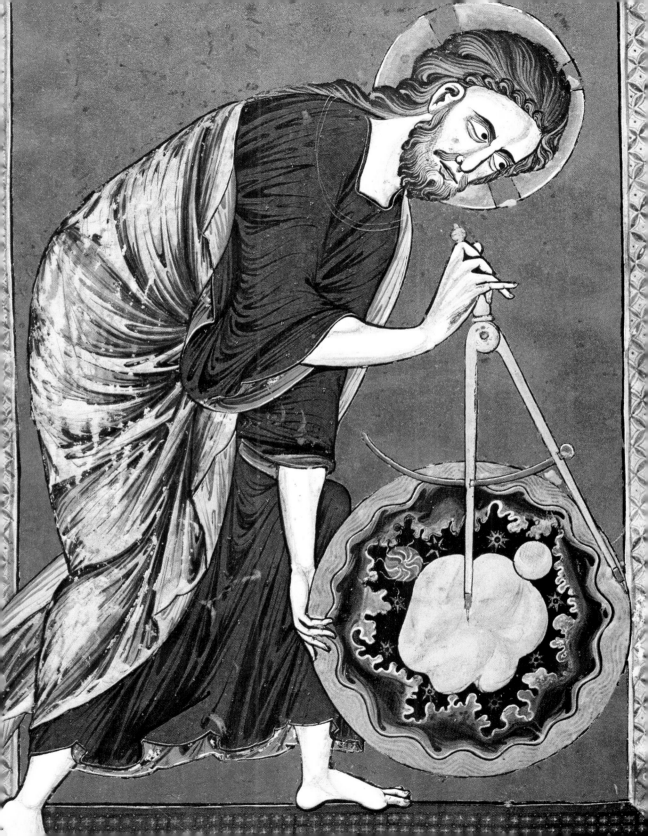

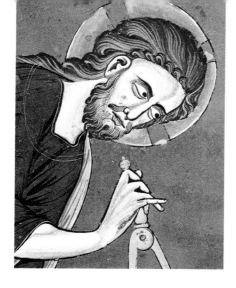

In the beginning, God created the heavens and the earth. The earth was without form and void, and darkness was over the face of the deep. And the Spirit of God was hovering over the face of the waters. (Genesis 1:1–2)

In this beautiful illumination, God is dressed in a blue robe with a rose-colored outer tunic; his hair is long, and he has a cropped beard. He bends at the waist in front of a gold-leafed backdrop while cradling the cosmos in his left hand and clutching a compass in his right.

The book of Genesis opens with God bringing order out of chaos. The formless waters of the deep symbolize chaos, a common motif in ancient creation stories. The Hebrew words for this formless void are *tohu wabohu*; together, they connote the absence of not only physical form but also the natural laws that structure the cosmos or moral ideals that give meaning to human existence. All of this is brought into being through creativity.

Although scientists and philosophers hold a diverse array of perspectives on the origins of the universe, the Genesis account describes a progression from idea to basic forms to dramatic diversity and multiplying growth. This pattern is common when people create art, write books, start businesses, or design experiments.

The twentieth-century American philosopher and theologian Gordon Kaufman described God using the metaphor "serendipitous creativity."* Kaufman suggested that we regard God as the "ongoing creativity in the universe."** This perspective preserves the mystery of God while connecting God with all that is new that comes into being. Kaufman connected this idea to the words of the book of Isaiah, in which God is portrayed as saying, "Behold, I am doing a new thing; now it springs forth, do you not perceive it?" (Isaiah 43:19).

If God is a transcendent being, then it is difficult to imagine God wearing a robe or using basic geometric tools to create the cosmos. These are human attributes projected onto God. And yet, as observed in *God as Cosmic Architect*, the artist's portrayal of God fashioning order out of the primordial chaos that is *tohu wabohu* brings the abstract and universal down to the tangible and particular level of the human.

* Gordon D. Kaufman, *In Face of Mystery: A Constructive Theology* (Cambridge, MA: Harvard University Press, 1995).

** Gordon D. Kaufman, "On Thinking of God as Serendipitous Creativity," *Journal of the American Academy of Religion* 69, no. 2 (June, 2001), 412.

M ichelangelo first earned his reputation as a brilliant artist at age twenty-five with his creation of the **Pietà** (1498–1499) for St. Peter's Basilica. Soon after, he created the celebrated statue of **David** (1501–1504). As a result of these magnificent works of art, Pope Julius II, in 1506, commissioned him to paint the ceiling of the Sistine Chapel.

Michelangelo chose to divide the long, arched spine of the ceiling into nine rectangular compartments, each depicting a scene from the book of Genesis. These scenes follow the creation of the heavens and the earth (chapters 1–2), the creation and fall of Adam and Eve (chapters 2–3), and the story of the Flood (chapters 6–9).

The biblical chronology begins above the altar with creation and extends toward the entrance of the chapel, culminating in the Flood and Noah's drunkenness. However, Michelangelo painted them in reverse order, beginning with Noah's shame and humanity's sinfulness and moving toward the creation. At the center of this visual narrative sequence is **The Creation of Adam**.

THE CREATION OF ADAM (1508–1512)
Michelangelo Buonarroti (1475–1564)

Current location: Sistine Chapel, Vatican Museums, Vatican City State

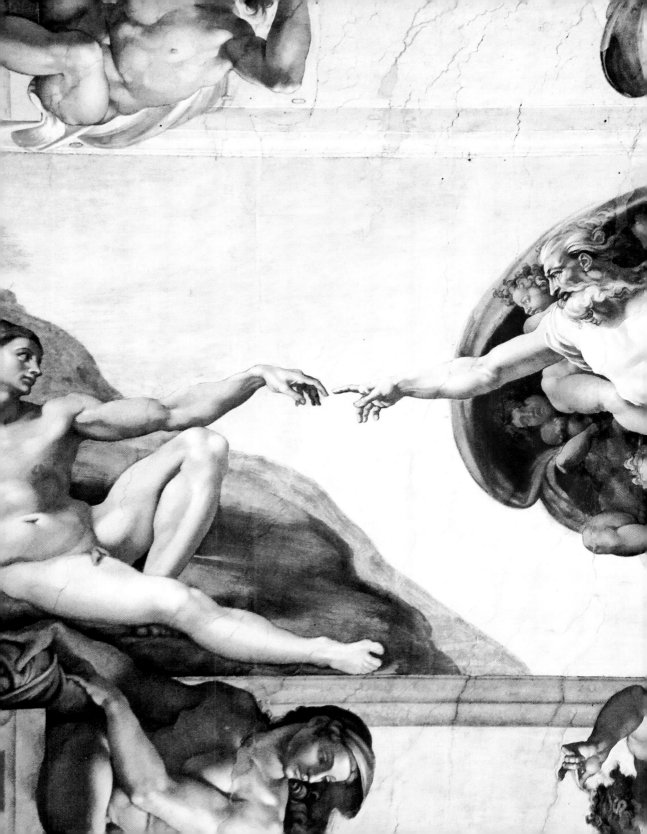

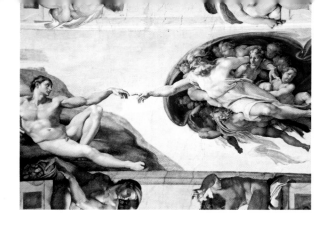

Then the L ORD God formed the man of dust from the ground and breathed into his nostrils the breath of life, and the man became a living creature. (Genesis 2:7)

The Genesis account of creation, which says that God made people "in his own image" (1:27), is filled with mystery. What does it mean to be made in the image of God? Michelangelo, one of the most famous Italian artists of all time, in his painting *The Creation of Adam*, presents a visual interpretation of that question.

God is portrayed as an older, well-muscled, white-bearded man lying in repose with his right hand outstretched, nearly touching Adam's outstretched left hand and preparing to impart life to humanity. Adam mirrors God's posture and appearance, recalling Genesis 1:27: "So God created man in his own image, in the image of God he created him." Adam lies quietly, his flesh having been fashioned from the earth but having not yet received the divine spirit, the "breath of life" (Genesis 2:7).

The Hebrew word *spirit* comes from the Latin word for *breath* or *wind*. In the painting, God is depicted with his windswept beard lying amid billowing drapery, appearing in contrast with the naked, listless Adam, who awaits the breath of life from God's outstretched finger.

Art historians and theologians have long debated Michelangelo's views on God's breath of life given to Adam. Some have suggested that the red drapery in which God is nestled appears to be the shape of a uterus, implying the breath of life comes with the miracle of birth. Others have suggested it is a cross section of the human brain, suggesting that the breath of life is reason. This idea is reinforced by those who see the woman beneath God's left arm, either being cradled by him or supporting him, as

the personification of wisdom described in Proverbs 8:22–30: "The LORD possessed me at the beginning of his work, the first of his acts of old. Ages ago I was set up, at the first, before the beginning of the earth. When there were no depths I was brought forth . . . when he marked out the foundations of the earth, then I was beside him, like a master workman, and I was daily his delight."

However the question of the giving of life is interpreted, it is clear from the painting that Michelangelo chose to represent human beings as consisting of both body and spirit. Therefore, the painting prompts us to consider the complex relationship between humanity and divinity.

*T*his image of Adam and Eve made from mosaic tiles shows them eating fruit from the tree of the knowledge of good and evil. The panel was originally part of a larger floor design in an early Byzantine church in northern Syria. The Greek inscription across the top paraphrases Genesis 3:6–7: "And they ate, [and] were made naked."

Another panel from the same site shows a grape harvester in a vineyard with a peacock. The vineyard and the grapes are symbolic references to the Eucharist wine, and the peacock was a well-known symbol of immortality. Together, these panels suggest that the mosaic may have depicted the garden of Eden with Adam and Eve's fall along with the symbolic reference to humanity's final redemption.

In the panel, Adam and Eve each grasp the forbidden fruit with one hand while clutching leaves to hide their nakedness with the other hand. Their full-frontal presentation, almond-shaped eyes, and teardrop-shaped noses conform to the classical Byzantine style that influenced iconographers for centuries. This style of portraying Adam also influenced images of Jesus for millennia.

ADAM AND EVE (5TH CENTURY)

artist unknown

Current location: The Cleveland Museum of Art, USA

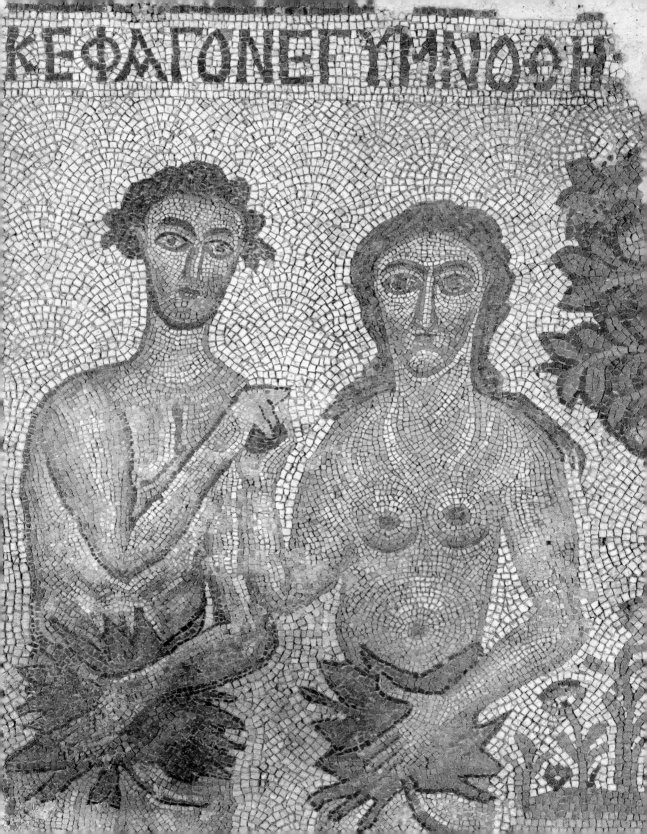

Now the serpent was more crafty than any other beast of the field that the LORD God had made.

He said to the woman, "Did God actually say, 'You shall not eat of any tree in the garden'?" And the woman said to the serpent, "We may eat of the fruit of the trees in the garden, but God said, 'You shall not eat of the fruit of the tree that is in the midst of the garden, neither shall you touch it, lest you die.'" But the serpent said to the woman, "You will not surely die. For God knows that when you eat of it your eyes will be opened, and you will be like God, knowing good and evil." So when the woman saw that the tree was good for food, and that it was a delight to the eyes, and that the tree was to be desired to make one wise, she took of its fruit and ate, and she also gave some to her husband who was with her, and he ate. Then the eyes of both were opened, and they knew that they were naked. And they sewed fig leaves together and made themselves loincloths. (Genesis 3:1–7)

In the mosaic, Adam and Eve share the fruit from the tree of the knowledge of good and evil. This depiction remains true to the biblical account. The artist's portrayal of their nakedness conveys their vulnerability. The mosaic shows them covering themselves with leaves, a sign that they feel shame.

Some interpretations of this passage suggest the serpent, who tempts Eve to eat the fruit, is a manifestation of the Devil, or Satan. When the serpent arrives on the scene in Eden, he creates confusion in Eve's mind. He questions her about the fruit with some clever twists of words, but he is not identified as Satan or the Devil. In Genesis the Hebrew word used to describe the serpent is *arum*, which means "clever," "subtle," or "shrewd." It is also a play on the Hebrew word *erom*, which means "naked."

In the biblical account, God holds Adam, Eve, and the serpent accountable for their actions. Eve immediately accepts responsibility (Genesis 3:13). However, when God confronts Adam, Adam blames Eve. Adam then blames God for giving Eve to him, saying, "The woman whom you gave to be with me, she gave me the fruit of the tree, and I ate" (Genesis 3:12).

Through the millennia, Eve has often been solely accused of introducing humanity to sin. This view has led to depictions of women as victims of temptation and as temptresses. While it is true that Eve was the first to be tempted to eat the fruit and that she then gave the fruit to her husband, God punished both Adam and Eve because they were equally responsible (Genesis 3:17–19).

In the mosaic, the artist portrays Adam and Eve as equals, two people now experiencing the natural consequences of their decisions. They stand naked, close to each other, unified in guilt and shame. This mosaic depicts Adam, the first human formed from the dust of the earth, and Eve, the original bearer of life, standing hand in rebellious hand. In these ways, the artwork invites us to consider our own humanity.

Adam and Eve sit on the ground, naked and ashamed after eating from the forbidden tree. Cradling their bodies, they attempt to cover their newly realized nakedness. Written between them in an ancient Semitic language called **Ge'ez** are the simple titles "Man [and] Woman" (the word for **man** is "adam").

This painting is housed in the church of Abreha and Atsbeha in northern Ethiopia. The church, hewn from the red-rock cliffside of a mountainous outcrop in the fourth century AD, is named after the two brothers who ruled over the region as the territory's first Christian kings. Although the building has been destroyed and rebuilt over the centuries, it remains an impressive example of solid rock-hewn church architecture.

The interior floor plan of the church is shaped like a cross (cruciform) with an elegantly carved roof supported by thirteen massive pillars. The church contains three sanctuaries and a number of auxiliary rooms—all carved from solid rock. At some point in the seventeenth century, the stone walls of the church were redecorated with exquisitely preserved murals recounting the history of Christianity in Ethiopia and several wall paintings, such as this one, depicting scenes from the Bible.

ADAM AND EVE (CA. 17TH CENTURY)

artist unknown

Current location: Abreha and Atsbeha Church, Wukro, Ethiopia

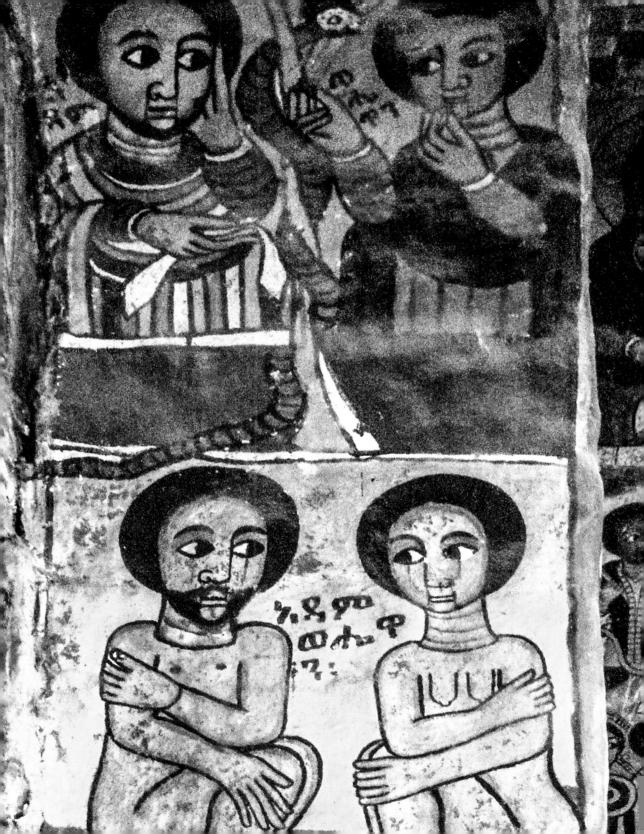

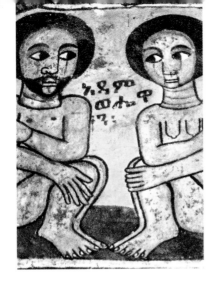

And they heard the sound of the LORD God walking in the garden in the cool of the day, and the man and his wife hid themselves from the presence of the LORD God among the trees of the garden. But the LORD God called to the man and said to him, "Where are you?" And he said, "I heard the sound of you in the garden, and I was afraid, because I was naked, and I hid myself."

He said, "Who told you that you were naked? Have you eaten of the tree of which I commanded you not to eat?" (Genesis 3:8–11)

The book of Genesis presents a profound story that describes both the goodness and the brokenness of human nature. Genesis describes humans as "created . . . in the image of God" (1:27) and as disobedient to God (chapter 3). In this work of art, an unknown artist provides a portrait of human nature that invites viewers to reflect on who we are as humans.

According to Genesis 2:16–17, God told Adam, "You may surely eat of every tree of the garden, but of the tree of the knowledge of good and evil you shall not eat, for in the day that you eat of it you shall surely die." When God created Eve to live as Adam's partner and companion in the garden, both of them were naked, yet they "were not ashamed" (Genesis 2:25). It was only after eating from the tree of the knowledge of good and evil that they knew shame (Genesis 2:17, 3:2–7). In this wall painting Adam and Eve sit, knees to chest. They fix their eyes on each other, as if to ask, "What have we done?" Their gaze and posture reveal a sense of human failure, vulnerability, and fragility.

Before the tragic events of Genesis 3—the story of the first human act of rebellion toward God, often called "the Fall"—Adam and Eve knew nothing of their own mortality. However, the Bible says that God exiled them from the garden and banned them from the tree of life. They would eventually die (Genesis 5:5).

In the painting of Adam and Eve, we can see our own mortal and vulnerable condition. Perhaps we might reflect on how we might all experience a degree of living in exile, wondering if we are made for more than this world. The painting's portrayal of Adam and Eve's vulnerability enables us to see our own fragility in new ways.

Genesis 3:8–10 describes God searching for Adam and Eve in the garden, even though their guilt made them afraid. "But the LORD God called to the man and said to him, 'Where are you?' And he said, 'I heard the sound of you in the garden, and I was afraid, because I was naked, and I hid myself.'" The painting vividly shows Adam and Eve's shame. Naked, they look into each other's eyes with the vulnerability of a relationship between two people who know they have failed.

This mural beautifully captures a way for people to regard one another in this world—as fellow humans, with compassion and mercy, knowing that we are equally vulnerable and mortal.

Santiago Rebull was a Mexican painter best known for **La Muerte de Marat** (1875), which drew inspiration from Jacques-Louis David's **Death of Marat** (1793). Rebull also taught the famous muralist Diego Rivera. Born in 1829, Rebull studied under Pelegrín Clavé at the Academia de San Carlos in Mexico City.

In 1851, Rebull won a scholarship for **The Death of Abel**, the painting featured here. The scholarship allowed him to study abroad in Rome, where he remained for seven years. When he returned to Mexico City, he was appointed Chair of Life Drawing at San Carlos and would eventually serve as the director of the school for two years at the order of President Benito Juárez.

Some scholars have speculated that **The Death of Abel** was intended as an allegory for the political divisiveness between liberals and conservatives in Mexico following its independence.

The painting shows Cain fleeing the scene immediately after killing his brother. The brothers' respective forms offer a study in contrasts. Abel's pale body lies open-armed and horizontally splayed over the rocky ground; Cain, with his darker-hued body, runs away with his arms flailing overhead as he casts a fearful backward glance at his dead brother.

THE DEATH OF ABEL (1851)
Santiago Rebull (1829–1902)

Current location: Museo Nacional de Arte (MUNAL),
Mexico City, Mexico

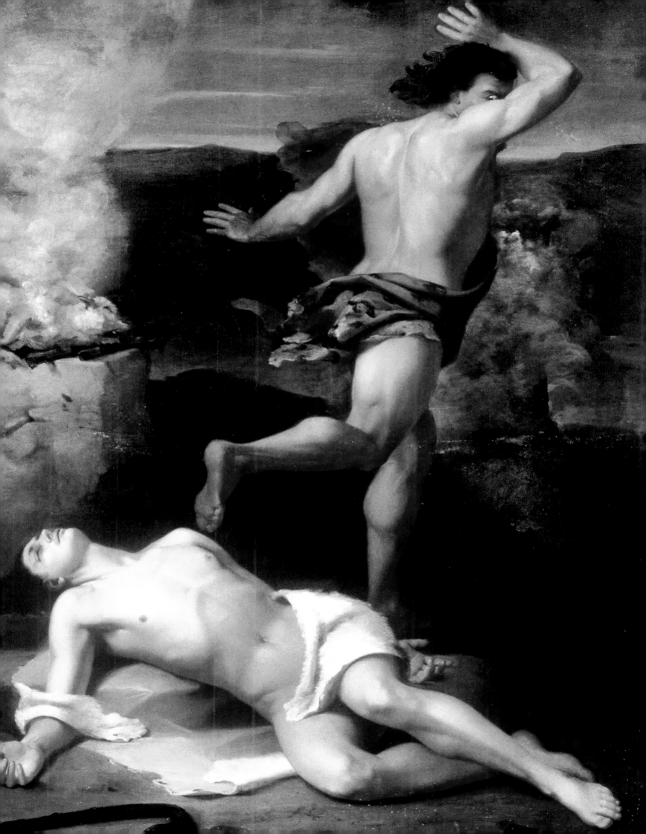

Cain spoke to Abel his brother. And when they were in the field, Cain rose up against his brother Abel and killed him. Then the LORD said to Cain, "Where is Abel your brother?" He said, "I do not know; am I my brother's keeper?" And the LORD said, "What have you done? The voice of your brother's blood is crying to me from the ground." (Genesis 4:8–10)

The story of Cain and Abel in Genesis 4 recounts the first murder in the Bible. Although the story is generally interpreted as a condemnation of Cain's jealousy over Abel's favored offering to God, the reason for God's preference is often debated. And although one of their sons murdered the other, Adam and Eve do not appear in the narrative beyond the introductory verses of Genesis 4. The text also leaves out details regarding the murder itself, saying only that "when they were in the field, Cain rose up against his brother Abel and killed him" (verse 8).

The name *Cain* (*Kayin* in Hebrew) is derived from the Hebrew word *kanah*, meaning "to possess." According to Genesis, he was the first child born to the first humans, and as a farmer, he would possess the earth. The name *Abel* (*Hebel* in Hebrew) means "vanishing-breath" and prophetically suggests Abel's relatively short life and impending death. Unlike Cain, Abel was a shepherd.

As a farmer, Cain gave God "an offering of the fruit of the ground" (verse 3); as a shepherd, Abel offered "the firstborn of his flock and of their fat portions" (verse 4). For reasons that are not stated, "the LORD had regard for Abel and his offering, but for Cain and his offering he had no regard" (verses 4–5). Some have suggested that Cain's offering was rejected

because he made it "in the course of time" (verse 3), which could mean that he offered the worst of his produce, while Abel offered the best portions (or the fat) of his firstborn sheep. Regardless of God's reason, Cain became angry.

The painting not only depicts the first deadly conflict between two men but also illustrates the prior internal conflict between Cain's murderous impulse and his inability to control that impulse. In his book *Civilization and Its Discontents* (1930), psychoanalyst Sigmund Freud claimed that in order for humanity to reap the benefits of civil society, the individual had to suppress his or her natural human impulses. Freud believed human instinctual drives were so strong that people would naturally turn to violent means to get what they wanted if there were no external controls in place.

Cain "the possessor" was punished by God and forced to wander the earth, eventually settling in the land of *Nod*, meaning "the land of wandering." His departure, according to some theologians, made it possible for a peaceful community and system of commerce to develop.

In Rebull's painting, Cain's backward glance represents the guilt and tragedy of violence, not only for the individual, but also for humanity. After all, are we not our brothers' and sisters' keeper?

At age three, Edward Hicks was sent to live with a Quaker family in Pennsylvania. His mother had died, and his father, a Loyalist (an American colonist who remained loyal to the British crown), returned to Britain after the Revolutionary War. Hicks eventually became a Quaker minister.

Though he never had formal artistic training, Hicks became known for his "outsider" folk-art style. He produced more than sixty versions of his **Peaceable Kingdom** paintings that depict Isaiah 11:6–8 with predator and prey lying side by side, typically in the company of children.

Noah's Ark, one of Hicks's final paintings, features the classic scene of the animals marching in pairs to the great ark before the Flood. Although Hicks likely copied the composition from a print by Nathan Currier, his animals are characteristic of the style in his earlier **Peaceable Kingdom** paintings.

His muted color pallet plays out in warm swaths of gray, green, and brown with the tawny ark standing alone on the rising pale-blue waters. Dark storm clouds threaten overhead as birds fly into the ark's open roof dormer and the animals embark in a looping line that swings to the foreground, where two trees cross one another.

NOAH'S ARK (1846)
Edward Hicks (1780–1849)
Current location: Philadelphia Museum of Art, Philadelphia, USA

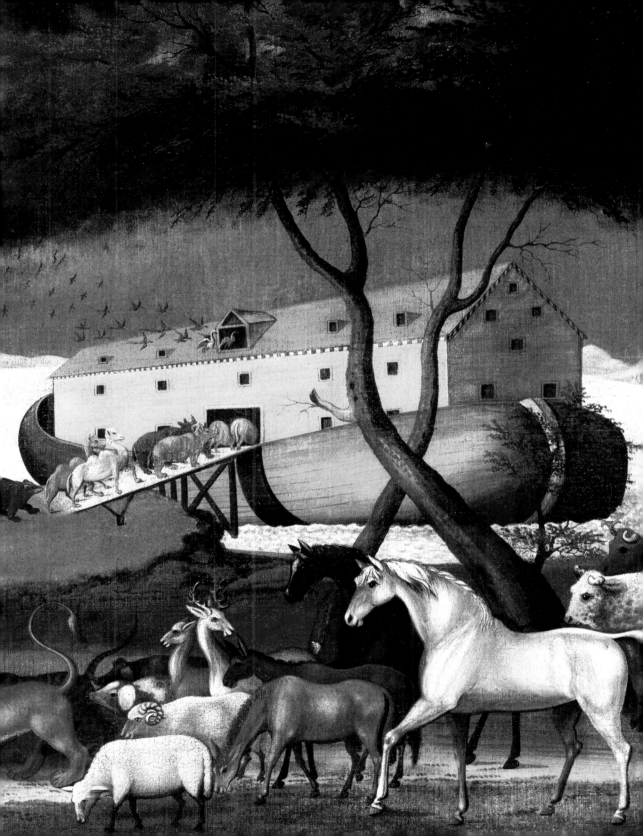

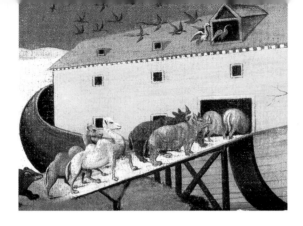

"And of every living thing of all flesh, you shall bring two of every sort into the ark to keep them alive with you. They shall be male and female." (Genesis 6:19)

In the story of the Flood, told in Genesis 6–9, God had become displeased with humanity's evil and violence and said to Noah, "I will blot out man whom I have created from the face of the land, man and animals and creeping things and birds of the heavens, for I am sorry that I have made them" (Genesis 6:7). Noah and his family, however, were deemed worthy of saving. God directed Noah to build an ark for the animals and Noah's eight family members. For forty days, God flooded the earth until the waters covered the mountains and all land creatures outside the ark died.

As the waters began to recede, Noah sent out a dove that returned with an olive leaf in its beak as proof that the waters were subsiding. After Noah left the ark, God said to him and his sons, "Be fruitful and multiply and fill the earth" (Genesis 9:1). With the sign of his colorful rainbow in the sky, God also said: "Behold, I establish my covenant with you and your offspring after you, and with every living creature that is with you, the birds, the livestock, and every beast of the earth with you, as many as came out of the ark; it is for every beast of the earth. I establish my covenant with you, that never again shall all flesh be cut off by the waters of the flood, and never again shall there be a flood to destroy the earth" (Genesis 9:9–11).

Some researchers believe the story of Noah and the ark may have been adapted from the Sumero-Babylonian *Epic of Gilgamesh* and the epic known as *Atrahasis*. Other scholars believe that the strong similarity between these Babylonian epic tales and the Genesis account indicates that they are all based on an earlier story about a flood in Mesopotamia, and that the stories diverged as they were retold over time.

Among its similarities with the Genesis account, the *Epic of Gilgamesh* concludes with the goddess Ishtar casting her jewels into the sky as a glimmering pledge that the gods will never again flood the earth. For those in the ancient world who periodically witnessed flooded rivers, stories of a flood and the gods who caused it could have helped them make sense of natural circumstances.

The story of Noah's flood and the Sumero-Babylonian versions also contain the idea of renewal and rebuilding. The Genesis account of Noah is about God preparing a new beginning, with the rainbow serving as the symbol of new hope. In the same way, Hicks's painting provides us with a visual meditation on the message that hardships can be overcome and that what has been broken can be restored.

*B*ruegel the Elder, from the Netherlands, was one of the most popular painters of the Northern Renaissance. His vivid depictions of farming and peasant life earned him the nickname "Peasant Bruegel." The words "The Elder" distinguish Pieter Bruegel from his son, who was also a painter with the same name.

Little is known of Bruegel's early training as an artist; however, records indicate that he joined the Antwerp painter's guild in 1551. Sometime thereafter, he traveled to France and Italy, where he studied Roman architecture and the work of Michelangelo. Upon returning to the Netherlands, Bruegel began painting in the fantastical tradition of the painter Hieronymus Bosch, whose works often tapped into humanity's deepest fears about death. **The Tower of Babel** illustrates the influence of Bosch's themes and techniques as well as Bruegel's own study of Roman architecture.

Bruegel painted three versions of **The Tower of Babel**. The first, which was lost, was a miniature painted on ivory and completed while he was in Italy. The second, featured here, is sometimes called the "large" **Tower of Babel.** His third tower painting, though similar in architectural structure to this painting, is smaller and lacks many of the details.

THE TOWER OF BABEL (1563)
Pieter Bruegel the Elder (1525–1569)
Current location: Kunsthistorisches Museum, Vienna, Austria

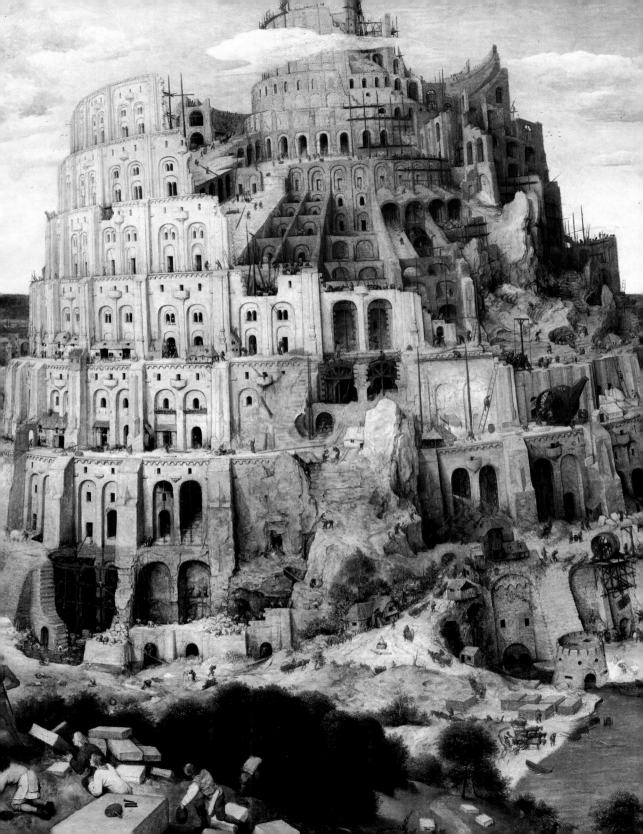

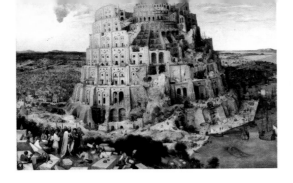

And the LORD came down to see the city and the tower, which the children of man had built. And the LORD said, "Behold, they are one people, and they have all one language, and this is only the beginning of what they will do. And nothing that they propose to do will now be impossible for them. Come, let us go down and there confuse their language, so that they may not understand one another's speech." (Genesis 11:5–7)

The theme of power is demonstrated in the biblical story of the tower of Babel (Genesis 11), which inspired Bruegel's large painting.

In the years after the Flood, a new generation of people settled on the plains of Shinar, and the entire earth had only one language. According to Genesis 10:8–10, Nimrod, a great-grandson of Noah, became the first mighty man on earth and established the kingdom of Babel. Nimrod was identified by the first-century AD Jewish historian Flavius Josephus as the man behind the tower of Babel in his *Antiquities of the Jews, Book 1*, in the chapter entitled "Concerning the Tower of Babylon and the Confusion of Tongues."

The people of Babel learned to make bricks and declared to one another, "Come, let us build ourselves a city and a tower with its top in the heavens, and let us make a name for ourselves, lest we be dispersed over the face of the whole earth" (Genesis 11:4).

Genesis 11:5–7 describes God seeing the people building the tower. He saw that with a common language, nothing they decided to do could be stopped. So he confused their language and thwarted their project, leaving it all incomplete. Then God "dispersed them over the face of all the earth" (Genesis 11:9).

Bruegel painted the tower based on the architecture of the Roman Colosseum, though scholars agree that the actual tower was most likely a Mesopotamian ziggurat—a terraced temple resembling a pyramid.

The story may have been inspired by a temple in Babylon called *Bab-ilu*, meaning "Gate of God." The Hebrew name for Babylon is Babel, which is derived from the root word *balal*, meaning "confusion." This could be a play on words that connects the story of the confusion of languages to the temple called *Bab-ilu*.

In the lower left corner of the painting is Nimrod, dressed as a "mighty man" in his finery and wielding his scepter. He parades before an entourage of workers as his lopsided and incomplete tower crumbles behind him. His arrogance in challenging God results in the loss of his subjects and the destruction of his tower.

The people who built the tower all spoke the same language and believed that a common goal—the building of a great tower—would give them increased power. But, as the opening chapters of Genesis demonstrate, God created diversity. The waters are separated. Day and night are divided. A plethora of creatures swarm the oceans and fill the skies. A vast array of unique species, from cattle to reptiles, roam the earth. And in Genesis 10 we see God establishing and blessing a multiplicity of nations (ethnicities). These biblical texts indicate that the God of the Bible favors diversity over uniformity.

From this perspective, the biblical account of the tower of Babel is a fascinating critique of political, linguistic, economic, and cultural uniformity.

Colin Nouailher, a sixteenth-century French artist who used enameling in decorative art, created this small plaque that measures only about nine inches by nine inches. It portrays the meeting of Abraham and the priest-king Melchizedek, as described in Genesis 14.

Nouailher used a process that involves affixing powdered glass to a metal substrate, in this case copper, with a painted glaze. The result is a vibrant and durable image that resists fading and often bears a translucent, otherworldly quality.

Melchizedek stands on the left holding out three loaves of bread, while behind him men carry large jugs of wine. Abraham stands to the right, outfitted in the armor of war with sword and helmet and backed by his men armed with weapons, as they receive Melchizedek's offering and blessing.

Nouailher uses the pale mountain to the left as a frame to direct the viewer's gaze to the priest-king Melchizedek. Conversely, the deep blue mountain range in the far background trails down to Abraham, leading our eyes to his. A star-studded sky pulses in blue-black hues that echo Melchizedek's mysterious priesthood.

MELCHIZEDEK AND ABRAHAM (1560–1570)
Colin Nouailher (Couly Noylier) (b. 1514, ca. 1539–1571)
Current location: Louvre Museum, Paris, France

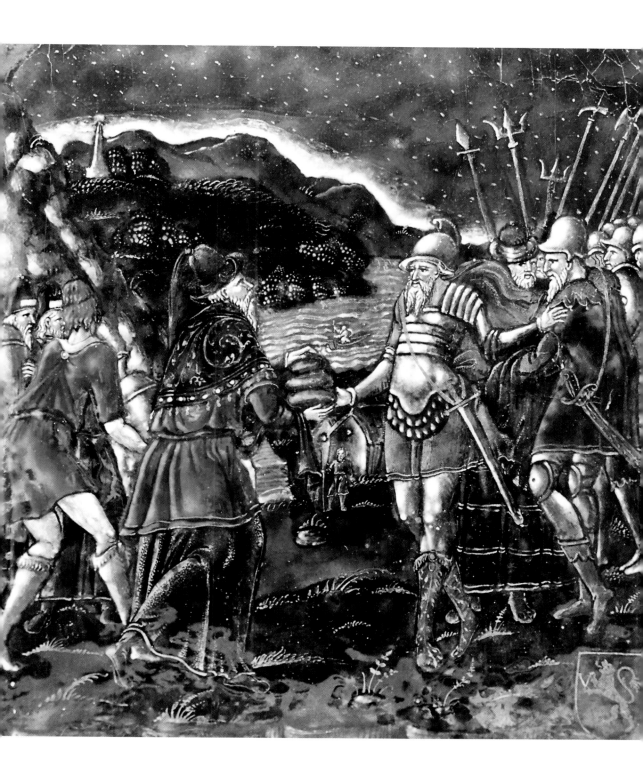

After his return from the defeat of Chedorlaomer and the kings who were with him, the king of Sodom went out to meet him at the Valley of Shaveh (that is, the King's Valley).
And Melchizedek king of Salem brought out bread and wine. (He was priest of God Most High.) And he blessed him and said, "Blessed be Abram by God Most High, Possessor of heaven and earth; and blessed be God Most High, who has delivered your enemies into your hand!"
(Genesis 14:17–20)

The story of Abram (later named Abraham) rescuing his nephew Lot, who had been kidnapped by ruthless ancient kings, conveys a message of courage, love, and hope in a tumultuous world.

Lot had settled in a land filled with evil and strife (Genesis 13–14). As unrest spread in the region, Lot was abducted. Abram could have stayed away from the conflict, but he courageously chose to put his own life, and the lives of his loyalists, at great risk to rescue his nephew. After he succeeded in defeating the enemy, he is blessed by a mysterious priest.

To better understand the meaning of the story, it is helpful to study the name *Melchizedek*. It comes from two Hebrew words: *melek*, meaning "king," and *tzadik*, meaning "righteous." Melchizedek was also the king of *Salem*, which was an ancient name for Jerusalem. This is significant because the name of the city is rooted in the Hebrew word for *peace* (*shalom* in modern Hebrew).

Therefore, in this event Abram, who has delivered Lot from his captors, comes to Jerusalem and is blessed by a king of righteousness and peace. In return for the blessing, "Abram gave him a tenth of everything" (Genesis 14:20). Some scholars believe that Abram's offering is a precursor to the tithing God required of the Israelites to provide for the Levitical priesthood

(Deuteronomy 14:22–29). Psalm 110:4 speaks of an eternal priesthood "after the order of Melchizedek." This is referenced in the New Testament book of Hebrews, positioning Jesus as the high priest (Hebrews 6:20).

In Genesis 14:15–16, the account of Abram's rescue operation occurs at night: "And [Abram] divided his forces against them by night, he and his servants, and defeated them and pursued them to Hobah, north of Damascus. Then he brought back all the possessions, and also brought back his kinsman Lot with his possessions, and the women and the people." Nouailher recreated the meeting between Abraham and Melchizedek at night, when both beautiful and terrible things can transpire, thereby increasing our sense of ominous uncertainty.

Through his art, Nouailher provides a visual way for us to contemplate our own hope for goodness and peace in the midst of conflict, trouble, and uncertainty.

*M*aerten de Vos, a sixteenth-century Flemish painter best known for *painting historical and religious scenes, was influenced by the Italian painter Tintoretto. Raised Catholic, de Vos converted to Lutheranism as a young adult, but he returned to Catholicism later in life. Some speculate this was in response to the Protestant effort in the Netherlands to destroy thousands of works of art. De Vos founded the Guild of the Romanists to bring together artists, writers, merchants, and nobility who sought to celebrate and preserve the humanist tradition.*

*In 1579, an Antwerp-based publisher and engraver issued the **Thesaurus Sacrarum Historiarum Veteris Testamenti**. This collection of prints, created by engravers, reproduced the works of several artists, including de Vos. The collection became the inspiration for numerous needlepoint reproductions. Based on the large stitching holes around its edges, this handsome linen and silk panel was likely a cushion cover. It features three scenes from the story of Abraham and several whimsically detailed flora and fauna.*

SCENES FROM THE STORY OF ABRAHAM (MID-17TH CENTURY)

Maerten de Vos (1532-1603)
embroiderer unknown

Current location: The Metropolitan Museum of Art, New York, USA

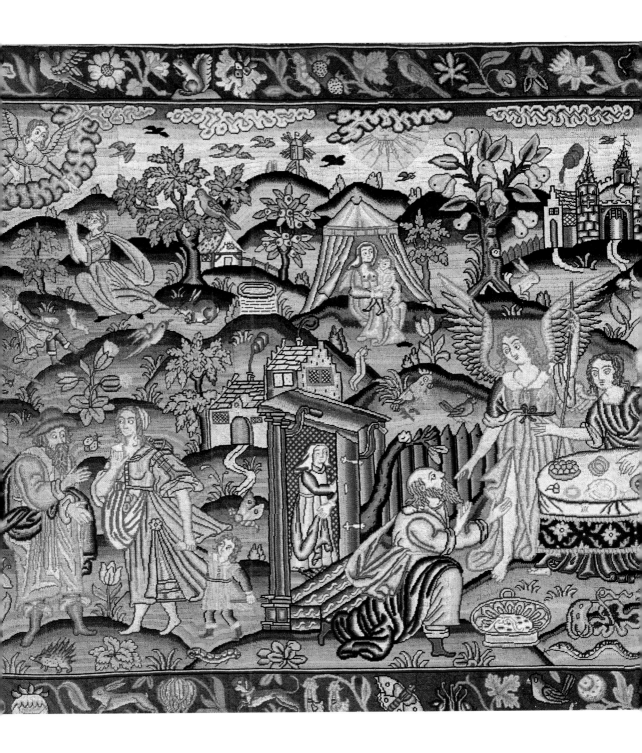

33

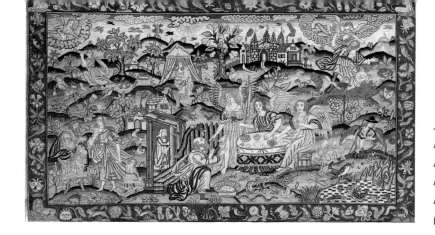

So Sarah laughed to herself, saying, "After I am worn out, and my lord is old, shall I have pleasure?"
(Genesis 18:12)

The three scenes on the panel are all taken from the story of Abraham found in Genesis 18–22. Using a combination of tent and couch stitching, the embroiderer created a remarkable reproduction of de Vos's images. The masterful scenes have a two-dimensional feel. The realism of Maerten's original images was undoubtedly challenging to reproduce using the stitchwork of the day, but the amount of detail, especially in the animals and flowers, is extraordinary. Looking closely at the details reveals the painstaking process and incredible skill that went into creating this stunning panel.

In the lower left corner, Abraham wears a common Flemish hat while signaling for Hagar to leave. Hagar holds Ishmael's hand and carries bread in the folds of her front drapery. The scene continues clockwise and depicts Hagar and Ishmael distressed in the wilderness. Hagar kneels, praying to an angel, while Ishmael languishes on the ground. The angel points to the well behind Hagar.

Continuing to the right of the well, Isaac sits on Sarah's knee in their tent-home. In the upper right corner, an angel aloft in a cloud stops Abraham's hand just before he brings his sword down on his son Isaac.

In the central foreground, three angels sit around a table while Abraham serves them on bended knee. Sarah hides in a doorway to the left of Abraham, appearing to be eavesdropping. The biblical account of Abraham and the three visitors begins with Abraham resting at the door of his tent when three men (traditionally believed to be angels) appear.

While Abraham is not aware that he is serving angels, his three visitors are messengers sent to tell him that he and Sarah will have a son. Upon overhearing the news, Sarah laughs in disbelief that she could have a child at her age.

Sarah's laughter (Genesis 18:12) echoes Abraham's laughter in Genesis 17:17: "Abraham fell on his face and laughed and said to himself, 'Shall a child be born to a man who is a hundred years old? Shall Sarah, who is ninety years old, bear a child?'" The Hebrew word for *laughter* used in both passages is *tz'chok* (*tsachaq*). This is the same root word for the Hebrew name *Yitzchaq* or *Isaac*, the name God gave to Abraham and Sarah's child (Genesis 17:19). The name *Isaac* means "he laughs." According to a rabbinic midrash (commentary), this laughter foreshadows the laughter that Sarah will experience after the birth of her son.

Reflecting on this beautiful work of embroidered art and its inspiration from the story of Abraham and Sarah reminds us that our lives do not have to conform to convention and existing cultural norms. And we should encourage and embrace those whose lives have not taken traditional paths.

Michelangelo Merisi, known as Caravaggio, was born in Milan. He was a master artist who created dramatic and captivating paintings. His subjects included both religious subjects and daily life. He tended to be a brawler and killed a man accidentally. Caravaggio died of fever before reaching the age of forty; however, despite his brief and turbulent life, he managed to create some of the most gripping paintings to come out of the Late Renaissance period. He's considered to be the artist who opened the Baroque era.

*In the early 1590s, Caravaggio went to Rome, where he painted for an elite group of Roman patrons. His dramatic, vivid realism and strong treatment of light and shadow began to earn him commissions from wealthier patrons. According to a seventeenth-century biographer, Caravaggio completed the **Sacrifice of Isaac** for Maffeo Barberini, the man who would become Pope Urban VIII.*

*The **Sacrifice of Isaac** shows Caravaggio using the contrast between light and dark in an extreme way (called chiaroscuro) to make it appear that his subjects are emerging out of darkness. The painting also demonstrates Caravaggio's skill for intensifying the drama of an unfolding scene.*

SACRIFICE OF ISAAC (1594–1596)
Michelangelo Merisi da Caravaggio (1571–1610)
Current location: Uffizi Gallery, Florence, Italy

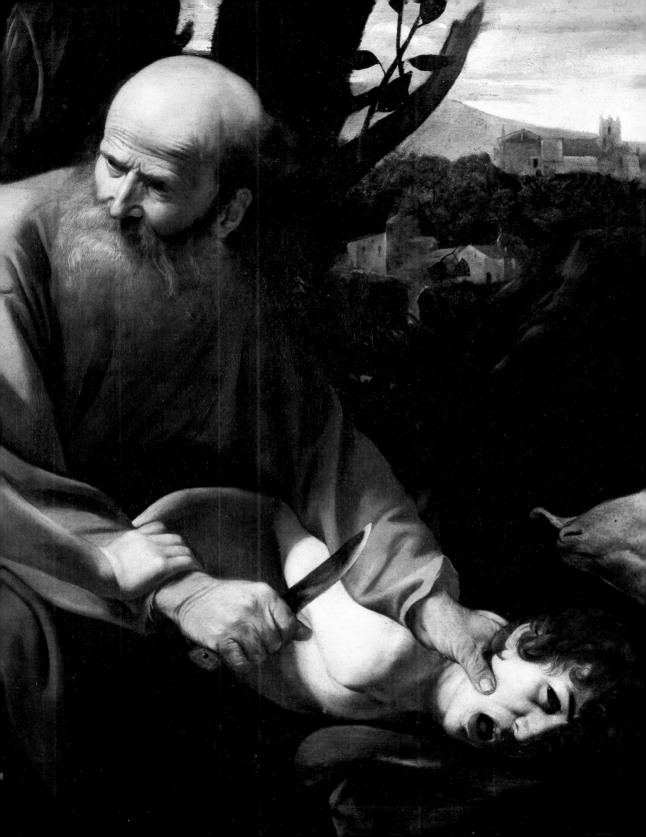

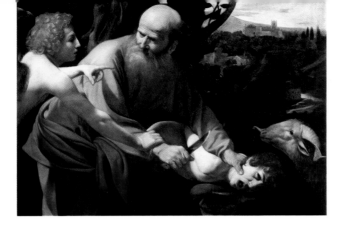

When they came to the place of which God had told him, Abraham built the altar there and laid the wood in order and bound Isaac his son and laid him on the altar, on top of the wood. Then Abraham reached out his hand and took the knife to slaughter his son. But the angel of the LORD called to him from heaven and said, "Abraham, Abraham!" And he said, "Here I am." He said, "Do not lay your hand on the boy or do anything to him, for now I know that you fear God, seeing you have not withheld your son, your only son, from me." And Abraham lifted up his eyes and looked, and behold, behind him was a ram, caught in a thicket by his horns. And Abraham went and took the ram and offered it up as a burnt offering instead of his son. (Genesis 22:9–13)

In order to appreciate the imagery of the *Sacrifice of Isaac*, it is important to understand what inspired the painting. In Genesis 22, God commands Abraham to sacrifice his son Isaac, the son whom God had promised to Abraham and his wife Sarah (Genesis 15:4, 17:15–16). In this dramatic scene, Abraham takes his son to a mountaintop in the land of Moriah, binds him, lays him on a sacrificial altar, and prepares to offer his body to God as a burnt offering (Genesis 22:2).

We see the gritty naturalism that Caravaggio was known for in Isaac's pleading eyes and open, crying mouth. We also see it in Abraham's furrowed brow, tightly gripped knife, and dark, heavy hand that presses Isaac's face to the cold rock.

Caravaggio directs the viewer's eyes to the triangle formed by the angel's shoulder, Abraham's head, and Isaac's face. This triangular composition draws viewers into the intensity of the moment. Meanwhile, the ram stuck in the brambles behind Isaac's head points to God's provision to spare Isaac.

The three Abrahamic religions interpret this event in Abraham's life differently. In Judaism, the event is known as the "binding of Isaac" (*Akedah*) and is commonly read as an example of Abraham's obedience to God's command and Isaac's willingness to become a martyr. In Christianity, the story is read through the lens of the death of Jesus, with the lamb representing Jesus as the sacrifice that spares people. And according to the Islamic retelling of the event, no binding was required because Abraham's son—believed by most Muslims to be Ishmael, not Isaac—was willing to be sacrificed; he was the embodiment of submission (Islam), and so he did not need to be bound.

Caravaggio's painting of the biblical story provides room for multiple interpretations. But the biblical story of a father who is told by God to kill his son stirs questions about faith, trust, and sacrifice. The account in Genesis and the painting invite us to consider what it means to live in faith and the importance of searching for opportunities to receive and show mercy, as represented by the ram in the thicket.

*T*his work is by Nicolas d'Ypres, a well-known artist of the early Renaissance, active in Avignon. d'Ypres takes us into a deeper consideration of the sacred. It is one of two panels of a large altarpiece created for the Carpentras Cathedral in Provence, France. The other panel, **The Miracle of the Fleece of Gideon** (1500), is of comparable size and style. Both works are currently in the Musée du Petit Palais in Avignon.

In rustic style, d'Ypres sometimes flattened his subjects and brought them to the foreground. But his work was any thing but two-dimensional. For example, he beautifully rendered the drapery of Jacob's clothing. The intricate folds in Jacob's robe recall classical Greco-Roman statuary. When scholars try to determine if a piece is by d'Ypres, they often look to the disproportionately large size of the figures' heads. This is evident in the crucifixion scene that originally accompanied this altarpiece.

In **The Dream of Jacob**, d'Ypres demonstrates a firm grasp of proportion and linear perspective. The sides of the ladder get closer together the higher they go, and the mountains and small building in the distance are rendered in lighter, hazier hues. A light source illuminates the scene from the left foreground. And d'Ypres portrays Jacob with individuality, in three dimensions.

THE DREAM OF JACOB
(JACOB'S LADDER) (CA. 1500)
Nicolas d'Ypres (ca. 1495–1532)

Current location: Musée du Petit Palais, Avignon, France

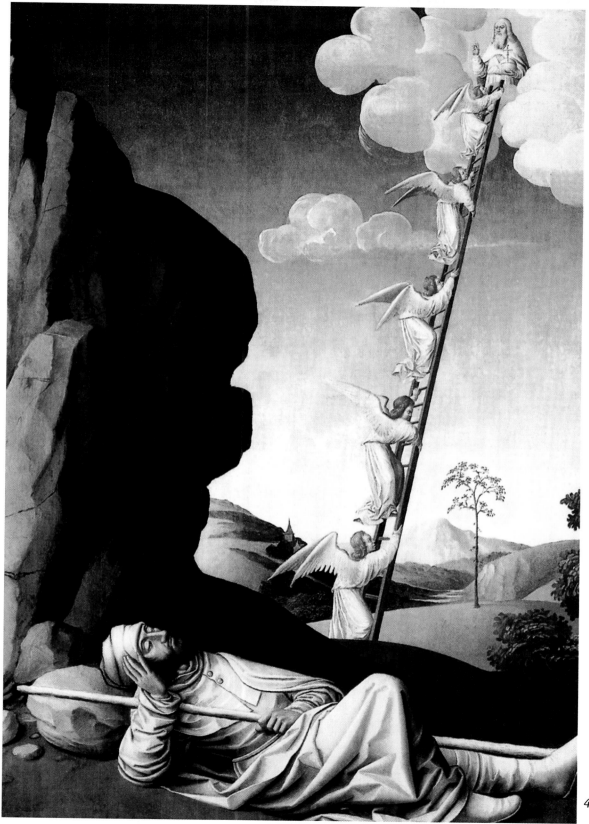

41

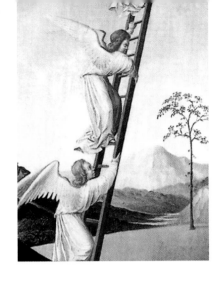

And he dreamed, and behold, there was a ladder set up on the earth, and the top of it reached to heaven. And behold, the angels of God were ascending and descending on it! And behold, the LORD stood above it and said, "I am the LORD, the God of Abraham your father and the God of Isaac. The land on which you lie I will give to you and to your offspring." (Genesis 28:12–13)

In this painting, d'Ypres has recreated a scene from Genesis 28:10–19, where the patriarch Jacob stops for the night at a placed called Luz (approximately twelve miles north of Jerusalem) and dreams of a ladder stretching between heaven and earth. In his dream, angels ascend and descend the ladder, and God tells him that his offspring will multiply and bless all the families of the earth.

d'Ypres uses the ladder and the rocky cliff as vertical frames. This brings our eyes down to Jacob, who slumbers with his head on the rock he will use to consecrate the place where God spoke to him.

Jacob's attire matches that of the angels. A double-buttoned white linen cape worn by priests is similar to the long cloak worn by God at the top of the ladder. This suggests an affinity—though not an identity—with God. d'Ypres's inclusion of Jacob's staff most likely foreshadows Jacob's struggle against an assailant (described as "a man" in the biblical text but often considered by Bible readers to be God) who injures Jacob's hip, causing him to walk with a limp, and gives Jacob a new name: Israel ("one who wrestles with God"), which becomes the national name of Jacob's descendants (Genesis 32:22–32).

In the Jewish tradition, Jacob's dream has been understood as an analogy for the Jewish experience of "ascending" into the land of Canaan and "descending" in exile from Israel. Jacob's ladder is also commonly understood as a metaphorical bridge connecting heaven and earth, the divine and the human, the holy and the mundane.

In Genesis 28:18–22, Jacob leaves a monument for his descendants to remember the place where God appeared to him in a dream. As soon as he wakes up, he anoints the rock he had used as a pillow with oil and sets it up as a memorial; he then renames the sacred place *Bethel* ("house of God") and vows his devotion to God.

Perhaps d'Ypres's work can help us recognize the beauty of sacred moments in our own lives: the birth of a child, a wedding, a hike in the mountains, coffee with a friend. These moments are set apart and worth remembering.

*J*acob Wrestling with the Angel *is one of 241 wood engravings produced by the French illustrator, printmaker, painter, and sculptor Gustave Doré. He produced this for the 1843 French translation of the Vulgate Bible known as the* **Bible de Tours.** *Today this Bible is commonly known as the* **Doré Bible***.*

By his early twenties Doré was a highly regarded illustrator in Paris. His impressive illustrations of Dante's **Divine Comedy** *(1866–1867) and Cervantes's* **Don Quixote** *(1863) brought him incredible success, and he remained a highly sought-after illustrator throughout his life. Doré died at age fifty-one.*

Doré's style has been described as academic romanticism. His illustrations frequently bear a dark, mysterious sensibility. Doré's illustrations of the Bible include 139 images from the Hebrew Bible, 21 from the books of the Christian Old Testament that are not part of the Hebrew Bible, and 81 from the New Testament. He often avoided the traditional renderings of familiar biblical scenes in favor of new, more dramatic adaptations. He also gave particular attention to discrete light sources with sharply contrasting shadows.

JACOB WRESTLING WITH THE ANGEL (1866)
Gustave Doré (1832–1883)
C. Laplante (1807–1903), engraver
Current location: Granger Collection, New York, USA

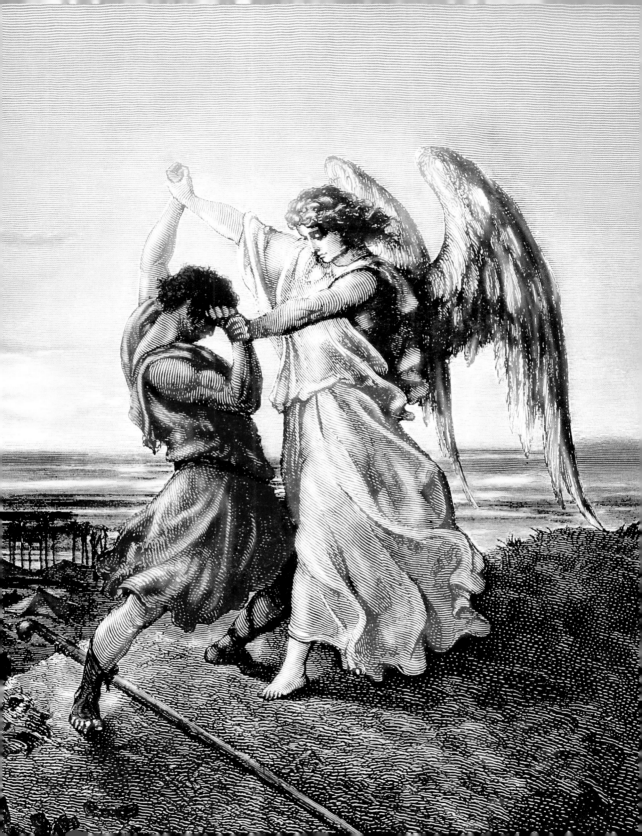

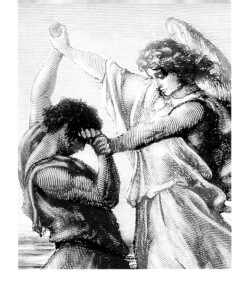

Then he [the one wrestling with Jacob] *said, "Let me go, for the day has broken." But Jacob said, "I will not let you go unless you bless me." And he said to him, "What is your name?" And he said, "Jacob." Then he said, "Your name shall no longer be called Jacob, but Israel, for you have striven with God and with men, and have prevailed." (Genesis 32:26–28)*

In this illustration, Doré captures the moment Jacob struggles in a divine encounter. But there is a backstory to this scene, one that describes Jacob as a conniver who manipulates even his own brother for selfish gain.

When Jacob and Esau were younger, Esau left home to hunt in order to make a meal for their father, Isaac (Genesis 27). While he was gone, his twin brother, Jacob, deceived Isaac, convincing his father that he was Esau. The aim of Jacob's deception was to win the blessing of the firstborn son, which rightfully belonged to Esau.

His tactic worked. But when Esau returned home and discovered that he had lost not only his birthright but also his father's blessing, he became so angry that Jacob fled for his life.

Years later, while living far from his father and brother, Jacob heard that Esau was coming with four hundred men to meet him (Genesis 32). Fearing retaliation for his deception, Jacob sent his family to the other side of a river. While alone, an unidentified man appeared and the two of them wrestled throughout the night. After a long struggle, the stranger finally struck Jacob's hip, setting it out of joint.

Although injured, Jacob held on to the man and refused to let him go unless he blessed him. The stranger then changed Jacob's name to Israel (which conveys the idea of a struggle with God), and Jacob called the place where they wrestled Peniel, which means "the face of God." Jacob declared, "I have seen God face to face, and yet my life has been delivered" (Genesis 32:30).

The first-century AD Jewish historian Josephus interpreted the event as a dream. Others have read the passage as a metaphor for prayer. Some see the story as another example of mythological heroes battling gods. Still others use the event to support the Jewish dietary restriction against eating the thigh muscle attached to the hip socket.

Central to these interpretations is the question about who fought against Jacob and changed Jacob's name to Israel. Various traditions suggest he was an angel, a vision of Esau, or God. Doré depicts the stranger as an angel. The Hebrew text uses *ish*, which denotes a "man," and the biblical text connects the stranger's identity with God (Genesis 32:26–30).

In Doré's illustration, it is night. Far off in the distance, the tents of Jacob's family can be seen. This correlates with the biblical story, which says that Jacob sent his family away in preparation for the arrival of Esau's fighting men. This indicates that Jacob felt guilty for having wronged his brother and that he was prepared to reap the consequences without risking the well-being of his family. It is not until the episode is over and Jacob, now called Israel, names the site Peniel that the divine identity of the man is revealed.

Jacob's experience is perhaps an important way of thinking about questions of faith. Contrary to a relationship based on blind faith or absolute certainty, Jacob's relationship with the divine includes wrestling, struggling, and pursuing truth but never giving up.

*P*elegrín Clavé, a Catalonian artist who studied painting in Barcelona and Rome, served as codirector of painting and sculpture at the Academy of San Carlos in Mexico City from 1846 to 1868. When he returned to Barcelona, he was chosen to be a member of the Royal Catalan Academy of Fine Arts of Saint George.

Clavé was best known as a painter in the romantic tradition. This work clearly reflects the influence of the German romantic painter Friedrich Wilhelm Schadow's rendition of the same scene—particularly in Jacob's rending of his gown and the coloration of his family's garments.

In this painting, the aged, snowy-bearded Jacob, seated on a chair, tears at his garment as he is presented with the bloody robe of his beloved son Joseph. His family gathers around him, seeking to comfort the elderly patriarch. The man holding the bloodstained robe is probably Jacob's eldest son, Reuben, and to Reuben's right is likely Benjamin, Jacob's youngest son and Joseph's natural brother.

JACOB RECEIVES THE BLOODY COAT OF HIS SON JOSEPH (1842)
Pelegrín Clavé (1811–1880)

Current location: Museu d'Art de Girona, Girona, Spain

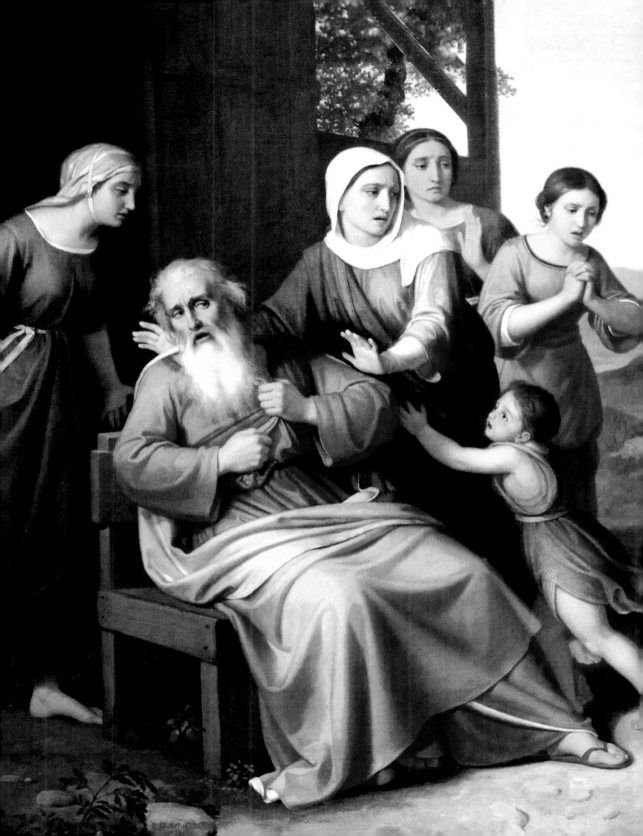

And they sent the robe of many colors and brought it to their father and said, "This we have found; please identify whether it is your son's robe or not." And he identified it and said, "It is my son's robe. A fierce animal has devoured him. Joseph is without doubt torn to pieces." Then Jacob tore his garments and put sackcloth on his loins and mourned for his son many days. (Genesis 37:32–34)

Envy, an ancient human trait, is central to the story of Joseph and his brothers. In Genesis 37, several events transpire that provoke hatred and envy in the hearts of Joseph's brothers.

First, Joseph betrayed his brothers by telling their father, Jacob, "a bad report of them" (verse 2). Then Jacob, who "loved Joseph more than any other of his sons" (verse 3), doted on Joseph by giving him a special robe. This special attention caused Joseph's brothers to hate him. Their hatred only grew toward Joseph—and combined with jealousy—when he told his brothers about two dreams he had that implied he would rule over his family.

While pasturing their flock, Joseph's brothers saw Joseph approaching and plotted to kill him. Reuben, however, persuaded his brothers to leave Joseph in a dry cistern rather than murder him. When Joseph arrived, they stripped him of his unique robe and threw him in the empty cistern.

As the brothers ate a meal, a caravan of Ishmaelites approached. The brothers decided to sell Joseph to the travelers rather than leave him to die in the well. Before returning home, Joseph's brothers dipped Joseph's robe in the blood of a slaughtered goat. They showed the robe to their father and convinced him that Joseph had been killed by a wild animal.

Envy is the desire for something someone else has: the attention and favoritism of a father, the affection of a lover, or material wealth. Envy stems from discontentment with one's own situation and often develops into resentment—or hatred—toward another.

Joseph's brothers hated him because of his relationship with their father. They knew they did not receive the same favor. They likely became insecure about their status within the family and may have reasoned that by killing Joseph, their father's affections, approval, and estate would belong to them. Perhaps they felt they would be free to live without the looming threat of their younger brother ruling over them.

However, the plot to get rid of Joseph did not free them. As shown in the painting, they would have to bear the guilt of their decision every day in the presence of their mourning father. The story ends on a positive note when Joseph, who had become a powerful official in Pharaoh's court, forgives his brothers and is reunited with his father (Genesis 45–46).

The story of Joseph and his brothers, so beautifully portrayed by Clavé, serves as a compelling study on the nature of envy—its root causes, its impact on relationships, and the idea that to be human is to yearn for what we do not posses and to transcend the given. This is our beauty and our burden.

In the 1920s and 1930s, an archaeological team, led by Yale University and the French Academy of Inscriptions and Letters, unearthed the ancient Roman city of Dura-Europos on the right bank of the Euphrates River in what is today southeast Syria. The city was abandoned sometime between AD 256 and 257, but it remained remarkably well-preserved. One of the most fascinating discoveries was a Jewish synagogue and its astonishing wall paintings, which are today the oldest examples of narrative biblical art.

*This image of **Moses in the Bulrushes** is taken from a series of three large frescos painted on the western wall of the main assembly room. The wall features scenes from the lives of Abraham, Moses, David, Ezekiel, and others. These paintings were likely used for instructional purposes in preserving the stories of the Jewish people. The narrative in Exodus 2 identifies the woman in the river as Pharaoh's daughter.*

INFANT MOSES IN THE BULRUSHES
(MID-3RD CENTURY AD)

artist unknown

Current location: Dura Europos synagogue, Syria

Now the daughter of Pharaoh came down to bathe at the river, while her young women walked beside the river. She saw the basket among the reeds and sent her servant woman, and she took it. When she opened it, she saw the child, and behold, the baby was crying. She took pity on him and said, "This is one of the Hebrews' children." Then his sister said to Pharaoh's daughter, "Shall I go and call you a nurse from the Hebrew women to nurse the child for you?" (Exodus 2:5–7)

This painting illustrates the biblical account of how Moses was found by Pharaoh's daughter after Moses's mother, fearing for the life of her baby, placed him in a basket (or *ark*—the same Hebrew word is used for Noah's ark in Genesis 6:14) and concealed it among the reeds of the Nile.

Fearing that the Israelites would become too numerous and more powerful than the Egyptians, Pharaoh set forth an edict commanding Egyptian midwives to cast every Hebrew male baby into the Nile (Exodus 1:15–22). This beautifully preserved fresco depicts how three women successfully overcame Pharaoh's cruel and inhumane policy with courage and compassion.

In the center of the painting, Pharaoh's daughter, who has been bathing, stands naked holding Moses in the river next to his floating basket, while her three attendants watch from the riverbank behind her. According to Exodus 2:6, Pharaoh's daughter immediately identified the child as one of the Hebrew boys destined for death. She had compassion for the baby and disregarded her father's order by saving him from infanticide.

To the left, the narrative continues with two Hebrew women receiving the baby from Pharaoh's daughter. In the biblical story, Moses's sister, Miriam, stood nearby in the reeds watching her brother's basket float in the river. When Pharaoh's daughter took him from the basket, Miriam

slyly asked, "Shall I go and call you a nurse from the Hebrew women to nurse the child for you?" (Exodus 2:7). Pharaoh's daughter, presumably not knowing that the girl was Moses's sister, sent her for a nurse from the Hebrew women. By obeying Pharaoh's daughter, Miriam stood in direct defiance of Pharaoh's command to drown all Hebrew baby boys.

Moses's mother defied the edict and hid her son in her home for three months. When he became too old to hide, she placed him in the basket and set him in the reeds on the bank of the river. The Nile River that Pharaoh declared would be her son's tomb became Moses's transport to safety. His mother returned with Miriam and served as Moses's wet nurse, even receiving payment from Pharaoh's daughter to nourish her own son (Exodus 2:9).

When Pharaoh's daughter took the child as her own, named him, and raised him in Pharaoh's own home, she completed an exquisite coup of civil disobedience, subverting the unjust power of her own father. The ultimate result was that Moses, reared in Pharaoh's home, became the man who would liberate Pharaoh's enslaved people.

This narrative reveals the courage of three women who resisted and undermined the policies of a tyrant king. These women are an example of how those who may be perceived as weak can thwart the unjust plans of the strong.

*E*ckersberg, who has been called the godfather of romanticism and the father of Danish painting, began painting as a child and learned the basics of perspective and coloration from his father. In 1803 he entered the Royal Danish Academy of Fine Arts, and in 1810 he traveled to Paris, where he studied with the master neoclassicist Jacques-Louis David.

Under David's instruction, Eckersberg learned to paint from life and open-air nature studies, which would become one of his greatest contributions to Danish painting. After three years in Italy, he returned to Denmark, where he taught as a professor at the Royal Danish Academy for three decades.

Eckersberg was in Rome when he received a commission from a Jewish merchant from Denmark who wanted a large painting of the Israelites crossing the Red Sea. However, Eckersburg chose to paint the Israelites resting after the crossing. As a student of the natural world, he wanted to emphasize the natural, human elements of the event more so than the supernatural.

THE ISRAELITES RESTING AFTER THE CROSSING OF THE RED SEA (1815)

Christoffer W. Eckersberg (1783–1853)

Current location: National Gallery of Denmark, Copenhagen, Denmark

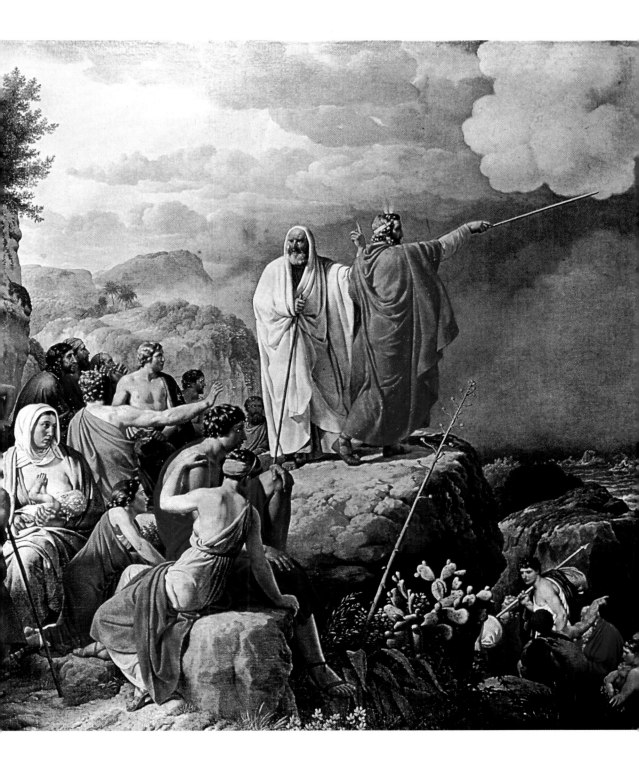

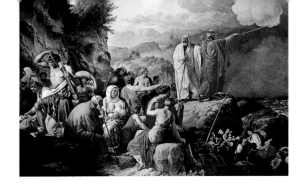

Then the LORD said to Moses, "Stretch out your hand over the sea, that the water may come back upon the Egyptians, upon their chariots, and upon their horsemen." So Moses stretched out his hand over the sea, and the sea returned to its normal course when the morning appeared. And as the Egyptians fled into it, the LORD threw the Egyptians into the midst of the sea. (Exodus 14:26–27)

Eckersberg's attention to nature is evident in this scene from Exodus 14 in the way he captures the sky and clouds. He stages his figures in natural poses surrounded by a realistic landscape. Moses stands atop a rocky outcrop and extends his staff out over the Red Sea, commanding its waters to collapse on Pharaoh's armies, who can be seen floundering in the distant sea. The white-robed figure on his left is his brother, Aaron, the first high priest of the Israelites. Aaron faces the Israelites and gestures heavenward, indicating the source of Moses's power.

In contrast to similar depictions of this biblical scene, Eckersberg does not put the drowning Egyptians in the foreground. Instead, he focuses on the more intimate details of the families who have just crossed the sea. As one mother breastfeeds her child, another mother holds her sleeping child on her shoulder. In the lower right-hand corner, a mother cradles her child close to her chest. In the foreground, a woman in a green tunic gently places her hand on her husband's shoulder. An old man sits on a rock holding a staff. Behind him a bare-chested archer looks down at a woman, perhaps his wife, as she opens a pack on top of a blanket that has been laid out on a rock, perhaps in preparation for a meal.

The climax of the biblical story is that the Israelites are saved and the Egyptian army is destroyed. However, by portraying the resting moment after the crossing, Eckersberg is perhaps pointing to what the Israelites were

saved *for* rather than what they were saved *from*. He captures the moment in which they must look to the future. The Israelites were saved from the Egyptian army so their descendants could flourish in a promised new land. Central to their future is the preservation of family, which Eckerberg's painting eloquently captures.

By focusing on the miraculous, people can miss the deep meaning that underlies many miracles in religious texts: the healing of someone who is hurting, the rescue of someone from death, or the liberation of an entire nation from slavery. The meaning in these types of events lies in the compassion of the one who saves another.

Everyone, regardless of one's beliefs, can focus on the love and concern that motivated the biblical wonders that transcend our understanding. By portraying the resting families in natural surroundings, Eckersberg's *The Israelites Resting after the Crossing of the Red Sea* emphasizes the beauty and human meaning found in the natural, not the supernatural, event.

*R*embrandt, the renowned Dutch artist of the seventeenth century, was born in 1606 in Leiden as the youngest of nine children. He started attending a university at age fourteen but dropped out after just two months to apprentice as an artist.

By 1625 Rembrandt was developing a reputation as a skilled painter of religious imagery. His early paintings, such as the **Raising of Lazarus** (ca. 1630) and the **Blinding of Samson** (1636), were powerful studies in composition and light.

Later in life—after suffering the deaths of three of his children and his wife, and experiencing bankruptcy—he turned to a more subdued, though no less powerful, style of painting. This change is reflected in **Moses Breaking the Tablets of the Law.**

This painting (over five feet tall and four feet wide) shows a towering Moses raising the tablets of the law over his head before the Israelites. Because the people are not shown, viewers can sense they are participants in the painting, face-to-face with Moses.

MOSES BREAKING THE TABLETS
OF THE LAW (1659)
Rembrandt van Rijn (1606–1669)

Current location: Gemäldegalerie, Staatliche Museen zu Berlin, Berlin, Germany

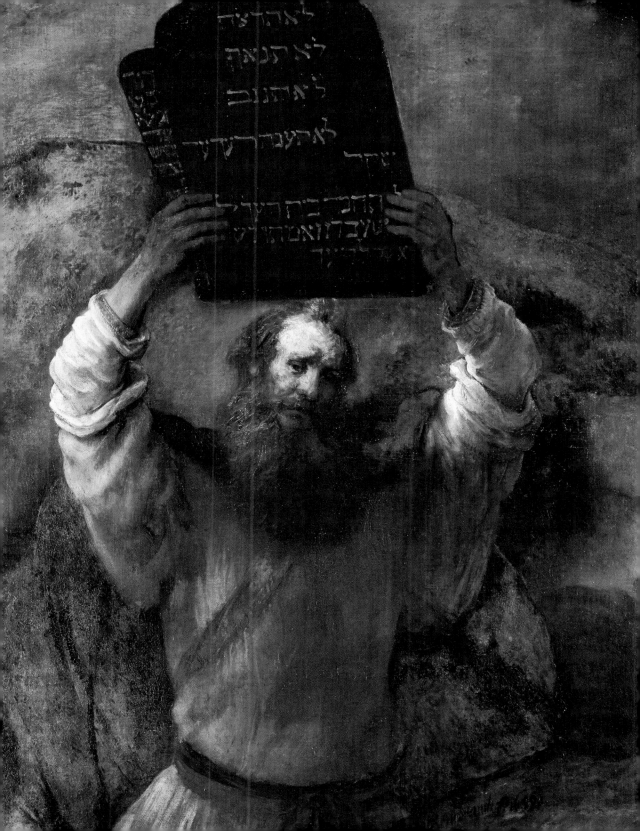

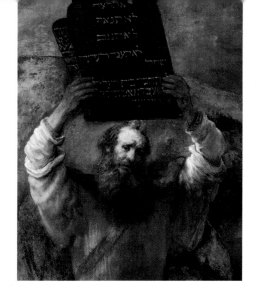

Then Moses turned and went down from the mountain with the two tablets of the testimony in his hand, tablets that were written on both sides; on the front and on the back they were written. The tablets were the work of God, and the writing was the writing of God, engraved on the tablets. When Joshua heard the noise of the people as they shouted, he said to Moses, "There is a noise of war in the camp." But he said, "It is not the sound of shouting for victory, or the sound of the cry of defeat, but the sound of singing that I hear." And as soon as he came near the camp and saw the calf and the dancing, Moses' anger burned hot, and he threw the tablets out of his hands and broke them at the foot of the mountain. (Exodus 32:15–19)

In discussions about the Ten Commandments, it can be easy for people to think about God's law in harsh legal terms. But this painting offers subtleties that can possibly help us consider a more personal understanding of God's law.

Rembrandt renders Moses in the same flushed red hue as the rocks behind him, strong and unwavering like the mountain itself. Above his head, he holds the record of the covenant between God and the Israelites.

The title *Moses Breaking the Tablets of the Law* is sometimes given as simply *Moses with the Tablets of the Law*. This suggests this painting may be a depiction of Exodus 34:29–32. In this passage, Moses receives a second set of tablets to replace the ones he had previously broken. As he comes down the mountain, Moses's face shines brightly "because he had been talking with God" (Exodus 34:29). In the painting, Moses's face is illuminated.

Because this painting could represent two similar but different biblical events, it is difficult to say with certainty whether Rembrandt painted Moses holding the first or second set of tablets.

Despite the ambiguity, Rembrandt's depiction of Moses's facial expressions unveils the painting's deepest meaning. The face of Moses reveals a contemplative man who has experienced a father's pain over the behavior of rebellious children.

The moral laws—the Ten Commandments—that Moses throws to the ground (Exodus 32:19) represent a covenant between God and the Israelites (Deuteronomy 4:13). A *covenant* is a mutually binding agreement that, unlike a legal contract, is born from a personal and heartfelt relationship. In this covenant, God agreed to provide the Israelites with land, descendants, and protection if they agreed to worship only him and keep his laws.

Therefore, when Moses finds the Israelites worshiping a golden calf, and when he throws down the tablets, which break into pieces, he expresses the pain of a relational breach between two close parties.

Rembrandt's painting shows that Moses's emotions are about more than a broken legal contract between two strangers. With his subtle and sensitive rendering of Moses's face, Rembrandt invites us to contemplate the relationship between God and humanity and the relational covenants we have with one another.

*F*lorentine painter Sandro Botticelli earned his reputation as a Renaissance master because of the light and delicate way he rendered the human form within linear compositions. His works proved his skill as a creative visionary and a technically astute draftsman. Botticelli is known for his paintings of biblical and mythological scenes as well as his portraits of the Medici family and Florence's cultural and political elite.

The Punishment of Korah and the Stoning of Moses and Aaron (sometimes called **The Punishment of the Rebels**) is a fresco in the Sistine Chapel and part of a cycle depicting the life of Moses.

It contains three scenes, viewed from right to left, of the rebellion of the Israelites against Moses and Aaron. On the far right, Joshua protects Moses from being stoned by discouraged people who had been wandering aimlessly in the desert after their liberation from Egypt. In the center, Moses, with his staff, and Aaron, dressed like a priest and holding a censer, banish Korah and his group of rebels from the community. On the far left, two conspirators are swallowed up by the earth as Moses stands over them condemning their rebellion.

THE PUNISHMENT OF KORAH AND THE STONING OF MOSES AND AARON
(1481–1482)
Sandro Botticelli (1445–1510)

Current location: Sistine Chapel, Vatican Museums, Vatican City State

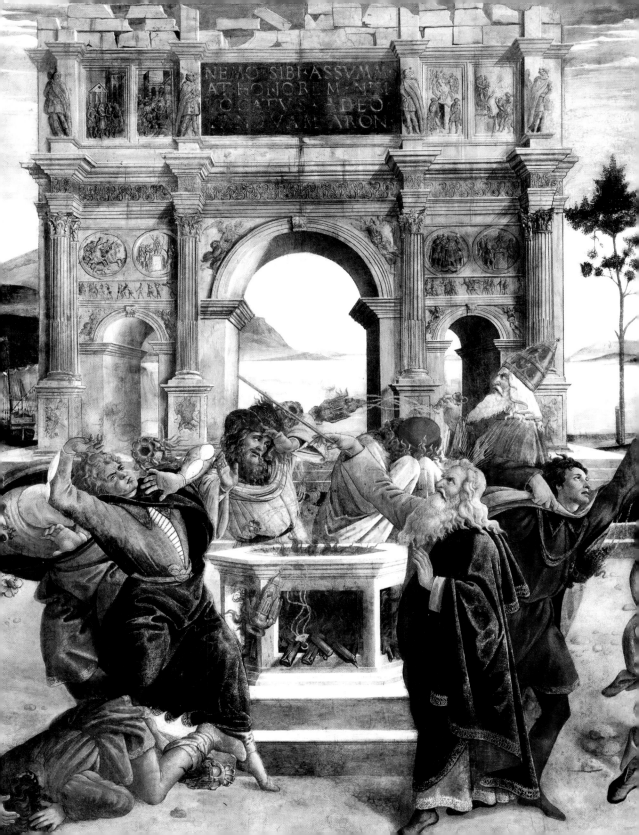

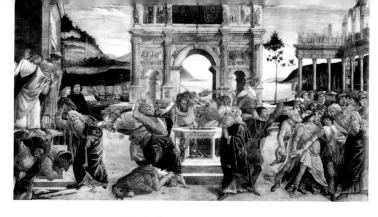

And as soon as he had finished speaking all these words, the ground under them split apart. And the earth opened its mouth and swallowed them up, with their households and all the people who belonged to Korah and all their goods. So they and all that belonged to them went down alive into Sheol, and the earth closed over them, and they perished from the midst of the assembly. (Numbers 16:31–33)

According to Numbers 16, Korah, a descendant of Levi, organized a rebellion from among the leaders of Israel. A group of 250 men gathered to protest the leadership of Moses and Aaron. "They assembled themselves together against Moses and and against Aaron and said to them, 'You have gone too far! For all in the congregation are holy, every one of them, and the LORD is among them. Why then do you exalt yourselves above the assembly of the LORD?'" (Numbers 16:3).

In response, Moses told Korah and his men to reassemble the next morning to see whom God favored. The rebels were told to bring censers and incense. The next day the 250 rebels gathered at the front of the tent of meeting. God told Moses and Aaron to separate from the community so he could pass judgment on the people of Israel, but Moses and Aaron "fell on their faces and said, 'O God, the God of the spirits of all flesh, shall one man sin, and you be angry with all the congregation?'" (Numbers 16:22).

God then told Moses to have the people separate themselves from Korah and the leaders of the rebellion. As soon as Moses finished giving the command, the ground opened and everyone who belonged to Korah, along with their households, was swallowed into the depths of the earth.

That Korah is identified as a Levite is important for understanding the motivations for the rebellion he instigated. The descendants of Levi were all considered priests. However, with the appointment of Aaron as the first high priest, Aaron's family and descendants were elevated within the priestly hierarchy over the other Levitical families. Though the Levites made up the priesthood, their role would be to serve the Aaronic high priest families.

Korah bristled at the idea that Moses would appoint his own brother as high priest and compel the Levites to serve him and his descendants. Moses's appointment of Aaron certainly has the appearance of nepotism. However, according to Numbers 17, God—not Moses—was responsible for choosing the person who would serve him as high priest.

The Latin inscription on the arch in the center of Botticelli's painting reinforces the theme of divine authority: "Let no man take honor to himself except he that is called by God, as Aaron was." The implication is that no one can claim religious authority except through God's election.

On its face, this biblical text could be interpreted as a reminder to all religious leaders that they are under the authority of God. The story of Korah's suppressed rebellion against Moses and Aaron has also been seen as a metaphor for the authority of the Catholic Church among Catholics. This view is emphasized in the fresco because Aaron is wearing a blue robe and the triple-tiered diadem of the pope and swinging a Catholic censer. In addition, Perugino's iconic *Christ Giving the Keys to St. Peter* (ca. 1481–1482), which some interpret as an affirmation of papal authority, appears opposite Botticelli's fresco in the Sistine Chapel.

Works of art such as Botticelli's fresco played an important role in communicating biblical stories and church doctrines at a time when many people were illiterate. This work illustrates the power of the visual arts to promote and reinforce officially sanctioned voices of power.

*J*ohn Linnell, one of the most respected and well-paid English painters of the nineteenth century, studied drawing and painting at the Royal Academy in London. The success of his early portrait work allowed him to cultivate his love of landscape painting during the last half of his career. Linnell, a dear friend of William Blake, always considered his landscape work as poetic expressions of the spiritual.

The industrial revolution saw the rising fortunes of a new social class that turned to the arts to demonstrate their cultivated tastes. A landscape by Linnell was considered mandatory in any respectable collection, and Linnell's fortunes swelled alongside the new industrial bourgeoisie.

In **The Prophet Balaam and the Angel**, Linnell's acute attention to light and his almost impressionistic brushwork give the scene vibrant energy. The large tree bursting from the rocks has a mystique that is mirrored in the purple-gray sky into which it stretches its arm-like branches. Compositionally, the tree forms the uppermost position in the painting and leads the eye down to the central scene where the sky opens to frame a man beating a donkey with a stick and an angel with a pale yellow halo.

THE PROPHET BALAAM AND THE ANGEL (1859)

John Linnell (1792–1882)

Current location: Museum of Fine Arts, Houston, USA

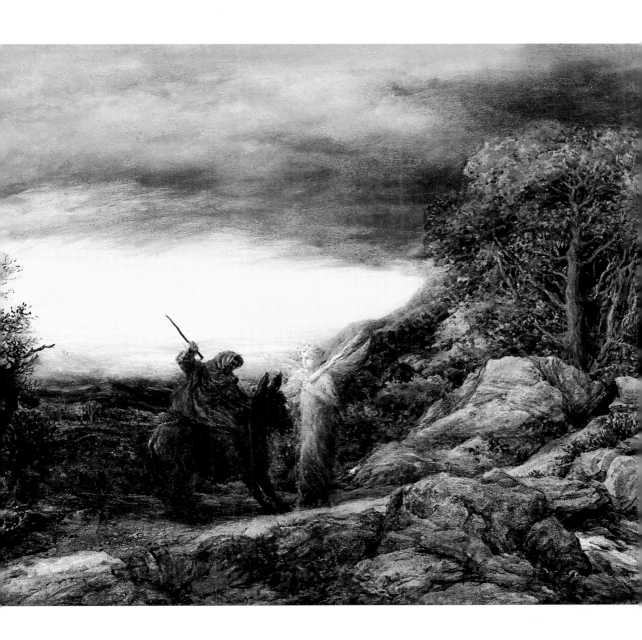

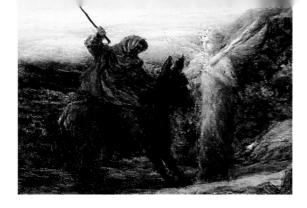

And the donkey saw the angel of the LORD standing in the road, with a drawn sword in his hand. And the donkey turned aside out of the road and went into the field. And Balaam struck the donkey, to turn her into the road. (Numbers 22:23)

This unusual scene depicts the story in the book of Numbers about Balaam, a man who supposedly had the ability to foretell the future and bring down curses on his enemies. According to Numbers 22–24, Balak, the king of Moab, summoned Balaam to come to Moab and to curse the Israelites, for fear they would defeat him in battle (Numbers 22:3).

On the way, an angel blocked Balaam's path as he rode to Moab on his donkey. At first, only the donkey could see the angel and so the animal veered into a field. Because Balaam could not see the angel and thought his donkey was simply being stubborn, he beat it with a stick. After three beatings, the donkey spoke, rebuking Balaam for his cruel mistreatment. It is this scene that Linnell so powerfully portrays.

Numbers 22:31 states that God opened Balaam's eyes so he could see the angel. Humbled and repentant, Balaam agreed to meet Balak in Moab, but only to deliver God's words to the king. God gave Balaam four messages to deliver to Balak, all of them in support of Israel. In one case, Balaam said to Balak that Israel's "kingdom shall be exalted" (Numbers 24:7).

Balak, who did not want to hear these words from Balaam, angrily said, "I called you to curse my enemies, and behold you have blessed them" (Numbers 24:10). But Balaam's change of heart led him to only say what God wanted him to say, even at great risk (Numbers 24:13).

This unusual story of a talking donkey is commonly interpreted as a confirmation of God's blessing of the Israelites over rival nations. However, Jewish philosopher Emmanuel Levinas (1906–1995) suggested an alternative interpretation.*

Levinas claimed that the cure for the idolatry of a singular and closed view of interpretation was a free and open exchange of ideas. He suggested that the Torah calls for continual and renewed interpretations that help its readers more fully understand one another and become better human beings. In light of this, this story can be read as an allegory for the importance of the distinctly human act of dialogue and discourse.

Balaam was willing to speak his mind (God's mind, in this case), even at the risk of personal loss. Are we fearful of saying important things for fear of losing our place in a social circle? Or, like Balak, are we listening only for what we want to hear? In both instances, dialogue is closed off and genuine interaction is thwarted.

Like many great works of art, Linnell's painting of this story leaves room for multiple interpretations. He painted the faces of the donkey, the angel, and Balaam with vague, suggestive brushwork that lacks detail. This approach encourages free interpretation of the painting and perhaps of the biblical story.

* Emmanuel Levinas, "Contempt for the Torah as Idolatry," in *In the Time of the Nations*, trans. Michael B. Smith (New York: Continuum, 2007), 43-63.

*T*he work of Italian Renaissance painter Luca Signorelli was influenced by Tuscan master Piero della Francesca and Antonio Pollaiuolo. Piero della Francesca's influence can be seen in Signorelli's strategic use of light, geometrical compositions, and solid, stock figures. The influence of Antonio Pollaiuolo is evident in Signorelli's attention to the human figure in motion. This piece, completed for the Sistine Chapel, also reveals Signorelli's personal style of dynamic composition infused with movement, drama, and raw physicality.

This painting depicts various scenes from the life of Moses. In the right foreground, Moses reads from the Torah. The ark of the covenant rests at his feet, revealing the tablets of the Law and a bowl of manna. Interestingly the men, women, and children are portraits of fifteenth-century nobles and important political people set in place to witness the biblical scene. Their attire distinguishes them from characters of the biblical time period. An enigmatic nude joins the group to sit on a tree stump.

In the left foreground, Moses passes leadership of the Israelites to Joshua by giving him his staff. In the center background, Moses stands on top of Mount Nebo with an angel, who extends a hand to show him the land that he will never enter. Moses then descends the mountain. On the left in the distance, Moses's body is laid out on a burial shroud as mourners prepare for his internment.

THE TESTAMENT AND DEATH OF MOSES (1482)

Luca Signorelli (1445–1523)

Current location: Sistine Chapel, Vatican Museums, Vatican City State

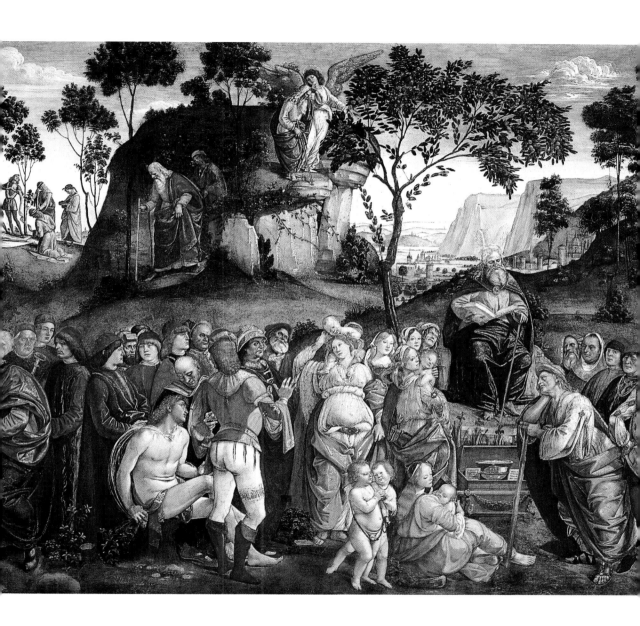

73

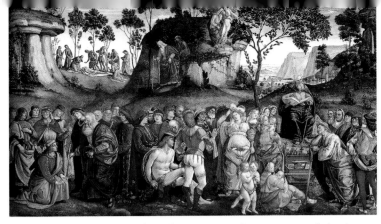

And the Lᴏʀᴅ said to him, "This is the land of which I swore to Abraham, to Isaac, and to Jacob, 'I will give it to your offspring.' I have let you see it with your eyes, but you shall not go over there." So Moses the servant of the Lᴏʀᴅ died there in the land of Moab, according to the word of the Lᴏʀᴅ. (Deuteronomy 34:4–5)

After freeing the Israelites from slavery in Egypt, Moses led his people through the wilderness for over forty years toward a land of promise he would never enter. Instead, he would die on a mountaintop overlooking his destination.

Moses's death outside Canaan is commonly seen as his punishment for striking a rock to draw water from it rather than speaking to it as God commanded (Numbers 20:12). Some have interpreted Moses's death as the symbolic atonement for the "wilderness generation" (the Israelites who wandered in the wilderness and died before reaching Canaan) and the simultaneous preparation of the new generation that would enter Canaan.

Moses's life had a remarkable impact. He freed his people from slavery and served as their leader in the initial phases of their cultural and moral development. But at the end of his life, he is left on the threshold of experiencing the fullness of God's promised land.

The word *threshold* comes from the Latin word *limen*. The Latin word refers to the threshold, the entrance. Anthropologists use it to describe in-between places and times. These include times and rituals that mark transitions from one stage in life to another, similar to the way a *bat mitzvah* celebrates the transition from girlhood to womanhood within Judaism. In many ways, Moses's life was liminal (on the edge) from beginning to end.

Moses lived through many different thresholds: born a Hebrew but raised as an Egyptian; called to lead a nation but feeling inadequate (Exodus 4:10); standing at the water's edge hoping for God to provide a way through; wandering for four decades as a migrant with no home; called to be the intermediary between God and the Israelites; dying on the edge of the promised land before he could see his life's work fulfilled.

Signorelli portrays these tensions in the full story of Moses's life and death—from the foreground where he passes his authority to Joshua, to the central scene of Mount Nebo where he sees the land of Canaan from a distance, to the background where his body lies ready for burial.

*J*ames Tissot, born in Nantes, France, was raised Catholic. In his early twenties, he studied at the École des Beaux-Arts in Paris. His first paintings were included in the Paris Salon, the official exhibition of the arts academy. His reputation as an accomplished painter of lavishly dressed aristocratic men and women posed in fashionable locales enabled him to earn a steady income from the upper crust of late-nineteenth-century society.

In 1885, Tissot had a profound religious experience during Mass at the Church of Saint-Sulpice in Paris. He spent the last seventeen years of his life traveling to the Middle East and completing over four hundred watercolors and illustrations based on the life of Jesus and the Hebrew Bible.

Although Tissot had a remarkable career, his watercolor paintings have often been considered inferior to his other works. His series **The Life of Christ** has had few exhibitions, and his series of gouache (a water-based paint) and watercolor works about the Hebrew Bible have never been exhibited as a complete collection.

However, according to Judith Dolkart, author of **James Tissot: The Life of Christ**, there has been a resurgence of interest in visual culture of nineteenth-century religious art since the 1980s, generating newfound interest in Tissot's religious work.

THE ARK PASSES OVER THE JORDAN
(1896–1902)
James Tissot (1836–1902)
Current location: Jewish Museum, New York, USA

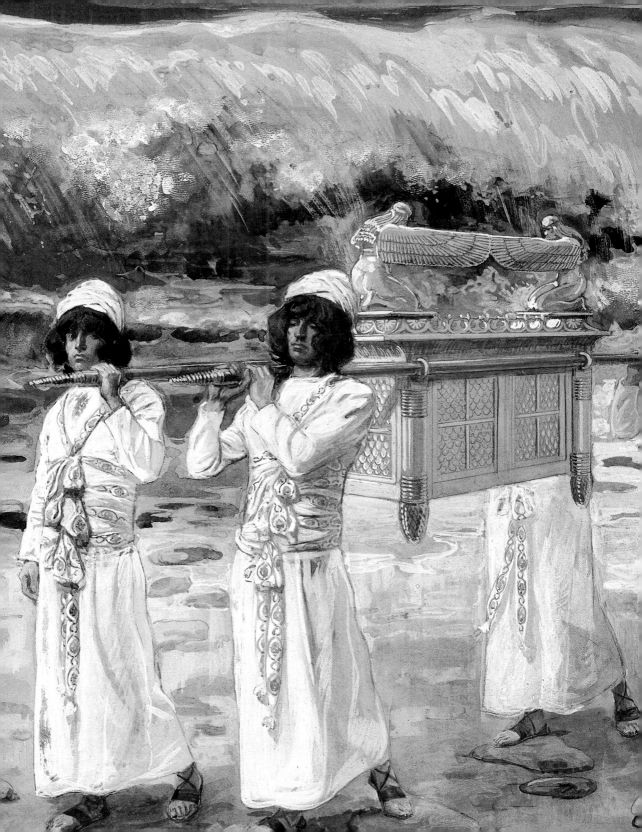

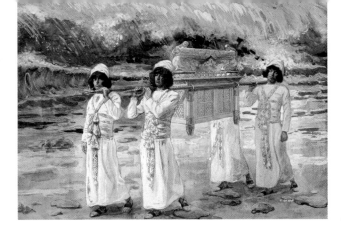

And as soon as those bearing the ark had come as far as the Jordan, and the feet of the priests bearing the ark were dipped in the brink of the water (now the Jordan overflows all its banks throughout the time of harvest), the waters coming down from above stood and rose up in a heap very far away, at Adam, the city that is beside Zarethan, and those flowing down toward the Sea of the Arabah, the Salt Sea, were completely cut off. And the people passed over opposite Jericho. (Joshua 3:15–16)

Everyone has been faced with a difficult decision that required stepping into the unknown: a change of profession, moving to a new city, getting married, having children. Such decisions take courage, and they define our lives. Perhaps for this reason the story of the Israelites crossing the Jordan River has had such lasting appeal.

According to Joshua 3, on their way to Canaan, the Israelites had to cross the Jordan River opposite the city of Jericho. As they approached the overflowing river, God instructed Joshua to bring the ark of the covenant to the front of the procession and have the priests carry it into the river. Like Moses before him at the Red Sea, Joshua followed God's command and the waters parted.

The ark of the covenant played a significant role in this story. The stone tablets containing the Ten Commandments were placed in the ark. The ark of the covenant gave the nomadic Israelite tribes a unifying sacred symbol that became a focal point for worship. For them, it was the ultimate manifestation of God's presence, promises, and power. According to some traditions, this power would destroy anyone who approached the ark who was not a consecrated priest.

When they reached the overflowing Jordan River, the people of Israel saw no way to cross over to the land God had promised to them. Joshua believed the people would follow the ark of the covenant—the tangible symbol of God's presence with them. The biblical text says that when the priests stepped into the water with the ark, the river parted.

Tissot's painting shows a wall of water threatening to rush over the priests carrying the ark. Despite the danger to them and the Israelites, the priests' faces are calm. Tissot captures their faith in the power of God, whose mighty throne they hold on their shoulders.

As depictions of faith and adventure, Tissot's painting and the biblical account in Joshua demonstrate the importance of courageously taking steps forward even when we do not see a clear path ahead.

*I*n 1855, at the age of twenty-five, Carl Bloch won a travel grant from the Royal Danish Academy of Art. He used the funds to travel through the Netherlands, France and Italy. During these travels he encountered the work of Rembrandt, who remained an inspiration to Bloch throughout his artistic career.

Bloch did not return to Denmark but instead moved to Rome, where he spent almost a decade absorbing the techniques and vocabulary of forms of the Old Masters. While in Rome, Bloch completed **Samson and the Philistines.** The influence of his Renaissance predecessors is apparent in the classical form and theatrical lighting rendered in the painting.

SAMSON AND THE PHILISTINES (1863)
Carl Bloch (1834–1890)

Current location: National Gallery of Denmark, Copenhagen, Denmark

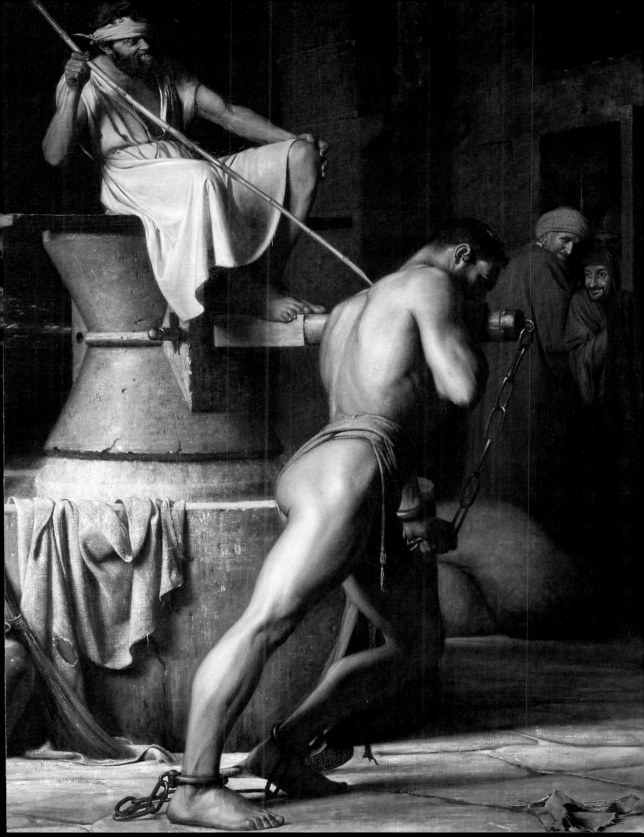

And the Philistines seized him and gouged out his eyes and brought him down to Gaza and bound him with bronze shackles. And he ground at the mill in the prison. But the hair of his head began to grow again after it had been shaved. (Judges 16:21–22)

Samson's epic story, found in Judges 13–16, reveals a man who had incredible physical strength but who had inner weaknesses that eventually undermined his life. Carl Bloch's painting of Samson depicts him in weak state, when he is subjugated by his enemies. We are drawn into a reflection on the importance of character.

Before Samson was born he was dedicated to God as a Nazirite (Judges 13:2–7). According to Numbers 6, people who took the vow of a Nazirite had to abstain from wine and all substances that contained grapes. Additionally, they could not go near the body of a corpse and were not permitted to cut their hair.

Samson was born when the nation of Israel had fallen under control of the Philistines, and it would be his destiny to defeat them. Samson fought the Philistines single-handedly with his unusual strength that apparently came from his long hair.

However, he had one downfall: his sexual desire for women. His most famous encounter with the beautiful temptress Delilah led to the violation of his Nazirite vow. He revealed to her that his hair was the source of his strength and then awoke to find it cut off.

Weak and without protection, Samson was captured, blinded, imprisoned, and forced to push an enormous millstone in the prison. However, his hair began to grow back. When he regained his strength, he took revenge on the Philistines by pulling down the temple of Dagon, a Philistine god, crushing three thousand of his followers.

Bloch's painting depicts Samson, blind and shorn, straining to push the millstone. Bloch draws the viewer into the piece by creating an alluring

triangle formed by the Philistine master's prodding staff and the angle of Samson's muscular right leg. The viewer enters from the same direction as the light hitting Samson's back, which completes the triangle.

The once-mighty Samson, now broken and humiliated, leans heavily against the gristmill post to which he is chained. Above him, the Philistine master sits on the grinding axel, relishing the added weight Samson must push. The master's one bandaged eye seems to mock Samson's own blindness, while his sinister grin reveals holes where teeth should be. In the distant doorway to the right, three pairs of lurid eyes look on the beaten Samson in wicked glee.

Throughout the biblical narrative, Samson is repeatedly shown as a man who acts first and thinks later. He impulsively burns the Philistine olive groves, vineyards, and grain fields (Judges 15:4–5). When the Philistine army comes for him, he kills a thousand of them with the jawbone of a donkey (Judges 15:15). Surprisingly, his rash decisions play a part in causing the downfall of the Philistines.

When the blinded Samson is called to entertain the Philistines at the temple of Dagon, he asks a man who holds his hand, "Let me feel the pillars on which the house rests, that I may lean against them" (Judges 16:26). After being dragged from his millstone prison, the first thing he does is search for a way to bring the entire temple down on the heads of his Philistine captors. He succeeds, and the account of Samson concludes with this observation: "So the dead whom he killed at his death were more than those whom he had killed during his life" (Judges 16:30).

Samson's extraordinary strength, along with the character flaw that led to his hardships, is a portrait of human nature—that every person has strengths and weaknesses. However, his story is one of hope. Despite his failures, his life ended with a victory. Samson brings down the enemy temple, reminding us that success often comes through hardships and failure.

*J*ulius Schnorr was a member of the Nazarenes, an association of German painters who rejected modern art movements in favor of the styles common to the late Middle Ages and the Renaissance. Schnorr trained at the Vienna Academy and eventually traveled to Rome, where he helped the German Nazarenes create a fresco for the **Casa Massimo al Laterano** in Rome. Returning to Germany, he joined the faculty at the Academy in Dresden.

His series of woodcut illustrations of the Bible, **Die Bible in Bildern**, is now commonly known as **Schnorr's Bible Pictures**.

This painting titled **Ruth in Boaz's Field** captures Schnorr's attention to detail and fluid forms, along with Nazarene symbolism. Boaz stands tall in his field, draped in a red cloak as he talks with Ruth, the Moabite. His vertical stature is emphasized by the staff his attendant holds as though measuring Boaz's height.

Conversely, Ruth extends a small offering of barley with a horizontal, downward gesture that mimics her downturned head. The result creates a **V**-shape from which emerges the vibrant green tree in the distance that shades the weary workers. The symbolism may point to Boaz and Ruth's eventual marriage and the fruitfulness of their union.

RUTH IN BOAZ'S FIELD (1828)
Julius Schnorr von Carolsfeld (1794–1872)
Current location: The National Gallery, London, UK

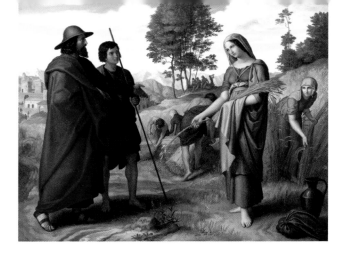

Then Boaz said to Ruth, "Now, listen, my daughter, do not go to glean in another field or leave this one, but keep close to my young women." (Ruth 2:8)

The book of Ruth is commonly read as an idyllic story of marriage that comes as a welcome reprieve in the midst of the tumultuous narratives of the young nation of Israel. Read annually at the Jewish Festival of Weeks (*Shavuot*) that celebrates the giving of the Torah, the book of Ruth echoes with the themes of harvest and divine marriage between God and the Jewish people.

Ruth was not an Israelite, but in an act of steadfast faithfulness after the death of her husband, she followed her Israelite mother-in-law, Naomi, back to her home village of Bethlehem. She met Boaz, a courageous Judean landowner, while gleaning in his grain fields. Because of a Levitical mandate requiring the protection of family line and property, Boaz married Ruth. They had a son, Obed, who was the great-grandfather of King David.

The central theme of the book of Ruth is best characterized by the Hebrew word *hesed*. There is no direct English translation for *hesed*. The closest approximation would be *loving-loyalty*, *loving-kindness*, or *abiding faithfulness*. But even these words fall short of its rich and complex meaning. English translators used words such as "kindly" and "kindness" to represent *hesed* in Ruth 1:8.

In the book of Ruth, acts of *hesed* are performed out of loyalty to family and pursuant to the family's preservation. Ruth demonstrated *hesed* when she refused to leave her mother-in-law, Naomi. And by marrying Boaz, Ruth preserved and honored her deceased husband's Judean heritage. Boaz showed *hesed* to Ruth by marrying a poor, foreign widow and bringing her into his family. He also exhibited *hesed* to Naomi, as she, too, was brought into his family.

Schnorr's painting offers a visual meditation on loving-loyalty, the ideal of *hesed* between Boaz and Ruth. The scene frames a bountiful overflowing of kindness and generosity from those who have much to those in need.

Elizabeth Jane Gardner Bouguereau's **The Shepherd David** *beautifully illustrates a passage from the Hebrew Bible in which young David appeals to King Saul to let him fight the enemy warrior Goliath on the basis of his ability to slay a lion.*

The talented artist was born in Exeter, New Hampshire, and studied language and art at Lasell Female Seminary in Massachusetts. She taught French at the Worcester School of Design and Fine Arts until 1864, when she left for Paris to pursue her artistic career.

For years she struggled in the male-dominated art world of Paris. In 1873 she applied to the Prefecture of Police for permission to dress as a man, which allowed her to study life drawing at the famous Gobelin tapestry school, best known for providing tapestries to Louis XIV. By 1879 Elizabeth had earned a reputation as an accomplished painter and won honorable mention at that year's Paris Salon.

It was also in 1879 that she became engaged to her teacher, William-Adolphe Bouguereau, though they would not marry until 1896. Gardner Bouguereau's painting style was profoundly influenced by her husband's academic style and technique, so much so that people occasionally mistook her work for his.

THE SHEPHERD DAVID (1895)
Elizabeth Jane Gardner Bouguereau (1837–1922)

Current location: National Museum of Women in the Arts,
Washington, DC, USA

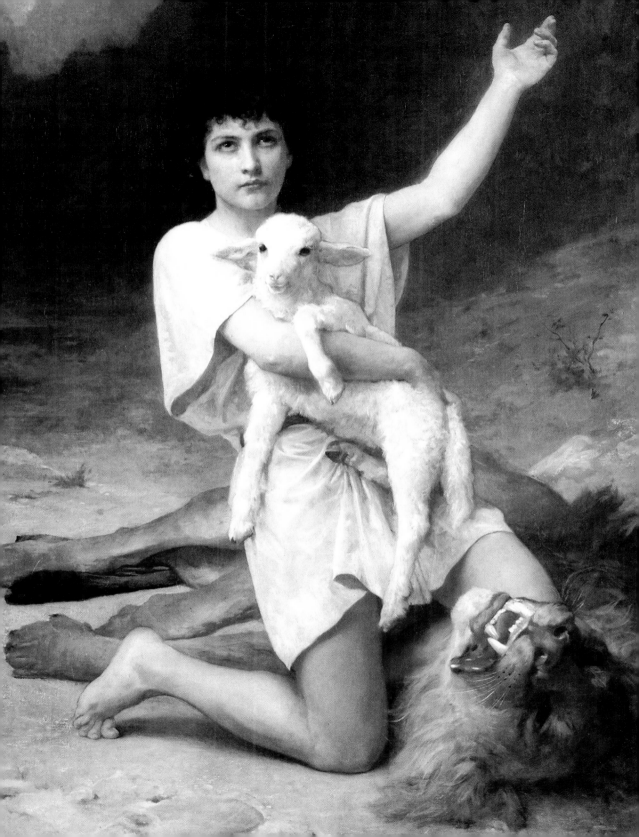

But David said to Saul, "Your servant used to keep sheep for his father. And when there came a lion, or a bear, and took a lamb from the flock, I went after him and struck him and delivered it out of his mouth. And if he arose against me, I caught him by his beard and struck him and killed him." ... And David said, "The Lord who delivered me from the paw of the lion and from the paw of the bear will deliver me from the hand of this Philistine." And Saul said to David, "Go, and the Lord be with you!" (1 Samuel 17:34–37)

In this monumental painting, which stands over five feet tall and three feet wide, Gardner Bouguereau captures David kneeling triumphantly on the neck of the slain lion and clutching a rescued lamb under his right arm. His left arm is raised to the heavens to honor both God and the old masters of classical painting and sculpture that the composition recalls.

His pale, statuesque arm is raised in a gesture that mirrors the contours of the dark mountains behind him, at once calling on and echoing their majesty. His eyes look heavenward, almost as if he were in a state of ecstasy. Following his gaze upward we first meet the black silhouette of the mountains, then the subtly lit purple mountains farther in the distance, and finally, a small patch of open sky.

The lion and the lamb are iconic symbols in art, representing aggressive ferocity and sacrificial innocence, respectively. The image of the lion was used to symbolize David's tribe, the tribe of Judah (Genesis 49:9; 1 Samuel 17:12). Conversely, the image of the lamb has a long history in the Abrahamic religions as a symbol of sacrifice. The Torah, for instance, calls for the ritual sacrifice of a lamb on the night before Passover.

The Shepherd David shows David as both the young lion of Judah and the conquering lion slayer who would rescue the sacrificial lamb (1 Samuel 17:34–35). David's pale tunic and the lamb's white fleece speak

to their respective purity and innocence, while the bloodred mouth of the dead lion and David's triumphant posture astride its corpse evoke power and strength.

The suspense portrayed in *The Shepherd David* is not in the rescued lamb or in the slain lion; it is in David's humility. In 1 Samuel 17:37, David gives God the credit for delivering him "from the paw of the lion and from the paw of the bear." In the painting, the humility rendered in David's upturned eyes and raised arm achieves this balance of power and innocence as he honors God, who rescued him from the wild beasts. In this way, the painting can enable us to reflect on the relationship between courage and humility.

In his book *The City of God* (AD 426), Augustine wrote, "There is, therefore, something in humility which, strangely enough, exalts the heart, and something in pride which debases it."

Humility relieves our hearts of the burden of perfection, the expectations of others, and the fear of failure. When we are humble before others, we are free to courageously face the obstacles and difficulties of life; we are free to chase lions and fight giants.

*S*alvator Rosa was an Italian painter known for his dark and ominous paintings filled with stormy landscapes, ancient ruins, and devious creatures, both natural and supernatural. While Rosa is typically considered a baroque painter, the mysterious and sometimes melancholic sensibility of his paintings has led some to regard him as proto-romantic.

Born outside Naples in 1615, Rosa studied painting under a series of family members, friends, and professional artists. Most notably, he was a student of José de Ribera, who was influenced by Caravaggio. This influence can also be seen in Rosa's dark and dramatic compositions.

As he matured as an artist, Rosa gained the attention of the Medici family in Florence. While working in the Medici court, he completed his **Scenes of Witchcraft** series (1645–1649). This featured some of his earliest depictions of witches, such as the one shown here. Although he lived five years after finishing **The Shade of Samuel**, it is likely the last work he ever completed, as his health and eyesight deteriorated considerably after 1668.

THE SHADE OF SAMUEL APPEARS TO SAUL IN THE HOUSE OF THE PROPHETESS OF ENDOR (1668)
Salvator Rosa (1615–1673)

Current location: Louvre Museum, Paris, France

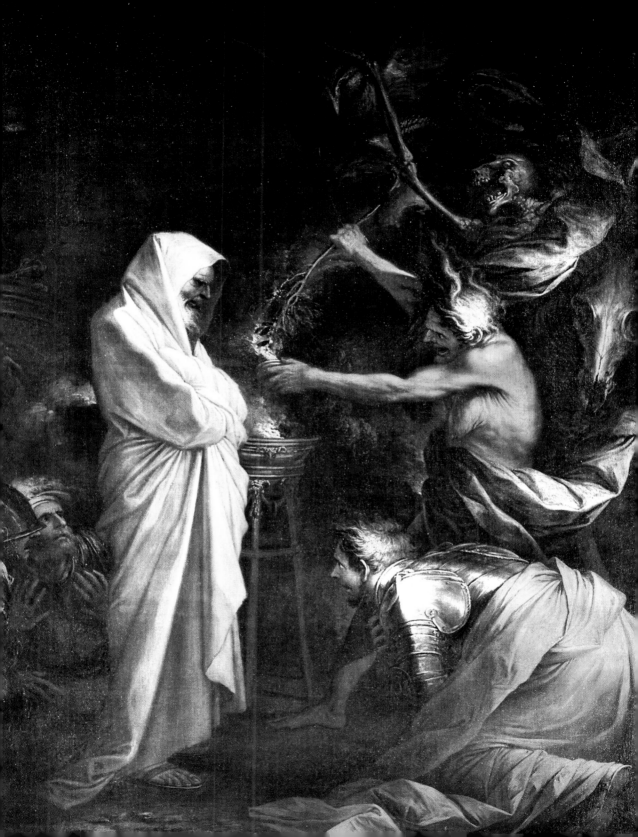

*The king said to her, "Do not be afraid. What do you see?"
And the woman said to Saul, "I see a god coming up out of
the earth." He said to her, "What is his appearance?" And
she said, "An old man is coming up, and he is wrapped in
a robe." And Saul knew that it was Samuel, and he
bowed with his face to the ground and paid homage.
(1 Samuel 28:13–14)*

This richly imagined and lusciously executed painting shows Saul and his men cowering as the witch of Endor conjures the spirit of the dead prophet Samuel. The elderly diviner stands with her arms outstretched, burning a small tree branch over a smoldering pot. Behind the frightful sorceress, a dark shroud wraps around a macabre scene of a horse skull, a human skeleton, a skull of a bird, and a great owl looming in the darkness. The ghost of Samuel stands cloaked in a white sheet scowling down at the prostrate king, who cautiously glances up at the apparition while his men, crouching, back away using their hands to protect themselves from the sight.

This ominous painting is based on 1 Samuel 28:6–14, the story about King Saul consulting the medium of Endor in an attempt to discern the outcome of an impending battle with the Philistines. He did this in spite of God's law against divination and sorcery in Leviticus 19:26.

Dressed in a disguise, he begged the witch to summon his former advisor, the prophet Samuel. The witch immediately recognized him as King Saul, but he promised her that she would not be punished and urged her to call forth the prophet. When Samuel began to appear, the witch said to Saul, "I see a god coming up out of the earth." Saul knew it was the prophet, and he bowed before him. The scene concludes with the ghost of Samuel telling Saul that God had given his kingdom to David and that Saul and his three

sons would die the next day when the Philistines would defeat the army of Israel.

In his painting, Rosa renders the witch of Endor as a hideous hag with wild hair and even wilder eyes as she performs her divinations. This was in keeping with his earlier depictions of witches as female hags, a view that was popular in satires and plays of his day.

The biblical text, however, does not describe the appearance of the witch of Endor; it only says she was fearful that she would be punished if she consulted the dead (1 Samuel 28:9). Saul had previously banned mediums and necromancers from the land (1 Samuel 28:3). When Saul assured her that she would not be punished, she did as Saul commanded. Following the event, Saul collapsed on the ground sapped of his strength. The sorceress nursed him back to health by serving him a meal of meat and unleavened bread.

In the biblical story, Saul was dealing with a severe crisis. His leadership was failing, he faced an existential threat from the Philistines, and God had left him alone. In this desperate moment, he decided to take matters into his own hands by seeking out a medium even though he knew he was disobeying God's law.

Along with Rosa's painting, the biblical account of Saul's secretive meeting with the medium serves as a meditation on the importance of maintaining a clear conscience and taking special care to think before acting in moments of crisis.

Bernini was one of the most prominent sculptors in Rome during his lifetime. A devout Catholic, Bernini sought to reflect his faith in his art.

Bernini worked to represent subjects in his art with exact details. However, he also sought to incorporate movement and dynamism. Many of his sculptures, including his **David**, emerge from swirls of clothing and hair, along with bodily tension and action.

Standing about five feet seven inches tall, **David** was commissioned by Bernini's patron, Cardinal Scipione Borghese. It still stands in the cardinal's former villa in Rome, now called the Galleria Borghese. Bernini is renowned for this marble sculpture as well as for his work in St. Peter's Basilica at the Vatican and in many other churches in Rome and in Italy.

DAVID (1624)
Gian Lorenzo Bernini (1598–1680)

Current location: Galleria Borghese, Rome, Italy

The Philistine said to David, "Come to me, and I will give your flesh to the birds of the air and to the beasts of the field." Then David said to the Philistine, "You come to me with a sword and with a spear and with a javelin, but I come to you in the name of the LORD of hosts, the God of the armies of Israel, whom you have defied. This day the LORD will deliver you into my hand, and I will strike you down and cut off your head." . . . When the Philistine arose and came and drew near to meet David, David ran quickly toward the battle line to meet the Philistine. And David put his hand in his bag and took out a stone and slung it and struck the Philistine on his forehead. The stone sank into his forehead, and he fell on his face to the ground. (1 Samuel 17:44–46, 48–49)

The story of David and Goliath is known as a classic underdog tale that has for centuries inspired people to courageously face challenges and embrace new adventures. Bernini's sculpture of David captures the spirit of a person undaunted by seemingly overwhelming barriers.

Bernini's life-size sculpture of David is perhaps less famous than Michelangelo's masterpiece *David*, which was sculpted nearly 120 years before Bernini's work. But the work by Bernini is no less remarkable. Whereas Michelangelo depicted David in a confident, reflective pose, Bernini presented David in the moment of battle against Goliath.

In Bernini's sculpture, David's expression is intense, his jaw is clenched, and his eyes are focused on his enemy. Seeing the sculpture in person, many people sense that Goliath is present. David's torso twists like a coil to the left, exposing sinews of muscle, as he prepares to hurl the stone

from his sling. David holds the sling taut with both hands, his left hand securing the stone and his right hand holding the ends of the sling's two leather straps.

A pile of armor lies at David's feet—the armor that King Saul offers David and that David refuses (1 Samuel 17:38–39). Bernini portrayed David wearing only loose shepherd's clothing. Also at David's feet is his lyre (1 Samuel 16:17–23)—Bernini's depiction of David as a sensitive musician as well as a bold warrior.

In the biblical story, when David and Goliath step onto the battlefield, they each declare their differing sources of strength and confidence. Goliath represents a self-confidence that is based on size, skill, and weaponry. In pride, he jeers at David, a young man with no armor (1 Samuel 17:39–44). David responds by announcing his confidence in God, not in his weapons or size (1 Samuel 17:45–47). David appears to be outmatched. But David's faith is not in himself; it is in God. This is the confidence we see in the eyes of Bernini's *David*.

Even today, Bernini's representation of David inspires many to see beyond personal weaknesses and to live with courage in the face of difficulties.

*T*he folio, **Scenes from the Life of David**, is from the **Morgan Picture Bible**, also known as the **Crusader Bible**, the **Maciejowski Bible**, and the **Bible of Shah Abbas**. Most scholars believe this Bible was commissioned for the crusader king of France, Louis IX, in the mid-thirteenth century.

In 1608 Cardinal Bernard Maciejowski, bishop of Kraków, gave the Bible to Abbas I, the Shah of Persia, who had some of the commentary translated from Latin to Farsi. This accounts for the Arabic script that appears on the sides and below the images.

Most of the folios are divided into four panels, each illustrating a sequence from the biblical narrative. This particular folio appears to have been removed from the book as early as the seventeenth century. Some scholars have speculated that the Shah had these pages removed because he disapproved of the story and images of a son rebelling against his father.

SCENES FROM THE LIFE OF DAVID (1250)

artist unknown

Current location: J. Paul Getty Museum, Los Angeles, USA

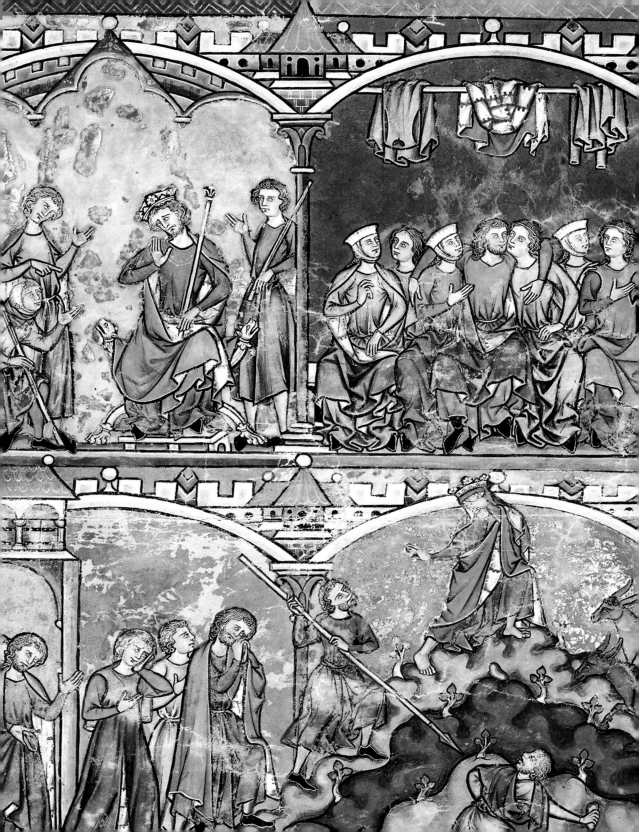

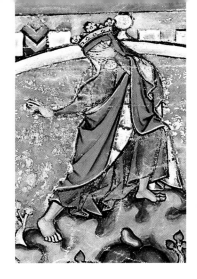

Then David said to all his servants who were with him at Jerusalem, "Arise, and let us flee, or else there will be no escape for us from Absalom. Go quickly, lest he overtake us quickly and bring down ruin on us and strike the city with the edge of the sword." (2 Samuel 15:14)

Biblical stories often reveal the most painful and tragic aspects of life, including the angst of broken relationships. One of those stories is portrayed in *Scenes from the Life of David*, which focuses on David mourning the rebellion of his son Absalom.

The artist rendered the story found in 2 Samuel 15–16. The sequence of the illustrations begins in the upper left panel with David, crowned and enthroned as king, distraught over the news that Absalom has rebelled and is preparing to invade Jerusalem from Hebron. Upon hearing of Absalom's conspiracy, David flees Jerusalem, taking his entire household with him except for ten concubines to care for the house.

In the next panel to the right, we see Absalom reveling in the comforts of his father's concubines, symbolically showing David's defeat. Translated, the Farsi writing (that is not present above but exists in the original's right-hand margin) reads, "When Absalom captured the city, he came to his father's harem and enjoyed his time with the ten women in front of his men."

The lower left panel was inspired by 2 Samuel 15:30. It displays David trudging barefoot up the Mount of Olives, covering his face with his hand in sorrow. His court advisers, along with those who honored him as king, follow behind grief-stricken. Covering one's head and going barefoot were traditional signs of mourning.

At the base of the mountain, a man named Shimei, son of Gera, hurls rocks at the king while one of David's soldiers threatens the man with a spear. On the lower right we see Ziba, a servant from the house of Saul, coming to meet David with supplies carried on two donkeys.

There are several theories as to why David fled Jerusalem when he heard of his son's impending attack. But the artist seems to portray David's flight as a way for David to avoid having to fight his own son. For the artist, David's mourning is about a broken relationship with his son. He is depicted as not only a king but also a father.

This dynamic work takes us intimately into a personal story. It leads us to wonder if David's choices as a father had turned his son against him. For example, when Absalom's sister Tamar was raped by their half brother Amnon, David did nothing to punish Amnon (2 Samuel 13:1–22). Is this why Absalom rebelled? Or was Absalom pursuing his own power, motivated by his own greed?

Whatever the case, the biblical story depicted in *Scenes from the Life of David* relates a profound human experience. While David might be mourning the loss of Jerusalem, it is equally likely that he is grieving the loss of his son.

*P*eter Paul Rubens's lush colors and dramatic compositions helped to define the Flemish Baroque period of the seventeenth century. After Rubens's father died, his mother moved the family from Germany to Antwerp, where Rubens was raised in the Catholic Church. At age twenty-one he was accepted into the Antwerp painters' guild. Two years later he served as a court painter for the Duke of Mantua in Italy. He traveled with the Mantuan embassy to Madrid, where he studied the works of classical Roman antiquity and the paintings of Titian and Raphael housed in the Spanish Royal Collection.

In 1608 Rubens returned to Antwerp, where he was appointed court painter to the Spanish Habsburg governors of Flanders. In this role, he completed his first major commission for the Catholic Church in Antwerp: the masterful triptychs (artworks divided into three sections) titled **Raising of the Cross** (1610–1611) and **Descent from the Cross** (1612–1614).

Following these successes, Rubens was flooded with commissions. In response, he established his prolific and lucrative workshop. After creating preliminary designs or drawings, Rubens would allow his assistants to execute the paintings before adding any necessary finishing touches himself. **The Judgment of Solomon** was likely completed in this manner.

THE JUDGMENT OF SOLOMON (CA. 1617)
Peter Paul Rubens (1577–1640)

Current location: National Gallery of Denmark, Copenhagen, Denmark

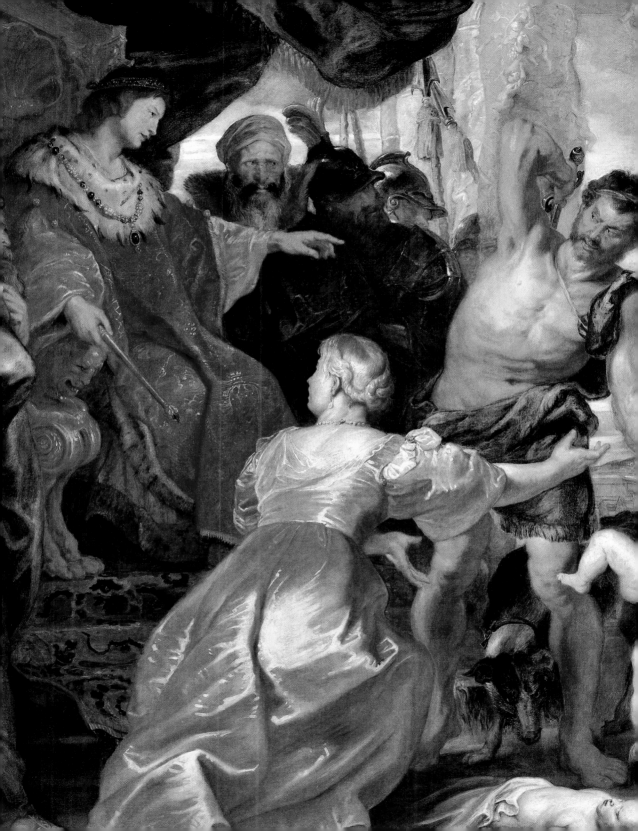

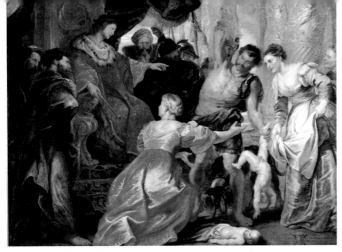

Then the king said, "The one says, 'This is my son that is alive, and your son is dead'; and the other says, 'No; but your son is dead, and my son is the living one.'" And the king said, "Bring me a sword." So a sword was brought before the king. And the king said, "Divide the living child in two, and give half to the one and half to the other." (1 Kings 3:23–25)

*T*he *Judgment of Solomon* illustrates a well-known story from 1 Kings 3:16–28. According to the text, King Solomon is called to pass judgment in the case of two prostitutes living in the same house. They had each given birth to a son, three days apart. One woman's child died in the night. The women appear before Solomon because one of them accused the other of stealing her baby and replacing him with the dead child.

To discern who the living baby belongs to, Solomon asks for a sword, saying, "Divide the living child in two, and give half to the one and half to the other" (1 Kings 3:25). The living baby's true mother cries, "Oh, my lord, give her the living child, and by no means put him to death" (1 Kings 3:26). Seeing the love of the real mother, Solomon renders fair judgment.

Rubens's painting captures the moment just before the child is to be cut in two. A master of color and light, Rubens clothes the true mother in a warm yellow gown while draping the false mother in cold and pale colors. Warm colors like yellow and red move outward toward the picture plane, so they bring the true mother closer to the viewer. Conversely, cool colors like blue and gray recede into the background, so they push the false mother away from the viewer. This creates a color and spatial tension between the two mothers.

Additionally, by extending Solomon's left arm, Rubens creates a triangle that moves the eye from Solomon's hand to the face of the false mother, then down to the outstretched arm of the true mother and her dangling child, and back to Solomon. This remarkable composition makes the story seem as if it were unfolding in real time. First, Solomon passes judgment. Second, the soldier prepares to carry out Solomon's command. Third, the false mother benignly awaits the death of the child with a chillingly neutral expression. Fourth, the true mother begs for the life of her child. And finally, we look back to Solomon, where we await his decision and realize the success of his ruse. This attests to Rubens's skill as a gifted artist and visual storyteller.

Many people believe this story is primarily about demonstrating Solomon's wisdom. But perhaps there is a deeper element. The key that ultimately unlocks justice in the story is love. The true mother's love for her child and her unwillingness to see him suffer, even if it meant losing him to another woman, was the precondition for the success of Solomon's scheme. The story—as well as Rubens's painting—speaks to the ideal universality of a mother's love for her child and her willingness to do anything to protect her baby.

*B*orn in 1836, Edward Poynter lived during the age of British expansion in the Middle East. He became fascinated with the artifacts that English explorers brought back from foreign lands. Poynter studied under the academic painter Charles Gleyre and was no doubt influenced by his images and tales of Egypt and the Middle East, where temples and tombs were plundered to fill British museums.

His painting titled **The Visit of the Queen of Sheba to King Solomon** epitomizes the artist's training as a classicist and his exquisite attention to detail. The architectural design of Solomon's palace demonstrates Poynter's ability to render the complexities of light and shadow. The perimeter columns are elegantly carved with red ribbing and topped with intricately designed golden capitals.

In contrast to the power and strength of the portico is the lazy, plush feel of the curtain behind King Solomon's throne and the delicate, wispy touch of the peacocks' feathers. Poynter masterfully directs the viewer's eye to Solomon by framing him within the colonnade and using the king's outstretched hand to draw attention to the statuesque queen of Sheba ascending the stairs to greet him.

THE VISIT OF THE QUEEN OF SHEBA TO KING SOLOMON (1890)
Edward Poynter (1836–1919)

Current location: Art Gallery of New South Wales,
Sydney, Australia

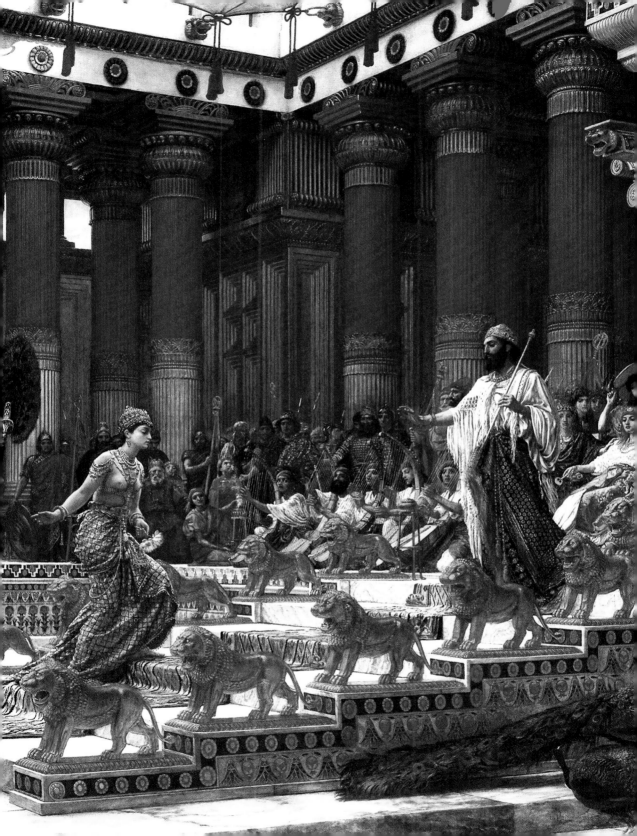

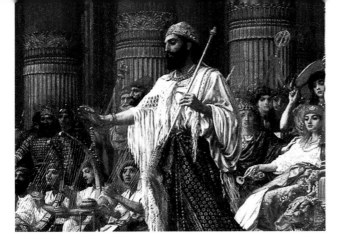

And [the queen of Sheba] *said to the king, "The report was true that I heard in my own land of your words and of your wisdom, but I did not believe the reports until I came and my own eyes had seen it. And behold, the half was not told me. Your wisdom and prosperity surpass the report that I heard." (1 Kings 10:6–7)*

Solomon, the son of King David, took his place on the throne of Israel when he was quite young. Faced with an overwhelming responsibility to lead a nation, he asked God for wisdom. Solomon prayed, "Give your servant therefore an understanding mind to govern your people, that I may discern between good and evil" (1 Kings: 3:9). Solomon's request demonstrates his view that good governance depends on moral wisdom.

God granted his request, and as a result of his wisdom, Solomon gained widespread fame. A queen from Sheba—a nation to the south of Israel—traveled a great distance to meet him. According to 1 Kings 10:1, she "heard of the fame of Solomon" and "came to test him with hard questions."

In his portrayal of the story, Edward Poynter imagined King Solomon with open arms, a slight bow, and downturned eyes. The queen's topless dress, the open flower in her hand, and Solomon's raised scepter perhaps suggest that the queen is offering herself to the king. This, however, is not the reason the biblical text offers for her visit.

The Bible does not suggest that the queen of Sheba traveled from a foreign country to be another of Solomon's many wives and concubines. It presents the queen not as a pliant, exotic beauty desiring to submit to a powerful king but as a highly intelligent, curious woman searching for wisdom and knowledge—perhaps because she, like Solomon, longed to govern her own nation well. In Matthew 12:42, Jesus describes the "queen

of the South" who came "to hear the wisdom of Solomon." She appears to have been a strong leader with an inquisitive mind: "And when she came to Solomon, she told him all that was on her mind" (1 Kings 10:2). Her questioning was relentless, to the point that "there was no more breath in her" at the end of her visit (1 Kings 10:5).

In this story the queen of Sheba understood the importance of wisdom. Rather than send a servant to test Solomon, she traveled great distances to bring her own "hard questions" and to match minds with the wisest king of her time.

In our own era, popularly known as the "information age," this biblical story and Poynter's painting remind us that in addition to knowledge, we also need wisdom. Perhaps for this reason, the book of Proverbs says, "For wisdom is better than jewels, and all that you may desire cannot compare with her" (Proverbs 8:11).

*In 1515, Pope Leo X commissioned a tapestry series titled **Acts of the Apostles** that depicted the lives and miracles of Peter and Paul using designs by Raphael Sanzio (1483–1520). These tapestries were woven in the Brussels workshop of Pieter van Aelst (ca. 1495–1560).*

The pope's commission made Brussels the tapestry capital of sixteenth- and seventeenth-century Europe, and "Brussels Manufacturer" became the hallmark name of superior tapestries throughout the continent.

This image is from a detail of a larger tapestry depicting the relationship of Elijah and Elisha. The image portrays the prophet Elijah being carried away to heaven in a chariot of fire. As he ascends, he drops his blue cloak. Elisha is shown reaching up to catch it. In the background on the right, Elisha, wearing the blue cloak under a light brown outer cloak, walks along a path toward a building in the distance.

Elijah and Elisha's Stories (detail) (1560–1565)

Brussels Manufacturer modeled tapestry after Raphael's cartoon

Current location: Museo Castello Sforzesco, Milan, Italy

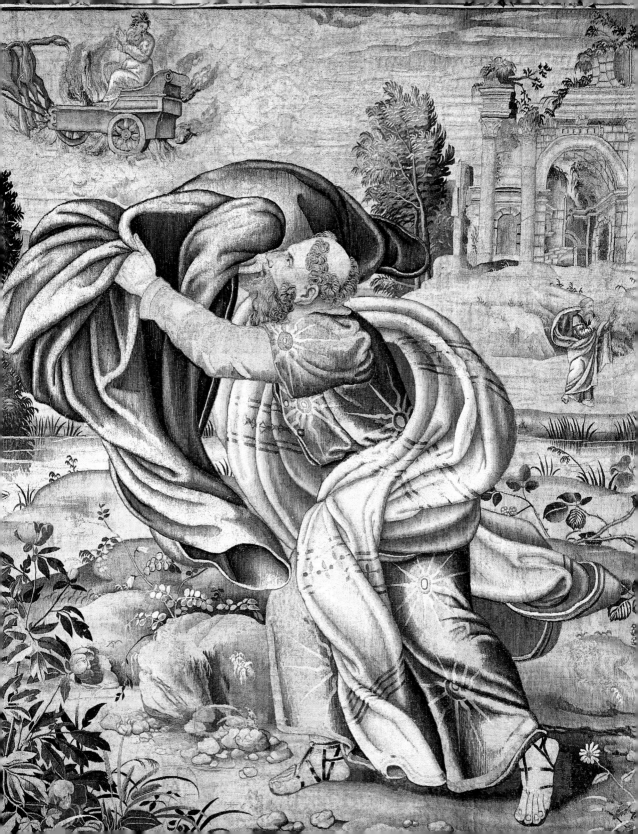

And as they still went on and talked, behold, chariots of fire and horses of fire separated the two of them. And Elijah went up by a whirlwind into heaven. And Elisha saw it and he cried, "My father, my father! The chariots of Israel and its horsemen!" And he saw him no more.

Then he took hold of his own clothes and tore them in two pieces. And he took up the cloak of Elijah that had fallen from him and went back and stood on the bank of the Jordan. (2 Kings 2:11–13)

This work of art captures a biblical story about the passing of responsibility from one generation to the next. Elijah lets go of his role as prophet and affirms the younger Elisha, trusting that Elisha will fulfill the role with integrity and competence. Elisha, as depicted in the tapestry's image, assumes the role despite his apparent fears, self-doubt, and inexperience.

According to the text in 1 and 2 Kings, Elijah was a prophet who boldly preached against the kings of Israel who had adopted the religious practices of the Canaanites. After defeating the priests of Baal in a contest on Mount Carmel, Elijah fled the wrath of King Ahab and threats from his wife, Jezebel, into the wilderness. The dangerous conflicts between Elijah and the kings gave Elisha reason to worry about inheriting the job.

After God told Elijah that Elisha would be his successor, Elijah took steps to encourage his apprentice. When they first met, he threw his cloak over Elisha's shoulders (1 Kings 19:19).

As 2 Kings 2:9–10 demonstrates, Elisha recognized his need for help in filling Elijah's shoes. Elisha asked Elijah for a "double portion" of Elijah's spirit. Elijah responded, "You have asked a hard thing; yet, if you see me

as I am being taken from you, it shall be so for you." As they continued on their way, fiery chariots and horses appeared and Elijah was taken to heaven by a whirlwind. Elisha watched him disappear and took Elijah's cloak as his own.

The relationship formed between Elijah and Elisha prior to the transition of leadership proved to be crucial to the outcome. Following Elijah's ascension, Elisha patterned his life after his spiritual mentor. He prophesied against corrupt rulers and duplicated many of Elijah's miracles.

In its depiction of Elijah and Elisha, this work of art captures the tensions, fears, and hopes that transpire when an older generation passes responsibility and wealth to a younger generation. This concern is highlighted in Ecclesiastes 2:18–19. "I hated all my toil in which I toil under the sun, seeing that I must leave it to the man who will come after me, and who knows whether he will be wise or a fool?"

The artistic depiction of Elisha beautifully illustrates how taking on responsibility is both exhilarating and frightening. When Elisha took up Elijah's cloak, he had to decide how he was going to wear it. The cloak was the same, but it now hung on different shoulders.

William Dyce was born in Aberdeen, Scotland, and he studied at the Royal Academy in London. At age twenty-one he traveled to Rome to study the work of the Italian masters of the Quattrocento, the name given to the artistic period between 1400 and 1499. Upon returning to Britain, he took up a post at the Royal College of Art and founded the Motett Society to promote traditional liturgy and sacred music in English churches.

Dyce is commonly associated with the Pre-Raphaelite Brotherhood, a group of English painters, poets, and critics who rejected the classical poses and elegant arrangements found in Raphael's compositions in favor of the detail and colors of the Quattrocento style. Though Dyce was not himself a member of this brotherhood, his attention to detail, sharp focus, brilliant color, and unconventional compositions all contributed to his association with it.

As seen in this delicately crafted painting, Dyce detailed Joash's loincloth with vivid colors. The parallel composition of the two figures shows his skill as a gifted figure painter. Dyce painted a number of scenes from the Bible, including this one, that represent the stoic ideal of keeping emotion in check.

Joash Shooting the Arrow of Deliverance (1844)
William Dyce (1806–1864)

Current location: Hamburger Kunsthalle, Hamburg, Germany

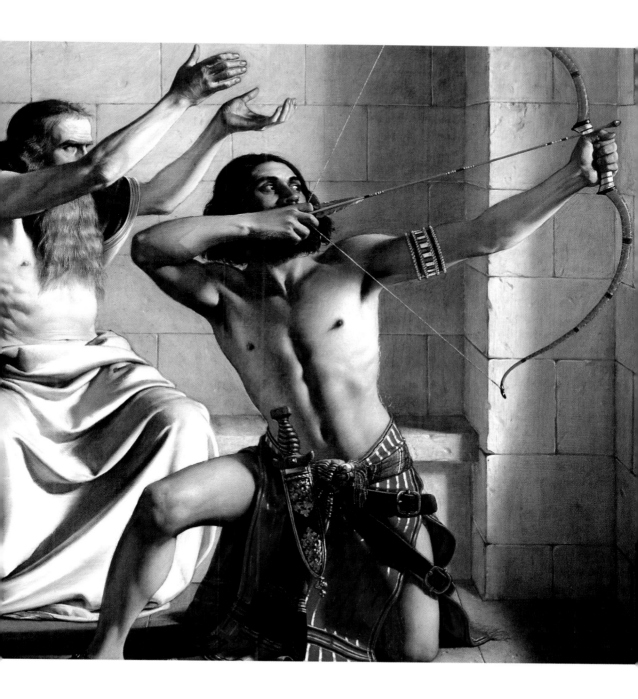

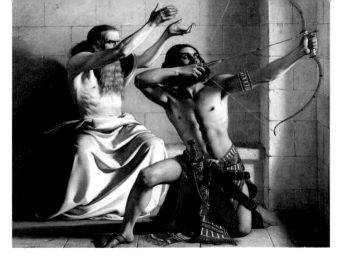

Then he said to the king of Israel, "Draw the bow," and he drew it. And Elisha laid his hands on the king's hands. And he said, "Open the window eastward," and he opened it. Then Elisha said, "Shoot," and he shot. And he said, "The LORD's arrow of victory, the arrow of victory over Syria! For you shall fight the Syrians in Aphek until you have made an end of them." (2 Kings 13:16–17)

This painting illustrates a scene from 2 Kings 13 in which Joash, the king of Israel, visited the dying prophet Elisha when the Syrians were threatening Israel. Joash wept and repeated the words Elisha had said when the prophet Elijah was taken: "My father, my father! The chariots of Israel and its horsemen!" (2 Kings 2:12, 13:14).

Elisha instructed King Joash to draw his bow and aim it out the eastern window. When Elisha gave the command, Joash shot the arrow. Elisha prophesied that the arrow signified victory and that Israel would fight the Syrians until they were no more.

The Syrians were threatening Israel from the east. By telling Joash to draw his bow and shoot his arrow out the eastern window, Elisha was telling the king to signal the beginning of war. In 2 Kings 13:16–17, these three instructions and their fulfillments are punctuated by their repetition: "Draw the bow" ("and he drew it"); "Open the window" ("and he opened it"); "Shoot" ("and he shot").

In Dyce's painting, the action pauses at its most critical moment: The bow is drawn taut; pale light spills in through the open eastward window; Joash, on bended knee, prepares to shoot; and Elisha motions in the background to let the arrow fly.

Elisha also told Joash to take the remainder of the arrows from his quiver and strike them on the ground. Joash obeyed, striking the ground three times. Elisha responded, "You should have struck five or six times; then you would have struck down Syria until you had made an end of it, but now you will strike down Syria only three times" (2 Kings 13:18–19).

If shooting one arrow symbolized a declaration of war, striking the remaining arrows on the ground apparently indicated Joash's commitment to pursue the fight to the end; what the launched arrow began, the deathblow arrows would finish. Yet, Joash only struck three times when he needed to double his force. Consequently, the Israelites would not completely defeat the Syrians.

This story helps us remember the importance of determination. Joash easily drew his bow and shot the arrow out the window because he was given specific instructions and was eager to begin the war against the Syrians. When called on to finish the fight, he only had the determination to strike three times. It appears that he lacked the zeal and unyielding resolve to see the war through to the end.

Like Joash in William Dyce's painting, most of us can follow instructions. We can draw the bow, open the window, and shoot. In the biblical narrative, before Joash shot the arrow, Elisha placed his hands on Joash's hands, possibly symbolizing God's blessing on the king's call for war. But there is no indication from the text that Elisha held Joash's hand when the king struck the ground with the arrows. These are the moments—when no one is there to hold our hand or affirm what we are doing—when we need unwavering determination.

Artemisia Gentileschi was a successful female Baroque painter. She first trained under her father, Orazio Gentileschi, who was an early follower of Caravaggio's style of painting with its strong contrasting light and shade to model dynamic three-dimensional forms. Artemisia showed talent as both a draftswoman and colorist.

To encourage her skill, Orazio hired painter Agostino Tassi to give her private lessons. The tutelage ended tragically when Agostino raped Artemisia. Adding to the horror of the rape, the trial that followed included humiliating medical examinations to verify whether she was still a virgin or not. This was to determine if Artemisia was telling the truth. Agostino, though found guilty, was never jailed. Many scholars have speculated that the horrific events of the rape and trial formed Artemisia's bravely feminist approach to her work.

Soon after the trial, Artemisia married a Florentine painter and moved to Florence. She was elected the first female member of the prestigious Florentine Academy of Design. She later returned to Rome, where it is believed she completed this piece. In 1638, she traveled to England to assist her ill father, who had been appointed court painter to King Charles I. After her father died, Artemisia returned to Italy and settled in Naples.

ESTHER BEFORE AHASUERUS (1628–1635)
Artemisia Gentileschi (1593–1656)

Current location: Metropolitan Museum of Art, New York, USA

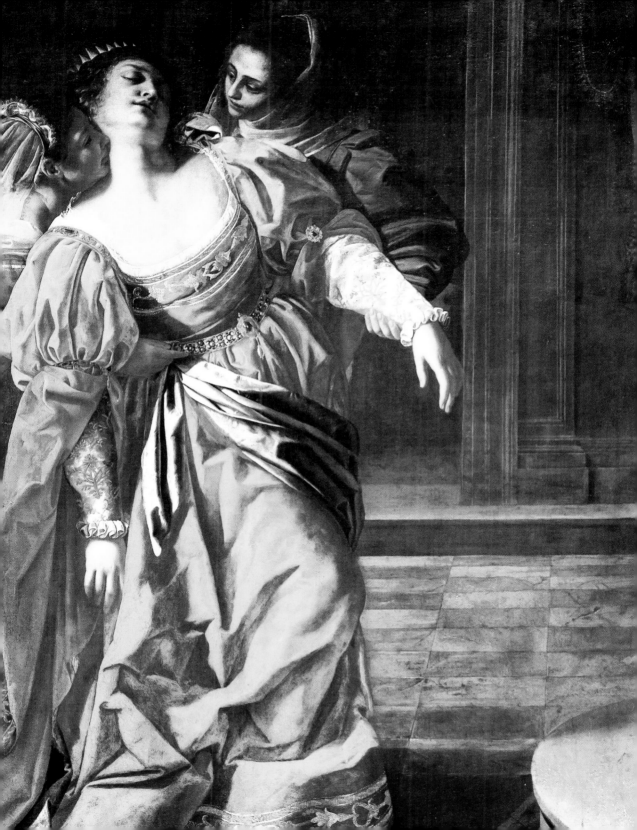

The queen faltered, and turned pale and faint, and collapsed on the head of the maid who went in front of her. Then God changed the spirit of the king to gentleness, and in alarm he sprang from his throne and took her in his arms until she came to herself. (Esther 15:7–8, NRSV)

Artemisia Gentileschi's painting of Esther's effort to stop an act of genocide demonstrates a fearful struggle against injustice.

As the book of Esther reveals, Esther was a young Jewish girl who became queen of Persia and saved her people from extermination at the hand of the king's vizier named Haman.

The story turns dark when, after several days of drinking and revelry, the Persian king Ahasuerus (Xerxes I), summoned his wife, Vashti, to show her beauty to his male courtiers. When she refused to appear, a series of events transpired that brought Esther to the palace, where she was eventually crowned queen.

Esther's Jewish cousin, Mordecai, refused to bow before Haman. Infuriated, Haman convinced the king to issue an edict calling for the massacre of all the Jews in Persia. Haman cast lots (*purim*) to determine the date of the slaughter.

Upon discovering Haman's dreadful plan, Esther bravely approached the king, risking her life, and pleaded for the lives of the Jews. The king issued another edict that allowed for the Jews to defend themselves and for the Persian people to assist them.

The Septuagint, a Greek translation of the Hebrew Bible, contains additional verses in Esther that are not found in the Hebrew texts. These extra verses state that Esther had maidservants with her when she approached the king. This is important to understand because Artemisia's painting, *Esther before Ahasuerus*, shows Esther's maidservants supporting her.

Rather than paint Esther's confrontation with King Ahasuerus in its Persian context, Artemisia presents the scene in her contemporary setting. A fair-skinned Esther swoons into the waiting arms of her maids. Alarmed at her collapse, the king, dressed as a foppish dandy, lunges from his chair to comfort her.

The plane of the painting is divided in half. On the left side, Esther wears a gorgeous golden gown with a striking blue sash. On the right side, the king is adorned in darker tones with a plumed hat, pantaloons, and fur-trimmed boots. Artemisia reinforces this contrast by framing Esther in the doorway behind her while keeping the king at a distance in the deep red frame of the drapery around his throne.

With the vertical line of the doorframe in the middle of the painting separating the two of them, each remains in their specified place. The result creates a moment that is about to expire. Like her stylistic mentor, Caravaggio, Artemisia's dramatic realism brings energy and tension to the canvas.

In Esther 4:11, Esther explained to Mordecai in a message that anyone who entered the king's inner court without being called would be killed. Therefore, when Esther approached the king without being summoned, she feared for her life. However, she courageously carried out her mission to prevent the genocide of her people.

Speaking truth to powerful people can be frightening. Esther's story shows that sometimes leaders and institutions must be confronted to avoid fear and tyranny. From Artemisia's painting, we see that despite her fears, Esther entered the king's court and did what was courageous and right.

Reflecting on Artemisia's version of the story, we can imagine the woman on Esther's right, with her face held close to Esther's ear, whispering resolute encouragement. By including the maidservants in the painting, perhaps Artemisia emphasized the importance of working together—rather than alone—against injustice. In this work, Artemisia inspires us to courageously stand against oppression.

Job's Servants Are Slain, to the Manifest Delight of Satan was inspired by Job 1:17, which describes when Job's servants are slaughtered and his livestock is stolen. The image is from a thirteenth-century Belgium illustration of Pope Gregory's commentary on Job.

The book of Job is a profound and poetic meditation on the question "Why do the innocent suffer?" The book begins with Job, a good man, who has been blessed with sons, daughters, servants, and livestock. The story shifts to a heavenly court scene, where Satan asserts that Job is pious only because God has blessed him. Satan challenges God: "Stretch out your hand and touch all that he has, and he will curse you to your face" (Job 1:11). God allows Satan to test Job, and Job loses his servants, his children, his livestock, and his health.

JOB'S SERVANTS ARE SLAIN,
TO THE MANIFEST DELIGHT OF SATAN
(1175–1200)

artist unknown

Current location: National Library of France, Paris, France

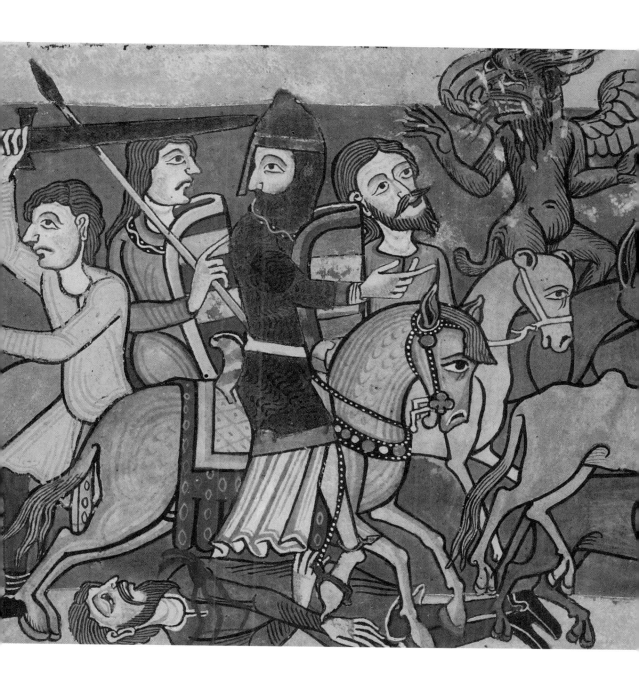

While he was yet speaking, there came another and said, "The Chaldeans formed three groups and made a raid on the camels and took them and struck down the servants with the edge of the sword, and I alone have escaped to tell you." (Job 1:17)

Although a good man, Job endures unimaginable suffering. In the midst of his suffering, Job questions God's justice, but not with animosity. "In all this Job did not sin or charge God with wrong" (Job 1:22). Thinking that the effect of suffering is caused by personal sin, Job's friends suggest that Job must have committed grievous moral error for such calamity to come upon him. Job affirms he is a sinner but desires an audience with God to declare his innocence (Job 29:1–31:40). God appears in a whirlwind, asking Job questions that only God can answer (Job 38:1, 40:6).

The book of Job is an ancient example of theodicy, which raises the question "How can God be good in light of human suffering?" *Job's Servants Are Slain, to the Manifest Delight of Satan* elegantly portrays a common human question. Like Job, many people search for answers when faced with suffering.

Prominent philosophers from all perspectives have addressed this question. For example, University of Notre Dame professor Alvin Plantinga, a theistic philosopher, devoted a section of his book *God and Other Minds* (Cornell University Press, 1990) to the issue. Oxford professor C. S. Lewis wrote his book *The Problem of Pain* (1940) to examine this important question. Numerous Jewish scholars have also written about the question in the context of the Holocaust.

Albert Camus, a French existentialist, approached the question from a presupposition that life is essentially absurd and meaningless. Based on

this premise, he wrote in *The Myth of Sisyphus*, "Judging whether life is or is not worth living amounts to answering the fundamental question of philosophy."* Camus argued that we should not give in to what he saw as the absurdity of existence, but persevere.

The book of Job offers a model of faith that includes suffering. While enduring his afflictions, Job received answers to his questions from God in the form of another question: "Where were you when I laid the foundation of the earth?" (Job 38:4). For the next several chapters, God reminds Job of how little he understands against the immensity of nature. Overwhelmed by God's sovereignty, Job responds, "Behold, I am of small account; what shall I answer you? I lay my hand on my mouth" (Job 40:4). Job concludes: "I had heard of you by the hearing of the ear, but now my eye sees you; therefore I despise myself, and repent in dust and ashes" (Job 42:5–6). He never learns of the cause of his suffering.

Throughout the book, Job maintains his integrity and insists he's done nothing wrong to deserve this torment. God never explains why he permitted Job to suffer terribly, but he points out the smallness of Job's perspective and his ignorance about the ways of God and the mysteries of the world.

* Albert Camus, *The Myth of Sisyphus and Other Essays*, trans. Justin O'Brien (New York: Vintage International, 1991), 3.

*B*orn Jheronimus van Aken, Bosch is better known by the name he used when signing the few works that bear his name—Hieronymus Bosch. He took the surname from his hometown of 's-Hertogenbosch in the Netherlands. Bosch was known for his fantastical depictions of heaven and earth, and his grotesque renderings of monstrous demons punishing the wicked.

Bosch belonged to the **Illustre Lieve Vrouwe Broederschap** (*Illustrious Brotherhood of Our Blessed Lady*), a local religious and social order. Though his works are fiendish and frightening, he appears to have been a devout Catholic.

Visions of the Hereafter consists of four wooden panels: **Fall of the Damned**; **Hell**; **Earthly Paradise**; and **Ascent into Heaven**. Because Bosch did not sign these panels, scholars have debated who painted them. However, most experts accept that Bosch painted the series based on stylistic analysis. The four panels probably formed the wings to an altarpiece attached to a centerpiece, which is now missing. It is unknown whether the panels were set side by side or on top of one another on either side of the centerpiece.

Visions of the Hereafter
(ca. early 1500s)
Hieronymus Bosch (1450–1516)
Current location: Doge's Palace, Venice, Italy

O Lᴏʀᴅ, you have brought up my soul from Sheol; you restored me to life from among those who go down to the pit. (Psalm 30:3)

Beginning on the left and moving to the right, the first two panels depict the torment and suffering that await the wicked; the last two panels illustrate the pleasures and joys that the blessed may expect.

In the first panel, gleeful but devilish ghouls with fangs and claws cast sinners into hell. In the second, rat-faced demons with bat wings and tails drag the damned into hell's black and fiery waters. The third panel shows an idyllic setting where the blessed await ascent into heaven. In the foreground, an angel converses with two figures while a bird lands on a man's arm behind them. On the right, a cluster of people gaze toward a fountain at the top of a steep hill. The forth panel presents the saved ascending with angels through the clouds to a great tunnel leading to heaven.

Bosch's vision of the afterlife reflected a popular medieval Christian theology that a great horde of sinners would be cast into hell while only an elect few would ascend to heaven. Hell was a place of darkness and never-ending suffering; heaven was a place of light and eternal peace. This theology developed in part to explain the horrors of the bubonic plague that decimated Europe several times. At the time, people believed that God punished the mass of sinners and saved only a select few.

The New Testament reveals heaven as God's perfected kingdom, complete with thrones and gates. Revelation 22:1 describes John's glorious vision of heaven with "the river of the water of life, bright as crystal, flowing from the throne of God and of the Lamb."

Conversely, the popular medieval view of hell is virtually absent from the Hebrew Bible. The writers of the Hebrew Bible described a shadowy, grave-like underworld called *Sheol*. The Greek version of the Hebrew Bible (the Septuagint) translated *Sheol* as *Hades*. It is possible that the idea of *Sheol* or *Hades* as a dark pit under the earth influenced the vision of hell as a spiritual place of darkness and torment.

Volumes of books have been written about the afterlife, representing and producing diverse notions of heaven and hell. As the title of Bosch's series suggests, the paintings included in *Visions of the Hereafter* express some of Bosch's own views about the afterlife. His paintings can inspire us to study more about other visions of the afterlife and to consider the foundations of our own views.

Mikhail Vrubel was a painter in the Russian symbolist style and is considered one of Cubism's visionary predecessors. During his lifetime, he was known not only for his artistry but also for his psychological and emotional instability. In 1902, a year after the death of his son, Vrubel suffered a complete mental breakdown. He was in and out of mental hospitals for the rest of his life. Tragically, in 1906 he went blind. Four years later, he died of pneumonia in an asylum after intentionally exposing himself to the penetrating cold of a St. Petersburg night.

In 1889, while living in Moscow, Vrubel read Mikhail Lermontov's (1814–1841) epic poem **Demon** for the first time. He became obsessed with the poem and saw the figure of the demon as representative of the struggling creative spirit—neither good nor evil, but suffering and vulnerable. Many of his paintings from that point on included elements of a demon figure.

The inspiration for Vrubel's **Six-Winged Seraph (Azrael)**, however, came from **The Prophet**, a poem by Alexander Pushkin (1799–1837) that is based on Isaiah 6:2–10. Sometime between 1904 and 1905, Vrubel experienced a period of lucidity and completed his vision of the angelic creature.

Six-Winged Seraph (Azrael) (1904)
Mikhail Vrubel (1856–1910)

Current location: The State Russian Museum, Saint Petersburg, Russia

In the year that King Uzziah died I saw the Lord sitting upon a throne, high and lifted up; and the train of his robe filled the temple. Above him stood the seraphim. Each had six wings: with two he covered his face, and with two he covered his feet, and with two he flew. And one called to another and said: "Holy, holy, holy is the LORD of hosts; the whole earth is full of his glory!" (Isaiah 6:1–3)

For this painting, Vrubel blended biblical imagery and Russian folklore with his own personal mythology of demons and angels. The face of the six-winged seraph is that of his wife, though stylized in the manner of a mosaic. In her right hand, she holds a lamp; in her left, she clutches a sword. Through a fractured crystalline kaleidoscope of color, Vrubel renders the elongated neck, fire halo, and penetrating eyes of the frightening and alluring angelic creature from his own imagination. The result is both painting and mosaic, and would be equally at home in a museum or cathedral.

The image of the divine given in Isaiah 6 is of an enormous God, too large to be contained in the temple and seated on a massive throne, accompanied by six-winged celestial creatures, or seraphim, that fly overhead, shielding their faces from his glory and declaring his praises.

In some religious traditions, the name *Azrael* is associated with the angel of death. In the Jewish tradition, an alternative spelling, *Azriel*, meaning "help of God," has been used to refer to a commander in God's angelic army. However, Vrubel's assignation of this name to his six-winged seraph is uniquely his own.

In contrast to the vision in Isaiah, Vrubel's six-winged seraph gazes out barefaced from the moonlit canvas, clutching a lamp to light its way. Far from the radiating glow of God's throne room, this seraph walks in the reality of the viewer's dark, mundane world—where the trivial and frivolous activities of life shroud any divine light—and carries the light of transcendence. Vrubel's seraph clutches a dagger in its right hand, prepared to defend the lamp that lights its path. It is as if the angel knows it must bear light in this dark world and must be prepared to defend light against those who wish to extinguish the flame.

The most well-known book in *Kabbalah*, or Jewish mysticism, is the *Zohar*. According to the *Zohar*, the universe was originally pure, boundless light. Out of this original divine unity came ten *sefiroth*, or active divine powers like wisdom, beauty, and love. These *sefiroth* are aspects of the divine and are often compared to colors or light that spilled out of the shattered unity of the original transcendence like water from a jar. Jewish mystics believe that some of this light is within each person as the divine spark that seeks to reunite with God.

With this view in mind, Vrubel's seraph, *Azrael*, appears to carry and defend the divine light in the midst of the darkness and corruption of the world while endeavoring to unite it with its original source, where the seraphim cry out, "Holy, holy, holy is the LORD of hosts."

*D*utch painter Geertgen tot Sint Jans only lived until he was in his late twenties, but scholars agree that his work demonstrates the artistic mastery of painters with much more experience.

Very little is known about Geertgen's personal life. He appears to have been born in Leyden, a town close to Amsterdam. The name Geertgen tot Sint Jans refers to the painter's involvement as a lay brother with the Brethren of Saint John, a religious order that at one time played a major role in naval warfare to defend the pope's global interests. Geertgen painted an altarpiece for the church of the Knights of Saint John in Haarlem titled **The Lamentation of Christ**. The beauty of this painting inspired well-known engraver Jacob Matham (1571–1631) in 1620 to create a mirror-image engraving of Geertgen's work.

Geertgen painted **The Tree of Jesse** by applying oil paint with pigments and drying oils on oak panels—a common technique of the day. This approach enabled artists to apply various layers of paint, thereby adding depth and texture to their works.

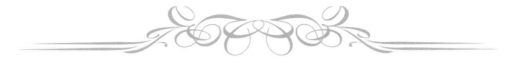

The Tree of Jesse (ca. 1495)
Geertgen tot Sint Jans (ca. 1465–1495)

Current location: Rijksmuseum, Amsterdam, The Netherlands

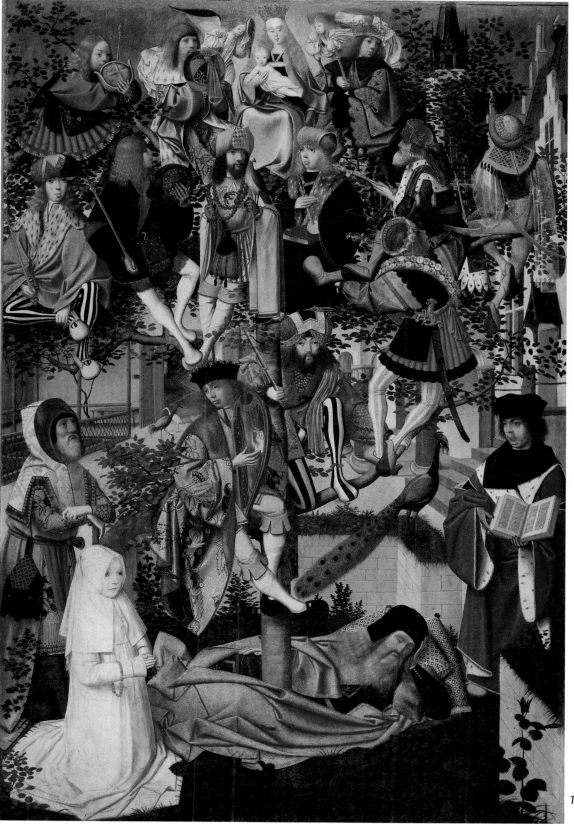

There shall come forth a shoot from the stump of Jesse, and a branch from his roots shall bear fruit. And the Spirit of the LORD shall rest upon him, the Spirit of wisdom and understanding, the Spirit of counsel and might, the Spirit of knowledge and the fear of the LORD. (Isaiah 11:1–3)

The *Tree of Jesse* is based on Isaiah 11:1: "There shall come forth a shoot from the stump of Jesse, and a branch from his roots shall bear fruit." This image of a plant growing into multiple branches depicts the source of a "family tree" of Jesse, who was the father of King David (1 Samuel 16).

Geertgen shows a reclined Jesse at the bottom of the painting from whom a tree grows into multiple branches, each populated with various figures in royal clothing. At the top of the painting (the culmination of Jesse's lineage) is Mary wearing a crown and holding the infant Jesus.

In the New Testament, both Matthew and Luke portray Jesus's lineage as connecting back to David, Jesse's son. Matthew's Gospel opens by saying, "The book of the genealogy of Jesus Christ, the son of David, the son of Abraham" (1:1). Matthew mentions Jesse as the father of David in Matthew 1:6.

The lineages of Jesus presented in Luke and Matthew have led some scholars to interpret Isaiah's "shoot of Jesse" as an ultimate reference to Jesus. This viewpoint is also based on subsequent verses in Isaiah 11 that depict a person who would display the wisdom and understanding of the Spirit of God, who would be a righteous judge for the poor and meek, and who would overcome evil (Isaiah 11:2–5). Isaiah also says this person would draw people "from the four corners of the earth" (Isaiah 11:12). Within the

Jewish tradition, however, this would have likely been read as a prophecy concerning a future leader of the nation of Israel.

It is also possible to see Geertgen's *The Tree of Jesse* as portraying the importance of family heritage. According to 1 Samuel 16, Jesse was simply the father of a shepherd boy who God raised up to be king. In the same way, we can only imagine the influence our children and grandchildren (and beyond) might have in the world. But we can consider ways to invest in this generation so that they too can "bear fruit" in their own lives.

*T*here is no definitive evidence for who created this intricately designed enamel piece. However, it is similar to works associated with the reliquary (a container holding religious relics) of Henry II, the Holy Roman emperor from 1014 to 1024. This fact has led some scholars to conclude that the art and the reliquary of Henry II were created by the same artist.

Specific similarities include the lapis blue enamel punctuated with gold dots for the background, and the gold and green for the foreground. Moreover, four holes and four semicircular indentions on the plate indicate that it was attached to a wood backing, possibly a reliquary or small mobile altar.

In the artwork, Ezekiel is shown with his right arm raised and pointing to the heavens while seated on the temple that he envisioned while in exile in Babylon (Ezekiel 40). The full-length, toga-style wrap with finely folded drapery was commonly used to represent ancient biblical characters.

EZEKIEL (1160–1180)

artist unknown

Current location: The Museum Kunst Palast, Düsseldorf, Germany

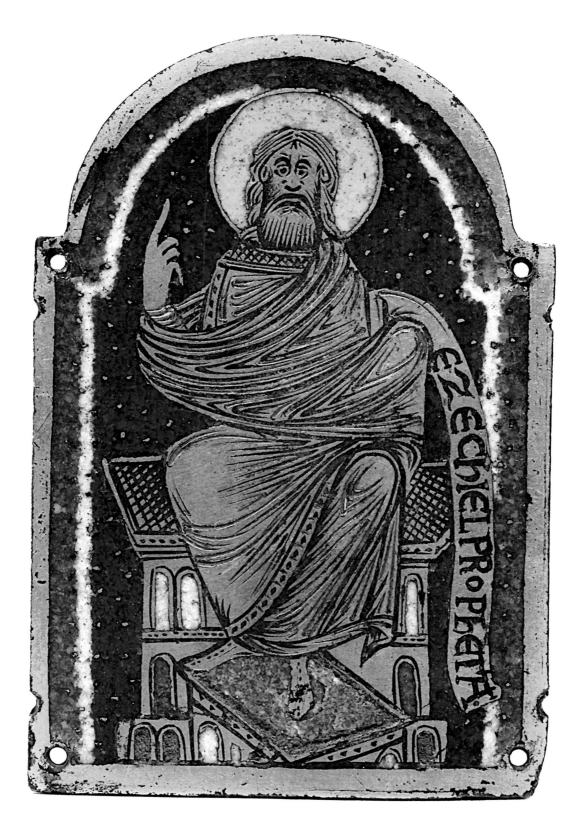

And the vision I saw was just like the vision that I had seen when he came to destroy the city, and just like the vision that I had seen by the Chebar canal. And I fell on my face. As the glory of the LORD entered the temple by the gate facing east, the Spirit lifted me up and brought me into the inner court; and behold, the glory of the LORD filled the temple. (Ezekiel 43:3–5)

Ezekiel was a prophet-priest who many believed lived between 622 and 570 BC. He would have originally ministered to people in Jerusalem before he and a great number of other Israelites were exiled and resettled in Babylon in 597 after King Nebuchadnezzar invaded Judah and destroyed Solomon's temple. While in Babylon he had a series of visions and issued prophecies calling for the people to take responsibility for their exile from and eventual return to Israel.

It is often believed that a prophet's role is only about telling the future. But in the Jewish tradition, a prophet brings God's message to the people and speaks with God's authority. Occasionally, but not exclusively, this involves telling people what will happen if they do not heed God's message.

In the Hebrew Bible, prophets are often seen speaking out against idolatry, greed, and oppression. Prophets like Ezekiel also encourage people to repent from these failures, as seen, for example, in Ezekiel 18:25–32. In other cases, they proclaim the hope of restoration and peace after periods of hardship, as we see in Ezekiel 34:25–31.

A traditional view of priests is that they chiefly manage temple or church affairs. They teach, counsel, comfort those in need, and conduct rituals.

The roles of prophet and priest are often considered irreconcilable. While both are concerned with the message of God, they are tasked with seemingly contrary projects. The priest is typically seen as a spokesperson for institutional religion, a brick in the wall of religious tradition, whereas the prophet often tears down those walls.

In this work of art, we see Ezekiel sitting atop a temple (as a priest) that has been destroyed. But he is also a prophet, pointing to God and to future hope and restoration. The story of Ezekiel and this artwork draws us in to a way of seeing a troubled, often broken world through a lens of humility, hope, and ultimate meaning.

*T*he painter Raphael, along with his Italian contemporaries Leonardo da Vinci (1452–1519) and Michelangelo (1475–1564), worked at a time in art history called the Renaissance. Some art historians have called these three artists the greatest artists who ever lived. Whether that can be determined objectively is impossible, but there is no doubt that Raphael was truly one of the great masters.

The son of a painter, Giovanni Santi (ca.1440-1494), Raphael was born in the town of Urbino, Italy. Raphael showed talent at a young age and learned to paint from the great master Pietro Vannucci, also known as Perugino (ca. 1446–1523). Overworked and neglectful of his health, Raphael died at the age of thirty-seven in Rome.

Housed today in the Palatine Gallery of Palazzo Pitti, in Florence, Italy, Raphael's **Ezekiel's Vision** portrays God in the heavens sitting on a throne made of four figures—a human, an ox, an eagle, and a lion—symbols of the Evangelists. This image corresponds to Ezekiel's vision in Ezekiel 1.

EZEKIEL'S VISION (CA. 1518)
Raphael Sanzio (1483–1520)
Current location: Palatine Gallery, Florence, Italy

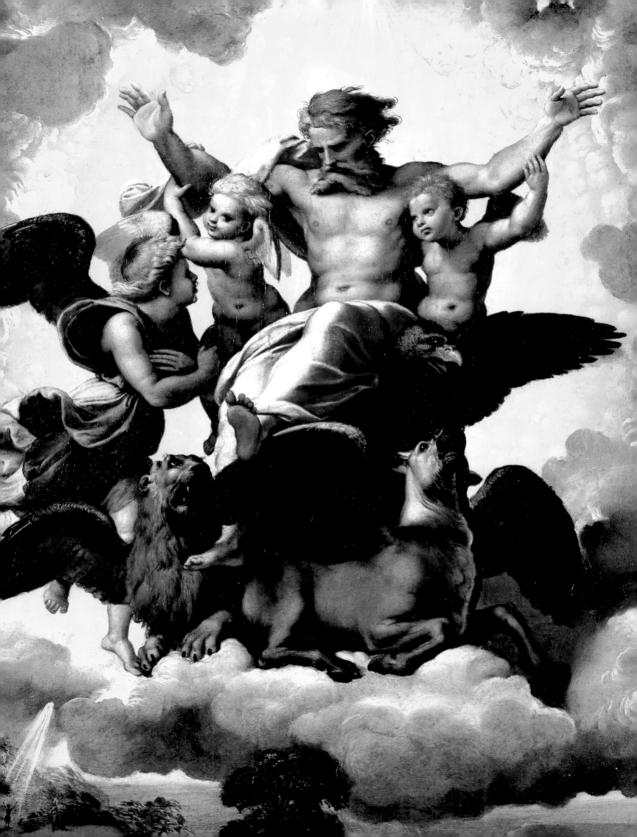

And there came a voice from above the expanse over their heads. When they stood still, they let down their wings.
And above the expanse over their heads there was the likeness of a throne, in appearance like sapphire; and seated above the likeness of a throne was a likeness with a human appearance. And upward from what had the appearance of his waist I saw as it were gleaming metal, like the appearance of fire enclosed all around. And downward from what had the appearance of his waist I saw as it were the appearance of fire, and there was brightness around him. Like the appearance of the bow that is in the cloud on the day of rain, so was the appearance of the brightness all around.
Such was the appearance of the likeness of the glory of the LORD. And when I saw it, I fell on my face, and I heard the voice of one speaking. (Ezekiel 1:25–28)

In the Hebrew Bible, Ezekiel is described as an Israelite prophet and priest during the time of Israel's captivity in Babylon. This was a tragic time for the people of Israel, who had lost their home and their security.

In *Ezekiel's Vision*, Raphael depicted a scene from the first chapter of the book of Ezekiel. Here, the prophet has a rapturous vision of "a likeness with a human appearance" (Ezekiel 1:26) seated on a heavenly throne above various winged creatures (Ezekiel 1:23–25). Ezekiel concludes that the figure has "the appearance of the likeness of the glory of the LORD" (Ezekiel 1:28). This encounter causes the prophet to fall on his face, apparently awestruck and humbled.

Although God is portrayed by Raphael with a white beard, proper of old men, in the painting, his physicality is that of a young, muscular man. His arms are open and uplifted as he descends to earth on the throne of

winged creatures, in this instance symbolizing the four gospels. The scene is framed by billowy, dark clouds, and the background is illuminated by sunlight, as if God were opening the clouds that darkened the land, a symbol of God overcoming the darkness of Ezekiel's time.

The painting also includes a small figure, thought to be Ezekiel, positioned in the lower left, standing in a beam of light. It's possible that Raphael placed Ezekiel in a diminished size and location relative to the rest of the painting to represent Ezekiel's humility, which is described in Ezekiel 1:28.

This painting can help us capture the essence of Ezekiel 1, which is a detailed but mysterious description of Ezekiel's vision. Although it can be difficult to understand the meaning of the winged creatures and other imagery in the chapter, Raphael's painting highlights God's majesty and the victory of hope in dark times, both of which are prominent in the biblical story of Ezekiel's vision.

As with many works of sacred art, one original purpose of *Ezekiel's Vision* was to serve as a devotional aid for people who could not read.* The painting can still function as a source of inspirational reflection today. Raphael's artistic mastery enables people of all faiths and creeds to experience not only Ezekiel's story but also the beauty and power of art.

* Paul Johnson, *Art: A New History* (New York: HarperCollins, 2003), 274.

This eighteenth-century icon illustrates scenes from the early chapters of the book of Daniel that occurred during the Babylonian exile of the sixth century BC. Some scholars believe the book of Daniel took its final form during the second century BC and symbolically refers to the people and events leading up to the Maccabean Revolt in 167 BC.

This icon depicts four stories from Daniel's life in Babylon. The top center shows Daniel in the lions' den. Below and to the right is a depiction of the song of the holy youths as they sit nestled in the trees surrounded by their instruments, which appears in Roman Catholic and Eastern Orthodox Bibles, as well as in the ancient Greek Septuagint translation, but not in most Protestant Bibles. King Nebuchadnezzar's great golden statue stands directly below the lions' den, while the three youths in the fiery furnace occupy the entire left side. King Nebuchadnezzar and his royal entourage stand in the lower right.

*The donor of the icon, Misail, the bishop of Didymoteicho from the island of Patmos, is shown kneeling by Nebuchadnezzar wearing the traditional black **klobuk** (head covering) commonly seen on bishops in the Eastern Orthodox tradition.*

THE STORY OF DANIEL AND THE THREE YOUTHS IN THE FIERY FURNACE (CA. 1725–1750)

Konstantinos Adrianoupolitis

Current location: Benaki Museum, Athens, Greece

Then King Nebuchadnezzar was astonished and rose up in haste. He declared to his counselors, "Did we not cast three men bound into the fire?" They answered and said to the king, "True, O king." He answered and said, "But I see four men unbound, walking in the midst of the fire, and they are not hurt; and the appearance of the fourth is like a son of the gods." (Daniel 3:24–25)

This story from Daniel 3 has for centuries inspired countless people to remain true to their convictions even in the face of danger and death. King Nebuchadnezzar had erected a giant golden statue on the plain of Dura and commanded all Babylonian officials to fall down and worship the statue whenever they heard "every kind of music" (Daniel 3:5). The icon shows the officials bowing before the great statue as horns are raised in the background.

Nebuchadnezzar also commanded that whoever refused to bow to the statue would be thrown into a blazing furnace. Three Jews—Shadrach, Meshach, and Abednego, who had been appointed over provincial Babylonian affairs—refused to bow to the statue.

According to the biblical text, and illustrated on the icon, miraculous events followed. After the furnace had been heated to seven times its regular temperature, the three Jews were bound and thrown into the fire. As Nebuchadnezzar watched, he was astonished to see that four men, not three, were unbound and walking unharmed in the middle of the flames. The fourth man had an appearance "like a son of the gods." The amazed king summoned Shadrach, Meshach, and Abednego out of the furnace and issued an edict that protected—and therefore legitimized—the religion of the Jewish people.

The twelfth-century Jewish philosopher and theologian Maimonides described this story as an example of *Kiddush HaShem*—the willingness to risk one's own life to sanctify God's name. Within the Jewish tradition, *Kiddush HaShem* describes the glorification of God through prayer, moral behavior, or martyrdom. In the context of Daniel 3, Shadrach, Meshach, and Abednego clearly chose martyrdom over idolatry.

In Adrianoupolitis's work, the three youths were willing to sacrifice their lives for what they believed. Their story can inspire us to act on noble convictions, even when it might require personal sacrifice.

*T*he work of well-known Italian painter Giotto di Bondone rests on the cusp of the Renaissance and foreshadowed the revolutionary advances that would define painting for the next five hundred years. Giotto's work is marked by a naturalism that gives life to its characters and scenes in a way that breaks from the rigid formality of late Byzantine art.

His work is filled with dramatic stories (usually biblical) that invite the viewer to step into the unfolding scene. As historian Paul Johnson wrote, Giotto "is the first Western painter whose pictures you feel you can scramble into and wander around in."*

Some of Giotto's most famous work is in the Scrovegni Chapel in Padua, Italy. The chapel features three tiers of frescoes on each side wall and are separated by vertical bands featuring floral designs and small quatrefoils (decorative frameworks) depicting biblical scenes.

Together, the frescoes tell the story of the life and passion of Jesus. However, Giotto included a scene from the book of Jonah alongside his depictions of Jesus's life. The probable reason for this combination is that early Christians saw the story of Jonah as an allegory of Jesus's death and resurrection.

JONAH SWALLOWED BY THE WHALE
(1303–1305)
Giotto di Bondone (1266–1337)

Current location: Scrovegni Chapel, Padua, Italy

153

*And the L*ORD *appointed a great fish to swallow up Jonah. And Jonah was in the belly of the fish three days and three nights. (Jonah 1:17)*

The book of Jonah tells the story of a reluctant prophet sent by God to preach a message of judgment to the people of Nineveh, a people Jonah disdained. He is caught between his natural inclinations and God's will.

Jonah flees on a ship, thinking he can escape God's request. However, a strong storm batters the ship. The crew, after casting lots, sees Jonah as the cause of the storm. Jonah agrees with them and says, "Pick me up and hurl me into the sea . . . for I know it is because of me that this great tempest has come upon you" (Jonah 1:12).

In the biblical story, a great fish swallows Jonah. In his fresco, Giotto captures this dramatic moment, showing Jonah's body half-swallowed, with only his legs and feet exposed. For three days and nights he sits in its belly until the fish spits him up onto dry land.

Having survived the ordeal, Jonah consents to go to Nineveh to deliver God's message. The people of Nineveh repent and God's judgment is mercifully prevented. Jonah recognizes that God is "merciful, slow to anger and abounding in steadfast love" (Jonah 4:2) toward the people Jonah hates. Seething, Jonah states he would rather die than surrender his anger (Jonah 4:3). To this God asks him, "Do you do well to be angry?" (Jonah 4:4).

His all-consuming bitterness, however, is seen at the end of the story. When God scorches the plant Jonah is using for shade, Jonah pouts, "It is better for me to die than to live" (Jonah 4:8).

The book of Jonah is commonly understood as a revelation of God's love for all people and all nations, whether Jew or Gentile. According to this interpretation, Jonah is viewed as an anti-prophet who refuses to deliver God's message because he would rather see the people of Nineveh destroyed than spared. Jonah comes off as a religious zealot determined to see the enemies of God destroyed; however, in the story, God desires mercy and not destruction. God is presented as a universal source of love and forgiveness rather than a militant exclusivist. Although Jonah finally accomplishes his mission, he does so reluctantly.

As we reflect on Giotto's depiction of Jonah, we can see how the story perhaps addresses the importance of civil discourse, debate, and peaceful reasoning in times of deeply held convictions—including those feelings inspired by racism.

* Paul Johnson, *Art: A New History* (HarperCollins, 2003), 256.

As the son of painter Charles-Olivier Merson, Luc-Olivier Merson was raised in the Parisian art world. He is known as a painter in the French academic tradition. He studied at the École des Beaux-Arts and eventually became a professor there. Merson rejected the innovations of the emerging impressionism movement in favor of the rigors of classicism, and he forfeited his professorship over what he perceived as an erosion of traditional artistic standards.

The success of Merson's **Rest on the Flight into Egypt** was due in part to its elegantly sparse and haunting composition, and the enigmatic use of the sphinx as Mary and Jesus's place of slumber. Joseph, wrapped in a blanket, lies on the sandy ground and rests his head on the sphinx's stone pedestal. A wisp of smoke rises from the remains of a fire, while the unsaddled donkey picks at a dry patch of desert brush and pulls against his tether. A sense of weariness permeates the scene as the holy family stops to rest in the darkened desert.

REST ON THE FLIGHT INTO EGYPT (1879)
Luc-Olivier Merson (1846–1920)

Current location: Museum of Fine Arts, Boston, USA

Now when they had departed, behold, an angel of the Lord appeared to Joseph in a dream and said, "Rise, take the child and his mother, and flee to Egypt, and remain there until I tell you, for Herod is about to search for the child, to destroy him." (Matthew 2:13)

According to the narrative in Matthew 2:1–18, wise men (Magi) from the East came to King Herod in Jerusalem looking for the baby who would be "king of the Jews." The chief priests and scribes quoted the prophet Micah and told Herod that a king would be born in Bethlehem (Micah 5:2).

Herod instructed the Magi to travel to Bethlehem and send word when they found the child. When the men found Mary and the child Jesus, they offered the child gifts of gold, frankincense, and myrrh before returning to their homeland. They did this without sending word to Herod. Soon after, an angel told Joseph in a dream to take his wife and son to Egypt.

Hosea, a prophet in the Hebrew Bible, spoke of the Israelites being called out of Egypt by God: "When Israel was a child I loved him, and out of Egypt I called my son" (Hosea 11:1). The author of Matthew adds, "This was to fulfill what the Lord had spoken by the prophet, 'Out of Egypt I have called my son'" (Matthew 2:15). Other than a cursory note in Matthew 2:14 about a nighttime departure, this is all the Gospel of Matthew says about the family's flight to Egypt. The other three Gospels do not mention this event.

Like many artists of biblical scenes, Merson interpreted the text and provided his view of the missing pieces. The journey from Bethlehem to Egypt is nearly two hundred miles. The trip would have taken over a month for a family traveling across the stark desert sands with a young child. Merson focused on the need for rest, incorporating the sphinx to indicate that they were on a journey to Egypt and placing Mary and the glowing Jesus between the great paws of the sphinx to foreshadow their safe arrival.

Joseph, Mary, and Jesus were political refugees. Jesus's life was in danger from a tyrannical king. The cruel law of their homeland left them no choice but to seek asylum in a foreign country. Perhaps the sphinx in the painting serves as not only a sign indicating the family's safe arrival in Egypt but also a symbol for a country that took in weak and weary people.

This story about Jesus's early life, and Merson's painting, convey a great lesson about helping those who are in need, sheltering those who suffer, and protecting those who are persecuted. Joseph, Mary, and Jesus were descendants of the Israelites who had been kept in bondage by the Egyptians. Those who once enslaved their people would now offer them refuge. This imagery is seen in Merson's use of the Egyptian sphinx protecting the foreign mother and child while standing guard over the sleeping father on the sands of this land they will soon call home.

*T*his manuscript leaf is taken from the **Gospel Book** created by the Armenian scribe and monk Petros. The manuscript contains illustrations that follow the narrative of Jesus's birth, ministry, crucifixion, and resurrection. The first illustration, however, depicts Abraham, Isaac, and the substitute sacrifice of the ram (Genesis 22). This reveals the artist's belief that both Isaac and Jesus were offered to God as innocent sacrifices. Near the end of the manuscript, Petros has drawn himself with a student, passing on the legacy of graphic storytelling.

This leaf contains two illustrations, one on top of the other. One scene shows Jesus feeding the five thousand; the other shows Jesus walking on the water. The Armenian text that appears on the leaf describes the scenes and identifies the primary characters.

THE FEEDING OF THE FIVE THOUSAND; JESUS WALKING ON THE WATER (1386)

Petros

Current location: The J. Paul Getty Museum, Los Angeles, USA

But Jesus said, "They need not go away; you give them something to eat." They said to him, "We have only five loaves here and two fish." . . . And Peter answered him, "Lord, if it is you, command me to come to you on the water." He said, "Come." So Peter got out of the boat and walked on the water and came to Jesus. But when he saw the wind, he was afraid, and beginning to sink he cried out, "Lord, save me." (Matthew 14:16–17, 28–30)

The work pictures Jesus providing care for the hungry. The top illustration on the leaf depicts the feeding of the five thousand found in Matthew 14. After Jesus heard of the death of John the Baptist, he took a boat to a "desolate place" (Matthew 14:13) to be alone. Despite this, the people followed him. When he saw the crowds, "he had compassion on them" (Matthew 14:14). He could have ignored the needs of the people and continued mourning the death of his friend. But Jesus went to serve the people. When evening came, Jesus multiplied the meager provision of five loaves of bread and two fish to feed the large crowd.

Immediately following this event, Jesus told the disciples to get into a boat and push off into the water while he dismissed the crowds and went to a mountaintop to pray. During the night, the disciples' boat was caught in a storm. Sometime in the early morning, Jesus appeared, walking toward them on the water. As he approached, Jesus called Peter to walk toward him on the water. Peter stepped out of the boat, onto the water, and walked toward Jesus. But when Peter focused on the strong winds around him, he became frightened and began to sink. Terrified, he called for Jesus to rescue him from drowning. Jesus "reached out his hand and took hold of him, saying to him, 'O you of little faith, why did you doubt?'" (Matthew 14:31).

These biblical events express two forms of selfless compassion: hospitality and rescue. The word *hospitality* comes from the Latin

root *hospes*, which can mean "host," "guest," or "stranger." Obviously, *hospitality* is linked to the word *hospital*, which conveys the idea of caring for someone's needs.

In the first story, Jesus demonstrated the selfless compassion of sharing, even though little was available, with people who were strangers in a large crowd who had walked long distances from their homes. One beautiful aspect of the story, beyond the seemingly impossible act of feeding over five thousand people, is that a man with little offered everything available to those in need.

In the second story, we see compassion in the form of a rescue. The moment Peter cried out while sinking into the sea, Jesus reached out his hand to grab him and bring him to safety. The wind calmed as soon as Peter and Jesus entered the boat. In Peter's moment of crisis, Jesus offered his help.

Hospitality requires us to forfeit time, energy, and possessions to meet the needs of others. To rescue those in crisis often requires a courageous willingness to face danger. The work of art compels us to provide care for those in need. It can be seen as a reminder to keep our focus on the needs of others rather than on our self-interest. As depicted in this work, Jesus demonstrated compassion to those in need by meeting tangible needs—and producing abundantly more than was expected—as well as by offering his help in a moment of crisis.

*B*orn in Bologna in 1638, Elisabetta Sirani painted in the Italian Baroque style. Her works clearly reflect the influence of Guido Reni (1575–1642). Her father, Giovanni Andrea Sirani (1610–1670), served as Reni's principle assistant. Elisabetta and her two sisters followed in their father's footsteps to become painters.

As word of her artistic skill spread, Elisabetta began to earn lucrative commissions and attract wealthy patrons. In 1652, she established an art school for women that flourished until her unexpected death in 1665. She was only twenty-seven years old.

At age nineteen, Elisabetta received the commission for **The Baptism of Christ** from the Church of San Girolamo della Certosa in Bologna, Italy. She completed the large and complex piece when she was twenty. The piece was mounted directly across from an earlier work by Elisabetta's father titled **Dinner at the Home of Simon** (1652). Elisabetta's masterful brushwork, eye for dramatic composition, and keen sense of color are all showcased in this exquisite painting.

THE BAPTISM OF CHRIST (1658)
Elisabetta Sirani (1638–1665)

Current location: Church San Girolamo della Certosa, Bologna, Italy

ELISABETTA
SIRANI·F·MDCLVIII·

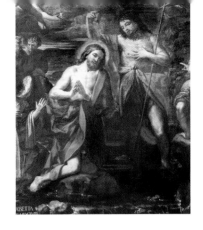

In those days Jesus came from Nazareth of Galilee and was baptized by John in the Jordan. And when he came up out of the water, immediately he saw the heavens being torn open and the Spirit descending on him like a dove. And a voice came from heaven, "You are my beloved Son; with you I am well pleased." (Mark 1:9–11)

Elisabetta Sirani's *The Baptism of Christ* focuses on the ritual of baptism by water. John baptized people in water as a symbol of repentance (Matthew 3:11). Many people believe that John's baptism of Jesus marks the beginning of Jesus's three-year period of teaching before his crucifixion. According to the Gospel of Luke, John the Baptist was the son of Zechariah, a Jewish priest, and his wife, Elizabeth (chapter 1). Prior to John's birth, an angel named Gabriel appeared to Zechariah and informed him that John would help many people turn to God (Luke 1:16–17).

In the painting, John the Baptist is humbly clad in a red robe and camel hair with a belt wrapped about his waist and a cruciform staff nestled in the crook of his arm. This depiction of John closely follows the biblical description of him: "John was clothed with camel's hair and wore a leather belt around his waist" (Mark 1:6).

Compositionally, the entire scene forms a *V* as the onlookers in the painting guide the eye to God and Jesus, who form the central axis. Flanked by angels, God looks down on Jesus and raises his hand in a gesture of blessing. A dove, often the biblical symbol of the Holy Spirit, appears directly below him encircled in a soft orb of light.

Below the dove, John the Baptist raises a small cup of water above Jesus's haloed head. Beneath him, Jesus is draped in a bright blue tunic that mirrors God's attire as he kneels on a rock in the river with his hands

in prayer. In the crowd, a man puts on a stocking; the straps of his other stocking rest on the ground nearby, perhaps a visual reference to John the Baptist's proclamation that he is unworthy to untie the sandals of the one who is coming (Luke 3:16).

In the lower right, a woman breastfeeds her child while looking into the eyes of an elderly woman (perhaps an allusion to John's mother, Elizabeth), which juxtaposes youth and old age while also referencing the artistic tradition of Mary nursing Jesus.

From the accounts about John the Baptist in the Gospels, we read that his primary message was related to "repentance for the forgiveness of sins" (Mark 1:4) and his main purpose was to "prepare the way of the Lord" (Matthew 3:3). Apparently, John had quite a following. People from "all the country of Judea and all Jerusalem were going out to him and were being baptized by him in the river Jordan" (Mark 1:5). But when Jesus approaches John to be baptized by him, John resists, saying, "I need to be baptized by you, and do you come to me?" (Matthew 3:14). John sees no reason for Jesus to repent.

In Elisabetta Sirani's painting, John stands with one foot behind the other, with his head tilted to one side, and with his left hand held up against his heart. These elements of John's posture might be interpreted as an expression of his humility as he stands before Jesus in the biblical narrative of the event.

*The twentieth-century Spanish surrealist Salvador Dalí described the theoretical foundation for his work as "paranoiac-critical." This method pulls images from dreams, visions, delusions, and memories to create impossible visionary realities. For instance, in one of his most famous pieces, **The Persistence of Memory** (1931), pocket watches melt and sag in the heat of an amorphous desert while a single closed eye languishes on the hot sand.*

Born in 1904 near Barcelona, Dalí studied art at the Academy in Madrid and focused on traditional artistic methods and styles. In his mid-twenties, he visited Paris, where he met Picasso and surrealists Joan Miró and André Breton. He was so taken with the energy of Paris that he moved there and became deeply involved in the Parisian surrealist movement.

*In 1948, after the horrors of World War II, Dalí returned to Spain and declared his intention to return to classical painting. He spent most of the 1950s devoted to Christian religious painting. In 1951 he completed his iconic **Christ of St. John of the Cross**.*

CHRIST OF ST. JOHN OF THE CROSS (1951)
Salvador Dalí (1904–1989)

Current location: Kelvingrove Art Gallery and Museum,
Glasgow, Scotland

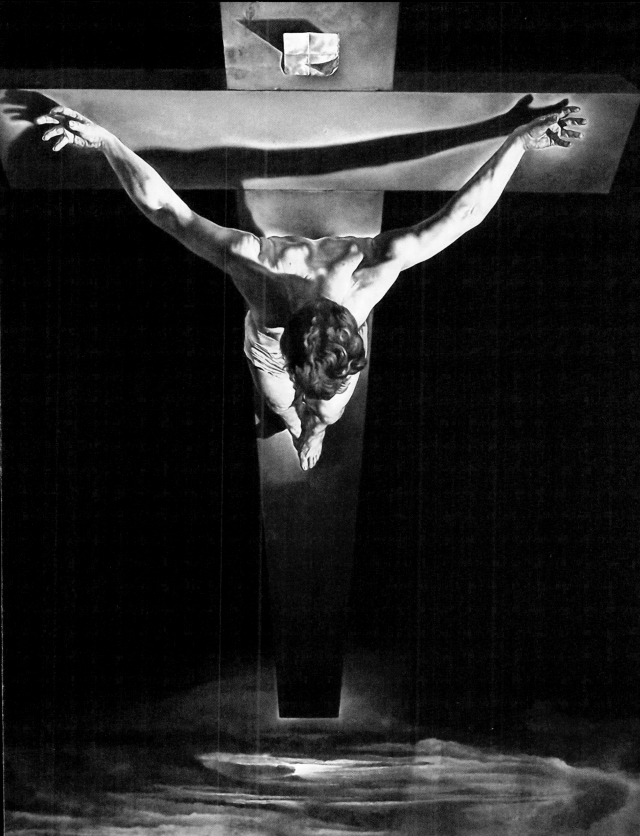

And at the ninth hour Jesus cried with a loud voice, "Eloi, Eloi, lema sabachthani?" which means, "My God, my God, why have you forsaken me?" (Mark 15:34)

The crucifixion of Jesus, as documented in the Gospels, has inspired countless works of art. Each can be seen as a visual interpretation of the event's meaning.

The inspiration for Dalí's portrayal of Jesus's death came from a small drawing done by a sixteenth-century Carmelite monk known as St. John of the Cross. The original drawing is rendered inside a circle and features a top-down view of Jesus on the cross.

Dalí's larger-scale reworking of the image also depicts a top-down view of Jesus on the cross, but he is radically foreshortened and floats above the sea and sky, supernaturally suspended above the bay of Port Lligat, Spain, where Dalí lived. Dalí maintained the composition of the original piece with a triangle and circle expressed in Jesus's outstretched arms and downturned head.

Dalí's crucifixion presents Jesus transcending his suffering. Whereas most images of Jesus on the cross portray his anguished face along with blood and nails, Dalí offers a mystical and beautiful Jesus who literally and metaphorically rises above the fleshly world of pain and suffering. Dalí himself claimed, "My principal preoccupation was that my Christ would be beautiful as the God that he is."

Dalí's *Christ of St. John of the Cross* shows two vantage points of the crucifixion. The first is from an overhead position and focuses on the crown

of Jesus's head. The second, in keeping with Dalí's surrealist inclination, presents the lower scene of the boat at the Port of Lligat at eye level. When viewing Jesus from above and looking down on the world, consistency of perspective would demand that we see the boat and the sea from above. However, they are viewed from the ground.

By elevating the cross above the earth while simultaneously rendering views from the earth and the heavens, Dalí's crucifixion speaks to the pleading space between Jesus and his Father when Jesus asks, "Why have you forsaken me?" By crying out the words from Psalm 22, a psalm of lament that begins with despair and ends with praise and thanksgiving, Jesus pleads for understanding as he waits for the glory described in the psalm's final verses: "Posterity shall serve him; it shall be told of the LORD to the coming generation; they shall come and proclaim his righteousness to a people yet unborn, that he has done it" (Psalm 22:30–31).

Dalí's version of *Christ of St. John of the Cross* is unparalleled in artistic representations of the crucifixion. Though anchored in the biblical text of Jesus's death on the cross, the imagery is not portrayed in reality but in an impossible scene. Like Jesus floating on the cross, the painting suspends the viewer between heaven and earth, between the abstract and the real. Because the crucifixion was so brutal, the art depicting Jesus on the cross inevitably invites us to reflect on the meaning of suffering and God's presence in it.

A masterpiece of Irish art, the **Book of Kells** is a manuscript of the Latin Gospels known for its intricate margin decorations and beautiful full-page illustrations. Written in **insular majuscule**, a popular script in the British Isles between the sixth and ninth centuries, the manuscript was likely created by Columban monks on the island of Iona off the west coast of Scotland. Sometime later, it was transferred to the Abbey of Kells in Ireland and is currently housed at Trinity College in Dublin.

Christ Enthroned, from the verso (back) side of folio 32, features Jesus sitting on a throne accompanied by four angelic-looking beings whose identities are unknown. To the sides of Jesus's head are two peacocks, classical symbols of immortality, along with two bowls of grapevines, perhaps symbolizing the wine in the Eucharist. Above Jesus's head is a traditional cross, while at his feet are two stylized Celtic crosses. An ornate frame with intricately woven Celtic designs surrounds the image.

References to Jesus seated "at the right hand of God" appear throughout the New Testament. However, it is not known whether the artist had a specific biblical passage in mind when creating this illustration.

CHRIST ENTHRONED, LEAF FROM THE BOOK OF KELLS (CA. 800)

artist unknown

Current location: Trinity College Library, Dublin, Ireland

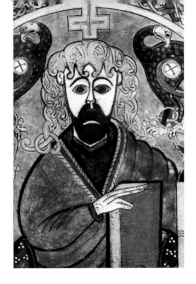

So then the Lord Jesus, after he had spoken to them, was taken up into heaven and sat down at the right hand of God. (Mark 16:19)

The image of Jesus with a heavy beard and long hair, raising his right hand in a symbol of blessing and pointing to a Bible, is reminiscent of a category of images known as "Christ Pantocrator." *Pantocrator* literally means "ruler over all." In these images, Jesus is depicted as a universal sovereign and judge. This imagery denotes kingly wealth, power, and glory.

Some Bible readers believe that references to Jesus as pantocrator appear in biblical passages such as John 1:1–3 and Hebrews 1:3–4. In addition, Colossians 1:16 says, "For by [Jesus] all things were created, in heaven and on earth, visible and invisible." This aspect of Jesus is emphasized in this work of art.

However, other parts of the Bible describe Jesus as a carpenter and nomadic preacher-prophet who exemplified compassion and mercy and lived a life of poverty. Throughout the last three years of his life, Jesus emphasized love through compassion, forgiveness, mercy, kindness, gratitude, and generosity. He told his listeners to take care of those in need, to forgive those who wronged them, to respond to violence with nonviolence, to love their enemies, to give to anyone who asked for something, and to be kind to those who hated them.

In Luke 6:17–26, Jesus blesses the poor, the meek, the hungry, and the ridiculed; he tells them their "reward is great in heaven." But he speaks harshly to the rich and powerful who have already received their earthly reward. In the Gospels Jesus repeatedly talks about the spiritual trap of personal attachment to material possessions and the spiritual blessing of showing mercy and compassion to others.

Just as he rejected worldly wealth and power, Jesus taught against the ideal of religious self-righteousness. He refuted those who prided themselves on observing strict religious rules. Like the rich person who revels in material wealth, the prideful pious delight in their own righteousness—neglecting basic human welfare and authentic human relationships.

Christ Enthroned presents Jesus—sitting among angels, peacocks, and grapevines—as the majestic sovereign and judge. Looking at the biblical texts that describe Jesus as pantocrator alongside the portrayals of him as a humble Jewish teacher who preached against worldly wealth, power, and religiosity, we gain a rich and complex portrait of Jesus.

Karel Slabbaert, a seventeenth-century Dutch painter well known for his portraits and still life paintings, may have been a pupil of Gerrit Dou. His attention to minute details and his inclusion of a Dou-style "niche" painting with its hallmark arched upper frame on the easel in this painting lend credibility to this suggestion. Little is known of his life except that he settled with his wife in the town of Middleburg on a southwestern peninsula in the Netherlands.

The Workshop of the Evangelist Luke is a study in the Lucan iconography and a celebration of Renaissance artistry. Slabbaert used an exaggerated form of linear perspective to give Luke's workshop an extremely elongated appearance. He positioned the elderly Luke as the principal focal point at the farthest end of the shop. The result is a funneling effect, with the scattered books, papers, and paintings appearing to tumble down toward the weary disciple. Even the odd angle of the lectern on which Luke rests his right arm appears as if it is about to spill the book down onto the old man.

THE WORKSHOP OF THE EVANGELIST LUKE
(1648)
Karel Slabbaert (ca. 1619–1654)

Current location: Gemäldegalerie, Staatliche Museen zu Berlin, Berlin, Germany

Inasmuch as many have undertaken to compile a narrative of the things that have been accomplished among us, just as those who from the beginning were eyewitnesses and ministers of the word have delivered them to us, it seemed good to me also, having followed all things closely for some time past, to write an orderly account for you, most excellent Theophilus, that you may have certainty concerning the things you have been taught. (Luke 1:1–4)

The scene in this painting is likely Slabbaert's own studio, with the painting in the foreground reflecting Slabbaert's artistic style. A self-portrait of the artist rests high on the ledge of the rear wall.

Seated at the table and slumped over an enormous text, Luke sits next to his token symbol, the ox. The books strewn around his workshop reveal his studious personality. The globe symbolizes Luke's travels, as recorded in the book of Acts. The skull resting on the high shelf is a classical *memento mori*—a reminder of the transience of life and the inevitability of death.

Why do we we see Luke in a painter's studio? Luke was the patron saint of painters and artists. It was believed that he painted the first Madonna and Child icon.

Artists traditionally depict Luke engaged in writing or reading because he is regarded in the Bible as the "beloved physician" (Colossians 4:14), and because many scholars believe he worked as a historian to write the Gospel of Luke and the book of Acts.

Luke's prologue is remarkable for the amount of information it reveals in only four verses. Although Luke states that many others had attempted to "compile a narrative" of the events that had occurred, Luke indicates that his narrative is based on stories from "those who from the beginning

were eyewitnesses and ministers of the word." And he explains that he wrote an orderly account after he had "followed all things closely for some time past," confirming that he investigated everything carefully.

Often overlooked, and not shown in Slabbaert's painting, is Luke's personal motivation for writing this Gospel and Acts. According to Luke 1:1–4 and Acts 1:1, he undertook the entire endeavor to help one friend named Theophilus. It appears that Luke's motivation was not fame or religious status; it was friendship.

More specifically, Luke says he wanted Theophilus to "have certainty concerning the things [he has] been taught." His narrative, then, was an attempt to correct errors and to reassure Theophilus of the truthfulness of the things in which he had been instructed.

The name *Theophilus* means "friend of God" in Greek. The title "most excellent" suggests Theophilus was of high social rank, perhaps a government official and perhaps Luke's patron.

Although Luke's stated reason for writing the Gospel was to help his friend, it is possible that he hoped others like him would have access to his written record about the life and teachings of Jesus. Whatever the case, the detailed nature of the Gospel of Luke and the book of Acts required hard work. Perhaps this is why in the painting Luke appears weary in his workshop—with his hand on his brow, he pours over yet another eyewitness account in search of the truth.

*P*aul Gauguin, a French painter and printmaker, was best known for his post-impressionistic style of expressionism. Gauguin had a career as a stockbroker, but after the Parisian stock market crash, he turned to painting. He became a key figure among the artists working in Pont-Aven in Brittany, where he experimented with pastels.

In 1892 he traveled to Tahiti, where he spent the rest of his life painting native people, plants, and animals. He experimented with unnatural coloration intended to elicit raw emotion at the expense of representational accuracy. His Tahitian works, with their simple compositions and bold, unusual colors, defined his distinctly "primitive" style.

Completed near the end of his life, this painting blends a number of Gauguin's travels and artistic influences. He likely started this piece in Brittany and finished it in the South Seas. The church steeple and gently curved snowcapped roofs in the background are modeled after those in the town of Pont-Aven. The two oxen suggest an Egyptian wall painting, and the primitive nativity scene appears to be set inside a small Polynesian-style temple structure. The way the standing figure is holding his left arm is reminiscent of a Javanese frieze (a horizontal or square block of sculpted stone).

CHRISTMAS NIGHT
(THE BLESSING OF THE OXEN) (1902–1903)
Paul Gauguin (1848–1903)

Current location: Indianapolis Museum of Art, Indianapolis, USA

And she gave birth to her firstborn son and wrapped him in swaddling cloths and laid him in a manger, because there was no place for them in the inn. (Luke 2:7)

In Luke 2, we find the only account of the iconic Nativity story with Mary giving birth and placing her newborn, Jesus, in a manger. A manger is a feeding trough for livestock, a common sight in settings where animals and people shared close quarters. Because "there was no place for them in the inn" (Luke 2:7), Mary and Joseph likely found whatever lodging was available, even if it meant sharing the space with animals.

The Greek word *kataluma* is translated as "inn" in this passage; it could also be translated as "guest room" or simply "place to stay." This has led some scholars to claim that an innkeeper did not turn away the pregnant Mary because there were not enough rooms but, rather, because the space that was available in that "guest house" was not suited for a woman who was about to give birth. The biblical text simply states that Mary and Joseph sought refuge in a place that happened to have a manger, and they resourcefully used the manger as a safe, warm place to cradle their baby.

While there is no manger in Gauguin's painting, he captures the moment by placing the newborn baby and family in a grotto-like chapel. Outside, two oxen lumber past, unaware of the precious newborn just feet away. The painting's muted tones and the faint orange-blue light settling on the horizon give the scene a dreamy, almost mysterious quality.

The painting's parenthetical title, *The Blessing of the Oxen*, probably comes from the 1906 catalog for the *Salon d'Automne*, in which the piece was listed as *La Bénédiction des Boeufs*. This is an unusual title because the oxen appear to have simply come upon the scene and are not integral to the unfolding events. There is, however, something different about the oxen that some viewers may not notice: Although there are two oxen, there are only seven legs.

Details about the exact circumstances of Mary and Joseph's lodging are missing from biblical accounts of Jesus's birth. While Luke's account provides the most description about the setting of the birth of Jesus, differing interpretations of the "inn" and the reason for the manger allow for a variety of interpretations. As a result, the uncertainty and mystery surrounding the story have given artists great liberty in depicting the scene in unique and remarkable ways.

However artists might render the event, it was a fragile moment for the young family. Far from home, they lacked money, medical care, a proper shelter to give birth in, and a crib in which to place their newborn child. To make matters worse, they would soon face the threat of persecution by King Herod. Clearly, the story of the first Christmas is far removed from the tranquility of "Silent Night" or "The First Noel."

*T*his work was painted in about 1330 by the Master of the Cini Madonna. Little is known about the artist, but some have speculated that he was the same artist who created **Madonna with Child and Angels** (ca. 1300). Other scholars disagree, stating that the two paintings were created by different artists but that both were influenced by the Italian painter Duccio di Buoninsegna (ca. 1255–1318).

Regardless, the Master of the Cini Madonna had only a basic familiarity with linear perspective, which was common among artists in the early fourteenth century. The painting, therefore, has little depth and appears flat. The orthogonal lines of the church building and the table where Jesus is presented vaguely recede to a single point, but they still bear a two-dimensional appearance. This flatness is especially apparent in the way the dark interior dome is shown in full view, which would be impossible.

The scene comes from Luke 2:22–40, when Jesus is presented at the temple forty days after his birth, according to Mosaic tradition. His parents offer a sacrifice of two turtledoves or young pigeons, an acceptable offering for those who cannot afford sheep (Leviticus 12:8)—suggesting they were of meager means.

PRESENTATION OF JESUS
AT THE TEMPLE (CA. 1330)
Master of the Cini Madonna

Current location: National Art Museum of Catalonia, Barcelona, Spain

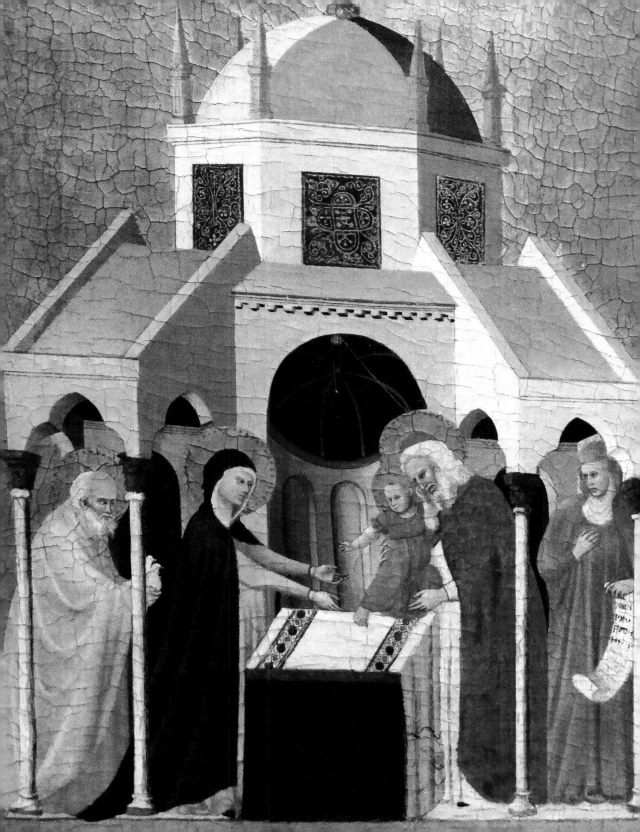

"Lord, now you are letting your servant depart in peace, according to your word; for my eyes have seen your salvation that you have prepared in the presence of all peoples, a light for revelation to the Gentiles, and for glory to your people Israel." (Luke 2:29–32)

The Bible presents Jesus's parents, Joseph and Mary, as faithfully following Jewish customs and laws. For example, they had Jesus circumcised eight days after his birth (Luke 2:21) and then later presented Jesus at the temple in Jerusalem to be consecrated (Luke 2:22–24). This painting reveals a touching depiction of a young, poor couple fulfilling Mosaic tradition.

According to the Gospel of Luke, when Mary and Joseph arrived at the temple, they met a good man named Simeon who had been waiting for the Jewish messiah. He took the baby "up in his arms and blessed God and said, 'Lord, now you are letting your servant depart in peace . . . for my eyes have seen your salvation'" (Luke 2:28–30). An elderly prophetess named Anna also appeared at the temple. When she saw Jesus she thanked God and talked about the baby to all the people "who were waiting for the redemption of Jerusalem" (Luke 2:38).

In the painting, the artist shows Joseph, on the left, clutching two white turtledoves. Mary, next to him, wears a traditional blue cloak and offers the infant Jesus to the red-robed Simeon. He holds Jesus as the child gently touches the old man's face. The prophetess Anna stands to the far right with her hand over her heart, holding an unfurled scroll.

It is important to note that the painting accurately depicts Luke's description of how Jesus was presented in the temple. This establishes Jesus's identity as one who followed Jewish culture and traditions. Throughout the rest of his life, as described in the Gospels, Jesus worshiped in Jewish synagogues, celebrated Jewish holy days, and taught from the Hebrew Scrolls. However, Jesus also performed miraculous healings on Sabbath days which was against Jewish Shabbat.

In Luke's account of Jesus's consecration, Simeon proclaimed that Jesus would be "a light for revelation" to non-Jewish people also, having a cross-cultural influence. He announced this at a time when Israel was dominated by an occupying Roman force that splintered Jews into factions and when the the influence of Greco-Roman culture still permeated the region. We can wonder if Joseph and Mary, as devout Jews, were surprised by Simeon's words about their son.

Joseph, Mary, and Jesus experienced a tension that many people share today: the impulse to preserve one's own cultural heritage, as shown in this painting, while engaging with the rest of the world. Perhaps, then, the message is that in order to preserve the spirit of tradition, we must transcend it.

*E*ugène Delacroix, a preeminent French Romantic-era painter, drew inspiration from secular mythologies and religious writings.

 As a young man, Delacroix turned away from the austere compositions and fixed colors of the neoclassicists and embraced the loose brushwork, bold colors, and dynamic movement that characterized the fierce, passionate liberty of his romanticism. His most famous work, **The Twenty-Eighth of July: Liberty Leading the People** (1830), located at the Louvre-Lens museum in Lens, Pas-de-Calais, in Northern France, stands over eight feet tall and features a bare-breasted lady liberty leading French-Republican revolutionaries over the bodies of dead or dying royalists. Delacroix completed this monumental painting after seeing the rebellious citizens of France force Charles X to abdicate his throne in the French Revolution of 1830.

 This same passion animates his **Christ on the Sea of Galilee**, where a violent storm, rendered in quick, fluid brushstrokes, threatens to overtake the small rowboat where Jesus peacefully sleeps. Delacroix painted at least six versions of this scene—some with rowboats, others with sailboats.

CHRIST ON THE SEA OF GALILEE
(CA. 1841)
Eugène Delacroix (1798–1863)

Current location: The Walters Art Museum, Baltimore, Maryland, USA

One day he got into a boat with his disciples, and he said to them, "Let us go across to the other side of the lake." So they set out, and as they sailed he fell asleep. And a windstorm came down on the lake, and they were filling with water and were in danger. And they went and woke him, saying, "Master, Master, we are perishing!" And he awoke and rebuked the wind and the raging waves, and they ceased, and there was a calm. He said to them, "Where is your faith?" And they were afraid, and they marveled, saying to one another, "Who then is this, that he commands even winds and water, and they obey him?"
(Luke 8:22–24)

This nineteenth-century painting by Eugène Delacroix of Jesus in the midst of a raging storm demonstrates the near-universal longing for peace.

Delacroix was drawn to biblical stories for their powerful images and dramatic narratives. This scene is based on the story found in Luke 8:22–25 of Jesus quieting a storm. As the storm raged and the disciples were literally afraid of perishing, Jesus calmly slept.

Delacroix renders one disciple, shown as a frantic blur, standing with arms raised and about to fall into the sea; another leans out over the edge of the boat reaching after a lost oar. In the stern of the boat, a man cowers, wrapped in his garments, while in front of him a nearly naked man rows against the waves. Delacroix adorns the disciples in the colors of their fear—red, orange, and blues—to match the swirling waters. In contrast, Jesus, swaddled in white and gray, calmly sleeps near the bow as the small boat cuts diagonally through the coming crash of a wave.

Delacroix's painting does not portray Jesus calming the chaotic waters. Rather, it shows him asleep, resting as though he were in the tranquil eye of the storm. Using the visual conflict of tumult and repose, Delacroix invites us to reflect on where we might find peace in the midst of chaos.

For people familiar with the biblical account of creation, the stormy water and the peaceful posture of Jesus may bring to mind the words of the first two verses of Genesis: "In the beginning, God created the heavens and the earth. The earth was without form and void, and darkness was over the face of the deep. And the Spirit of God was hovering over the face of the waters." As the waves crashed over the sopping wet disciples and the winds threatened to capsize their small boat, perhaps Jesus could sleep soundly in the hull because he had faith in the God who tamed the formless waters of primordial chaos to bring order to the cosmos. In stressful, fast-paced times, when struggling to experience peace and inner rest, this painting can help.

*J*an Wijnants, a Dutch landscape painter influenced by Jacob van Ruisdael (1628–1682) and Otto Marseus van Schrieck (1619–1678), spent his life painting in Amsterdam. He was known for his sandy, naturalistic dunes and craggy, twisted, weathered trees. Many scholars believe other artists completed the figures in his paintings.

In this depiction of the good Samaritan, the soft, pale light of the sky filters down through the branches of an aged tree that frames the central scene. In the foreground, an injured man lies draped only in the outer robe that robbers left after beating him and taking his clothing.

Kneeling over him, the Samaritan tends to his wounds with oil and wine. The beaten man's white robe symbolizes his innocence, while the Samaritan's red cloak likely suggests the blood of Jesus. The prickly thistle bush that springs up in the foreground, almost shielding the injured man, was a common symbol of protection. In the middle, beyond the Samaritan's tethered horse, a Levite walks down the road. Farther in the distance, framed between two trees, a priest similarly travels on.

PARABLE OF THE GOOD SAMARITAN (1670)
Jan Wijnants (1632–1684)

Current location: The State Hermitage Museum, Saint Petersburg, Russia

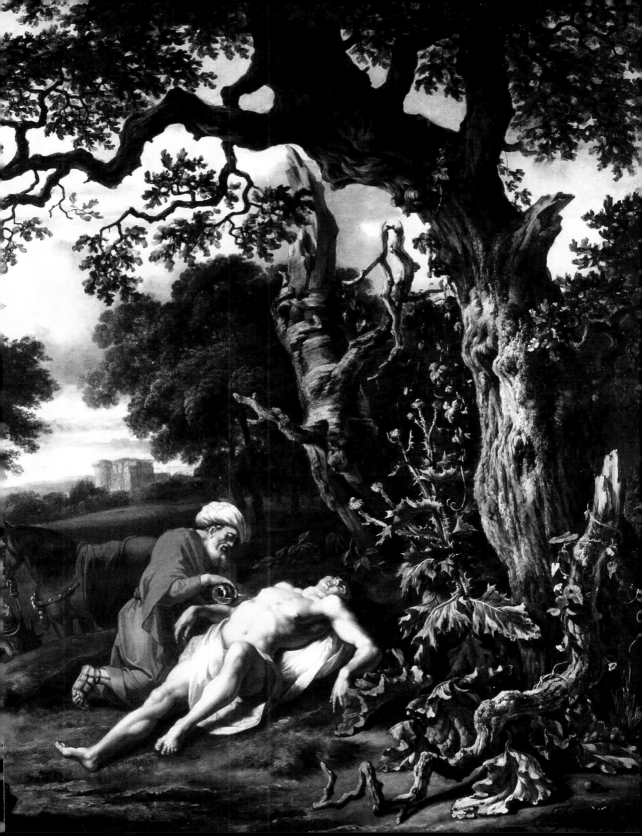

But a Samaritan, as he journeyed, came to where he was, and when he saw him, he had compassion. He went to him and bound up his wounds, pouring on oil and wine. Then he set him on his own animal and brought him to an inn and took care of him. (Luke 10:33–34)

The parable of the good Samaritan appears in the Gospel of Luke. According to Luke 10:26–29, a lawyer asked Jesus what he must do in order to inherit eternal life. Jesus responded by saying, "What is written in the Law? How do you read it?" The lawyer answered, "You shall love the Lord your God with all your heart and with all your soul and with all your strength and with all your mind, and your neighbor as yourself." Jesus told the lawyer that he had given the right answer, but the man pressed further, asking, "And who is my neighbor?" In response, Jesus told the parable of the good Samaritan.

According to the story, a man was traveling down the road from Jerusalem to Jericho when he fell into the hands of robbers. They beat him, stole his clothing, and left him stranded and half-dead on the side of the road.

A temple priest came upon the unfortunate man, but he passed by on the other side of the road. Soon after, a Levite (Temple aide) came upon the man and also passed by on the other side of the road. Finally, a Samaritan (a person the Jews at that time considered spiritually unclean and socially unacceptable) came down the road. He didn't pass by the man but had compassion on him. He poured oil and wine on his wounds, bandaged them, and then put him on his own donkey and took him to an inn where he provided for his needs.

When he completed the parable, Jesus asked the lawyer, "Which of these three, do you think, proved to be a neighbor to the man who fell among the robbers?" The lawyer answered, "The one who showed him mercy." Jesus commanded the lawyer, "You go, and do likewise" (Luke 10:36–37). It is interesting to note that Jesus did not directly answer the lawyer's question

about his neighbor but instead told a story that would reveal the answer and then instructed the lawyer and those listening to imitate such mercy.

During the first four centuries of Christianity, church fathers such as Irenaeus (AD 130–202), Origen (AD 185–254), Ambrose (AD 337–397), and Augustine (AD 354–430) read the parable allegorically and suggested that the Samaritan represented Jesus. He was the savior of sinners, and the man who was beaten and robbed represented humanity abused by the Devil. Rather than encouraging followers to imitate the Samaritan's actions, these church fathers held that Christians should identify with the beaten and bloody man.

Later interpreters of the parable tried to define a true neighbor. Was Jesus saying that a neighbor was anyone who showed compassion and mercy to those in need? Or was he saying that a neighbor is anyone in need? Still others read the parable in light of the lawyer's original question, "What shall I do to inherit eternal life?" (Luke 10:25), suggesting Jesus's parable is a story of salvation and not neighborly compassion.

Nearly all interpretations, however, agree on two things: In the cultural context of the story, Samaritans were viewed as ethnic and religious foreigners; the priest and the Levite represented the traditional forms of religious life. The man who fell among thieves was tended to by a Samaritan, while the religious authorities did nothing.

Some scholars speculate that the priest and the Levite passed on the other side of the road to avoid the impurity of approaching a man who was half-dead. The Samaritan, they say, simply saw a man in need. He did not see a Jew, an Egyptian, or a Greek but rather another human being in need, and he acted with mercy.

Too often semantics and debates over interpretation drown out the simplicity of the message in a biblical text. Perhaps the greatest lesson we can learn from the parable of the good Samaritan and Wijnants's painting is to recognize people who are suffering and show them mercy and compassion.

*J*ohannes Vermeer was a Dutch artist who masterfully captured daily life with elegance, precision, and beauty. His vibrant use of colors and his attention to detail are unparalleled. Because of his precise technique, some people have speculated that he used mechanical aids—such as a camera obscura, a camera lucida, and mirrors—to achieve the astounding photorealism of his works.

Little is known about Vermeer's life except the few details recorded in official church and city documents. He was baptized as an infant in the Nieuwe Kerk, a Protestant church, and spent most of his adult life running an inn and dealing art in the city of Delft in the western Netherlands. He was a member of (and eventually headed) the Guild of St. Luke, the local association for artisans and painters.

In 1653 Vermeer married Catharina Bolnes and converted to Catholicism. He completed **Christ in the House of Mary and Martha** over the course of the next year. Standing over five feet tall, it is the largest painting he ever completed and is one of the few overtly religious works he created.

CHRIST IN THE HOUSE OF MARTHA AND MARY (1654–1655)
Johannes Vermeer (1632–1675)

Current location: National Gallery of Scotland, Edinburgh, Scotland

Now as they went on their way, Jesus entered a village. And a woman named Martha welcomed him into her house. And she had a sister called Mary, who sat at the Lord's feet and listened to his teaching. But Martha was distracted with much serving. And she went up to him and said, "Lord, do you not care that my sister has left me to serve alone? Tell her then to help me." But the Lord answered her, "Martha, Martha, you are anxious and troubled about many things, but one thing is necessary. Mary has chosen the good portion, which will not be taken away from her."
(Luke 10:38–42)

Dutch artist Johannes Vermeer, in his painting *Christ in the House of Mary and Martha*, compels us to consider the tension between busyness and relationships, between work and rest, between anxiety and peace. It is a painting that speaks to every generation.

As described in the Gospel of Luke, we find Jesus in the house of Martha, who is "distracted with much serving," while her sister, Mary, sits at Jesus's feet. Martha complains to Jesus about her sister's lack of support, but Jesus responds by defending Mary for spending time with him.

In Vermeer's painting, Jesus sits in an armchair gesturing to Mary while looking at Martha as she serves him a loaf of bread. With three simple elements, Vermeer manages to capture the entire story in a compelling masterpiece.

The drama portrayed in the painting opens us to a compelling view of human nature. Martha busies herself with household tasks—perhaps looking for encouragement from Jesus while chiding Mary's idleness. Jesus answers her with a look and a gesture, but it is clear that he affirms Mary's attentiveness over Martha's distraction. The scene is filled with relational tension. Vermeer captures envy, humility, pride, anxiety, and rest.

Some have interpreted the story of Mary and Martha as an admonition against choosing an active life over a contemplative life. Vermeer portrays Martha's hard work and busyness (offering Jesus a loaf of bread); she is too busy to enjoy the meal with her guest. In the biblical text, Jesus corrects Martha—not for serving, but for being "anxious and troubled about many things." It seems, therefore, that it is not Martha's work that Jesus faults; rather, it is her worry.

The world is full of stress and uncertainty. Our concerns are spread thin over a myriad of demands and expectations. Like Martha, we can obsess over these matters and miss opportunities for rest and relationships. We can become so worried about the important details of daily life that we lose a sense of peace and well-being.

*B*orn Doménikos Theotokópoulos, this Renaissance master is more widely known by his nickname El Greco (The Greek). He briefly trained as an icon painter in Crete before moving to Venice, where he apprenticed under Titian (1490–1576). He also studied the manner and techniques of Tintoretto (1519–1594), whose influence can be seen in El Greco's works from this period.

El Greco lived in Rome in the early 1570s before settling in Toledo, Spain, where he joined a thriving group of artists and humanists. Earning a commission from the Church of Santo Domingo el Antiguo, he completed a set of nine paintings that established his reputation in Spain. El Greco remained in Toledo for the rest of his life and continued to create powerful and passionate works of intense religious expression.

El Greco's work is clearly recognizable for his strong use of color, elongated figures in flowing and often unnatural poses, loose regard for proportion, and his impressionistic brushwork. The result is a portrayal of ecstatic emotion charged with spiritual drama and mystical impact. El Greco's idiosyncratic style and dexterous use of color defies strict identification with a single artistic tradition. His work transcends classification and transformed painting.

CHRIST CLEANSING THE TEMPLE (CA. 1570)
El Greco (Doménikos Theotokópoulos) (1541–1614)
Current location: National Gallery of Art, Washington, DC, USA

The Passover of the Jews was at hand, and Jesus went up to Jerusalem. In the temple he found those who were selling oxen and sheep and pigeons, and the money-changers sitting there. And making a whip of cords, he drove them all out of the temple, with the sheep and oxen. And he poured out the coins of the money-changers and overturned their tables. And he told those who sold the pigeons, "Take these things away; do not make my Father's house a house of trade." (John 2:13–16)

The story of Jesus cleansing the temple occurs in all four Gospels, but only the Gospel of John mentions a whip. Many have wondered why Jesus would wield a whip and turn over tables. What was he so upset about?

To those who sold pigeons, Jesus said, "Take these things away; do not make my Father's house a house of trade" (John 2:16). In Matthew's account, Jesus says, "'My house shall be called a house of prayer,' but you make it a den of robbers" (Matthew 21:13), indicating that corrupt trade was occurring in the temple. The accounts in Mark and Luke also record Jesus using the phrase "den of robbers" (Mark 11:15–17; Luke 19:45–46).

Christ Cleansing the Temple captures this emotional, intense moment. El Greco likely painted this work prior to 1570 while he was in Venice before moving to Rome. El Greco did at least three versions of this scene. Although the chronology of these pieces is unclear, the one featured here is likely an early rendition.

In the painting, Jesus is barefoot and clad in a dark red robe. He strides through a knot of people while brandishing a small whip. The figures twist and collapse about him. One woman appears to have fainted. Another woman in the foreground is in the process of falling and braces herself on a wooden birdcage. All around Jesus, people raise their arms to shield themselves from his flailing whip while food, livestock, birds, and money spill to the ground.

Some scholars believe that during Passover as many as one hundred thousand people would have come to Jerusalem to participate in the holiday's customs and rituals. It is possible that money changers came to the temple to convert foreign currencies into the coins allowed in the temple. This activity would have taken place in the outer temple courtyard, where non-Jews were allowed.

Although there are a number of interpretations of the story, a prominent view sees Jesus's actions as an attempt to reclaim, purify, and even extend the role of the temple and temple worship. According to this view, Jesus was implicitly extending the holiness of the temple's inner courts to the outermost sections of the temple courtyard and thereby affirming the role of a purified temple in Jewish religious life. When Jesus says, "Zeal for your house will consume me" (John 2:17), he is quoting Psalm 69:9 ("For zeal for your house has consumed me"), affirming the institution of the Jewish temple for his first-century Jewish contemporaries.

Based on the story, Jesus was clearly angry about "robbers" using the temple and the Passover holiday to make money in ways he considered thievery. It is possible to conclude that Jesus rejected the mix of economic corruption and religion, or that he adamantly opposed blending any commerce with the temple, as evidenced by his declaration "Do not make my Father's house a house of trade" (John 2:16). Because the temple at that time was known as the house of God, perhaps Jesus was concerned about blending the worldly power of money with the spiritual power of faith.

In El Greco's *Jesus Cleansing the Temple*, we can reflect on the anger of Jesus, who saw the threat that money and corruption posed to sincere faith. The story also provides an opportunity to consider the root causes of corruption and its consequences in the public sphere.

*L*eonardo da Vinci's mural **The Last Supper** is one of the most widely recognized religious paintings in the world. It is an iconic painting by one of the greatest Renaissance masters. The Duke of Milan, Ludovico Sforza (1452–1508), commissioned the painting for the refectory (dining hall) of the monastery of Santa Maria delle Grazie in Milan. The monks would gather together daily and break bread beneath Leonardo's rendition of Jesus's final meal with his disciples.

The mural is approximately twenty-eight feet wide and fifteen feet high, and it is located on the far wall of the refectory, roughly ten feet above eye level. Rather than painting in fresco, a technique in which pigment is added to wet plaster, Leonardo painted directly onto dry plaster with oil tempera paint. Because the walls contained a small degree of moisture, the painting quickly began to deteriorate; by the mid-sixteenth century, the figures were barely discernable. In the seventeenth century, the monks who occupied the monastery cut a doorway through the bottom center of the mural. After a number of attempts at restoration, very little of Leonardo's original masterpiece survives today.

THE LAST SUPPER (1495–1498)
Leonardo da Vinci (1452–1519)
Current location: Church of Santa Maria delle Grazie, Milan, Italy

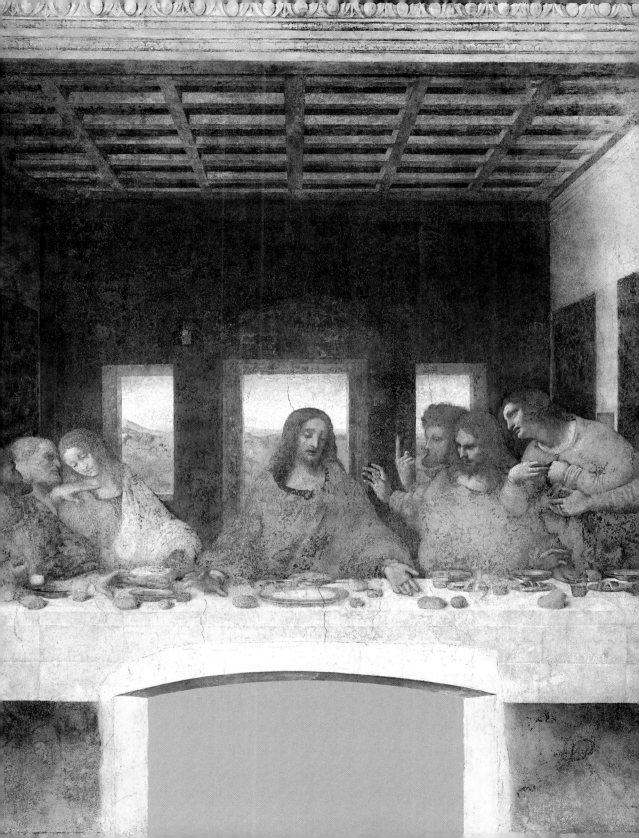

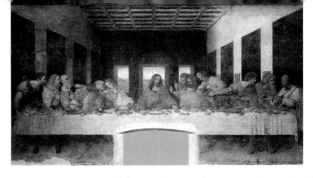

After saying these things, Jesus was troubled in his spirit, and testified, "Truly, truly, I say to you, one of you will betray me." The disciples looked at one another, uncertain of whom he spoke. One of his disciples, whom Jesus loved, was reclining at table at Jesus' side, so Simon Peter motioned to him to ask Jesus of whom he was speaking. So that disciple, leaning back against Jesus, said to him, "Lord, who is it?" Jesus answered, "It is he to whom I will give this morsel of bread when I have dipped it." So when he had dipped the morsel, he gave it to Judas, the son of Simon Iscariot. (John 13:21–26)

We often think of religious traditions in formal contexts, with a minister, rabbi, or priest officiating, with liturgy and music. But Leonardo da Vinci's *The Last Supper* demonstrates the beauty of simplicity—common people eating a meal with Jesus, albeit at a critical moment.

With his arms outstretched on the table, Jesus is the focal point of the piece. The disciples are clustered around him in four groups of three. Four pairs of tapestries hang on either sidewall and three windows recede in the distance on the back wall. Jesus appears haloed by the central rear window.

Many scholars agree that *The Last Supper* captures the moment just after Jesus announced that one of his disciples would betray him. Leonardo sought to render each disciple's emotional reaction to Jesus's announcement through facial expressions and postures. To the right of Jesus we see Judas, Peter, and John.

Judas, with his left hand, clutches the purse that contains the silver he was paid to betray Jesus. As he retracts his coins, perhaps to conceal them, his wrist upsets the salt bowl. His face is fully shadowed as he turns his head, exposing his neck and forecasting his suicide by hanging (Matthew 27:3–5).

Peter angrily holds a knife behind his back and lurches forward to protect Jesus. The young disciple John, closest on Jesus's right, tilts his head

and swoons in reluctance to believe Jesus. To Jesus's left is Thomas, raising the finger that would probe the wounds of the resurrected Jesus (John 20:27–28). The arms of James the greater are splayed wide in shock, and Philip has a contrasting pose with his arms retracted in disbelief.

In addition to displaying the unique personalities of the disciples, Leonardo brings the scene into touch with common people through his use of people from the streets of Italy as models. It is said that he found the model for Judas in the thieves' district of Milan. Using people with unique characteristics and appearances allowed Leonardo to give each disciple his own mannerisms, expressions, and personality.

Prior to the Renaissance, the subjects of religious imagery—from the Virgin Mary to Jesus—lacked individuality. They were tokens, meant to represent an idea more than a person. Painting the average Italian citizen was rare, as portraiture was usually reserved for kings, queens, and saints. The Renaissance, however, saw the rise of the common person as a subject worthy in his or her own right, regardless of social or economic class. Thus, Leonardo offers us a vision of humanity in all its messiness.

Another interpretation sees *The Last Supper* as a depiction of the moment when Jesus instituted the sacrament of communion (Matthew 26:26–28). According to this view, the emphasis should be on Jesus reaching for wine with his right hand while reaching for bread with his left. The disciples, in turn, are reacting to his admonition to eat the bread and drink the wine as his own body and blood.

Regardless of the interpretation, the painting's elegant symmetry, Jesus's serenity, and the disciples' unique expressions all give *The Last Supper* a genuine sense of transcendence. Everything is precisely where it should be, as though it were fated. Remarkably, Leonardo captured all these layers of meaning without invoking any formal religious symbols. In this way, the painting inspires us to see the nobility and meaning in every moment, formal or otherwise.

*The Swiss-born painter Antonio Ciseri trained, and later taught, in Florence, Italy, at the Accademia Di Belle Arti and would have no doubt studied the famous **Ecce Homo** paintings of Titian (1490–1576), Caravaggio (1571–1610), Mantegna (1431–1506), and others. The Latin phrase **ecce homo** means "behold the man" and is attributed to Pontius Pilate when he presented the beaten and bloodied Jesus to the angry mob (John 19:5).*

*During the Renaissance, **ecce homo** was commonly used as the title of paintings depicting Pilate's presentation of Jesus to the hostile crowd; subsequently, the phrase became the name for a genre of works illustrating this biblical scene. In this version of **Ecce Homo**, Ciseri displays his mature and objective style along with a masterful attention to detail and use of vibrant colors.*

ECCE HOMO (1871)
Antonio Ciseri (1821–1891)

Current location: Gallery of Modern Art, Florence, Italy

So Jesus came out, wearing the crown of thorns and the purple robe. Pilate said to them, "Behold the man!"
(John 19:5)

Ciseri's depiction of Pilate presenting Jesus to the crowd is distinct because he portrays the scene from the back, positioning the viewer as a backstage member of Pilate's court rather than a member of the masses. The focus becomes Pilate gesturing to Jesus as he declares, "Ecce homo." As Pilate offers the decision to crucify Jesus to the crowd, a woman with her head down—perhaps Pilate's wife—turns away from the mob scene and steadies herself on the shoulder of her companion.

Ciseri's ability to paint intricate details can be found throughout this work of art. The spotted fur draped over Pilate's throne is bristling and alive. Pilate's body is revealed in silhouette form beneath his robes. Between the latticework of the gate, the upturned faces of the angry mob stretch off into the distance. In the middle of the composition, a detailed relief sculpture spirals around the great pillar.

Despite this focus on details, Ciseri did not reveal Pilate's face, and the face of Jesus is only shown in quarter-profile. By not including the faces of the central actors, Ciseri pulls us deeper into the painting. He invites the viewer to imagine the blood running down Jesus's forehead. We can almost hear Pilate yelling above the crowd, perhaps cupping his right hand around his mouth to amplify his voice as he shouts, "Behold the man!"

The Greek word used in John 19:5 for "man" is *anthropos*, which simply means "human being." The phrase "behold, the man" also occurs in Genesis 3:22. After Adam and Eve have eaten from the tree of the knowledge of good and evil, God declares, "Behold, the man has become like one of us in knowing good and evil."

Though Pilate submits to the crowd's demand to execute Jesus, he considers Jesus innocent of any crime (Matthew 27:23–24). When he declares "Behold the man!" it seems he is pointing to the humbled, scourged, and trampled nature of Jesus's humanity and therefore does not believe Jesus to be a divine figure or the Jewish messiah.

This painting captures the essence of the pivotal moment in which Pilate condemned Jesus. The mob in the streets demanding an execution, Pilate's concerned wife, Pilate's power to condemn an innocent man, the submitted but inwardly powerful Jesus—it all becomes a compelling study on human nature, justice, and moral conscience.

Eugène Burnand was a nineteenth-century Swiss painter known for his naturalistic landscapes, depictions of animals, religiously inflected portraits, and illustrations of Jesus's parables. Because Burnand moved frequently, his artistic subjects often changed with each location. While living in Paris, he earned a reputation as a traditionalist for his perceived rejection of the modernism that was fashionable in the European art capital. Later in his life, he turned to graphic arts and portraiture.

In this painting, the near-impressionistic sky with hues of purple, blue, and gold forms the background for two disciples hurrying to the empty tomb. Peter, with his graying beard, furrows his brow, while John wrings his hands. With worried expressions and hurried gaits, Peter and John appear as common men.

The sun rising over John's right shoulder indicates it is early morning, and the three faint hash marks on the hill imply the three crosses at Golgotha. The composition suggests the disciples are running from the place of Jesus's death toward the place of his resurrection. Despite the obvious theme of resurrection, nothing supernatural is depicted. This reflects Burnand's desire to capture the supernatural in the natural.

THE DISCIPLES PETER AND JOHN RUNNING TO THE SEPULCHRE ON THE MORNING OF THE RESURRECTION (1898)

Eugène Burnand (1850–1921)

Current location: Musée d'Orsay, Paris, France

So she ran and went to Simon Peter and the other disciple, the one whom Jesus loved, and said to them, "They have taken the Lord out of the tomb, and we do not know where they have laid him." So Peter went out with the other disciple, and they were going toward the tomb. Both of them were running together, but the other disciple outran Peter and reached the tomb first. (John 20:2–4)

According to the book of John, Mary Magdalene arrived at Jesus's tomb to find the stone had been removed. She ran back to Peter and John to tell them that someone had taken Jesus's body out of the tomb and she didn't know where they had put him. Peter and John immediately ran to the tomb together, but John reached the tomb first.

In keeping with the biblical account in John 20:2–4, Burnand places John ("the other disciple") slightly ahead of Peter. Peter appears to be pointing toward John, perhaps foreshadowing his arrival at the tomb first. Although John reaches the tomb first, he does not go inside. "And stooping to look in, he saw the linen cloths lying there, but he did not go in" (John 20:5). However, when Peter arrives at the tomb, he goes inside and sees the discarded linen wrappings. Only then does John go inside.

The biblical text says that when John entered the tomb, "he saw and believed" (John 20:8). Yet, it is unclear precisely *what* John believed. At this point in the narrative, the resurrected Jesus had not yet appeared to the disciples; he wouldn't appear until later that evening. One possibility is that John believed in Jesus's resurrection when he witnessed the empty tomb even before seeing the risen Jesus.

The significance of this for understanding Christianity's origin is that regardless of whether Jesus actually rose from the dead, his earliest followers believed he did, and this is the story they told. The simple statement that John "saw and believed," despite having not yet encountered the risen Jesus, is the foundational story of what would become the Christian tradition.

The Disciples Peter and John Running to the Sepulchre on the Morning of the Resurrection depicts two men hurrying to see what Mary meant when she said the stone was rolled away and Jesus's body was missing. Burnand, by painting Peter and John with intense expressions and hurried postures, conveys the relational bond that these two men felt with Jesus, the man who had changed their lives, and the man whose execution they had just witnessed. The power of the empty tomb, for them at that moment, left them perplexed and full of hope. Burnand's painting captures all these dimensions, showing the supernatural in the natural.

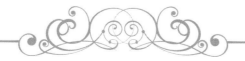

*F*rench artist Nicolas Poussin, a history painter, is considered the founder of the French Classical tradition. He was born in Normandy, France, but spent most of his life in Italy. His subtle and devotional religious paintings inspire contemplation and reflection.

His arrangement of clusters of people in a composition emphasizes the drama of a scene and creates a narrative in a single moment. This creativity is accentuated by the way his scenes are painted with distinct foregrounds, middle grounds, and backgrounds—all of which interact with and complement each other, adding to a visual complexity in his paintings.

In the **Death of Sapphira** Poussin employs a linear perspective, emphasized by the tile work in the foreground that leads the eye to the lightly reddish building on the horizon in the background. This front-to-back visual space is enriched by the right-to-left movement in the foreground, starting with Peter, who points to the collapsed Sapphira, and continuing to the left, where a woman holds a baby on her hip. These two visual movements meet at Peter's outstretched finger, which points to the scene of Sapphira and to the scene of a man, who appears to point back at Peter while helping a beggar-woman.

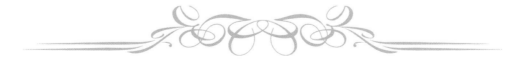

DEATH OF SAPPHIRA (1654–1656)
Nicolas Poussin (1594–1665)

Current location: Louvre Museum, Paris, France

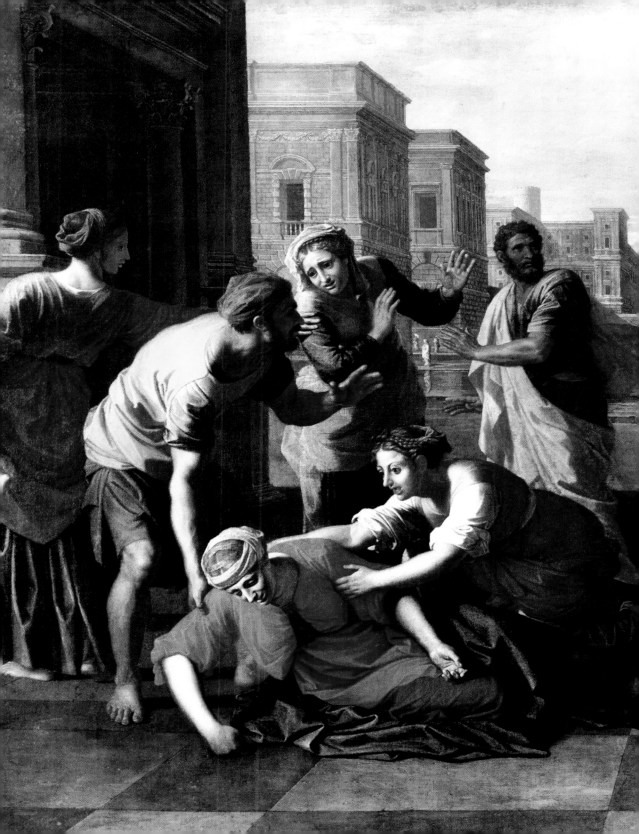

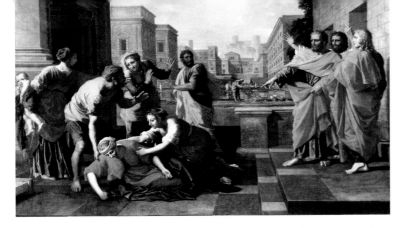

After an interval of about three hours his wife came in, not knowing what had happened. And Peter said to her, "Tell me whether you sold the land for so much." And she said, "Yes, for so much." But Peter said to her, "How is it that you have agreed together to test the Spirit of the Lord? Behold, the feet of those who have buried your husband are at the door, and they will carry you out." Immediately she fell down at his feet and breathed her last. When the young men came in they found her dead, and they carried her out and buried her beside her husband. (Acts 5:7–10)

The story of Sapphira's death takes place as the young Christian community in Jerusalem struggled to articulate its identity and prepared for what they believed was the impending return of Jesus.

The early church appears to have been facing a severe economic crisis that was exacerbated by the Roman government's hostility toward them. For example, in Acts 4, Peter and John are arrested and forced to defend themselves before a high council.

In this context, the early church forged strong bonds of solidarity. Acts 4:32 states that the people "were of one heart and soul." This unity extended to their material possessions. They had agreed to share all their possessions, even if it meant selling property. As a result, "there was not a needy person among them" (Acts 4:34). Sharing possessions enabled everyone to survive.

Ananias and his wife, Sapphira, sold a piece of land and withheld some of the proceeds from the apostles. They also lied about what they had sold the property for. Peter tells them they lied to God (Acts 5:3–4) and tested God (Acts 5:9). Upon being found out, they died in front of Peter—first Ananias, and then, three hours later, Sapphira.

The biblical text does not include many details about how Ananias and Sapphira died. Although Peter predicted Sapphira's death (Acts 5:9), there's no account of Peter controlling or ordering either of the deaths; they both just collapsed as he talked with them (Acts 5:5,10).

In the painting, Poussin includes a distant image of a man compassionately helping a beggar-woman. While Peter ostensibly points to Sapphira, his hand is also pointed in the direction of the man and the beggar in the center of the composition. Perhaps the artist wanted his viewers to look beyond what was happening to Sapphira in the foreground to the mercy and kindness happening in the background.

William Blake, recognized now for his brilliant poetry and painting in *Songs of Innocence and Experience* (1789) and **Marriage of Heaven and Hell** (ca. 1790–1793), was relatively unknown during his lifetime. Born in London, he began working as a child apprentice to an engraver and entered the Royal Academy of Arts in his early twenties. The pieces he sold were bought more for friendship than artistic or economic value.

Considered a romantic and idiosyncratic mystic, Blake claimed to see visions of angels and experience spiritual hallucinations. He despised organized religion, which he felt crushed the spirit and punished the body, and struggled with aspects of some Christian theology, saying, for example, that it stifled creativity.

Though he considered the Bible a source for inspiration, Blake probed its spiritual depths at the expense of the literal text. He created **Angel of the Revelation** as one of eighty biblically inspired watercolors for his friend and patron Thomas Butts.

ANGEL OF THE REVELATION (CA. 1803–1805)
William Blake (1757–1827)

Current location: The Metropolitan Museum of Art, New York, USA

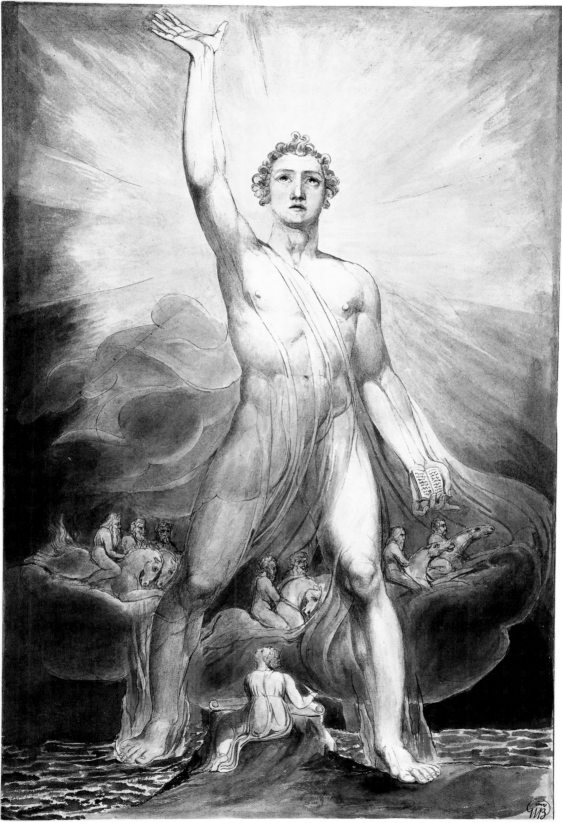

And the angel whom I saw standing on the sea and on the land raised his right hand to heaven and swore by him who lives forever and ever, who created heaven and what is in it, the earth and what is in it, and the sea and what is in it, that there would be no more delay, but that in the days of the trumpet call to be sounded by the seventh angel, the mystery of God would be fulfilled, just as he announced to his servants the prophets. (Revelation 10:5–7)

Blake's watercolor titled *Angel of the Revelation* depicts the mighty angel described in Revelation 10. In the illustration, the towering angel of God resembles the ancient Colossus at Rhodes standing astride the sea and land with a face like the sun and feet like pillars of fire.

At the base of Blake's triangular composition, between the angel's feet, John (the author of Revelation, according to Revelation 1:1) records his vision as seven horsemen ride in the clouds, symbolizing the sound of the seven thunders that announced the angel's message.

The angel holds an open book in his left hand. In the biblical account, the angel holds a scroll and instructs John, "Take and eat it; it will make your stomach bitter, but in your mouth it will be sweet as honey" (Revelation 10:9). Many Bible scholars believe these words, which echo the words in Ezekiel 3:1–4, indicate that John's prophecy will be welcomed like honey by some but will bring bitter despair for others.

According to Revelation 10:3–4, John hears a loud voice from heaven that tells him, "Seal up what the seven thunders have said, and do not write it down." This passage is the only instance in the book of Revelation where a message is sealed up, implying that some divine secrets must remain hidden.

Such mystery undoubtedly appealed to Blake's sense of mystic spirituality. Mysteries free up the imagination and inspire us to learn and explore. Because Blake gave this mighty angel the features of his own face, we might imagine Blake also enjoyed the mysteries contained in Revelation.

This illustration, found on the back side of the forty-first folio of the Dyson Perrins Apocalypse, offers a thirteenth-century depiction of the biblical book of Revelation.

*Originally named after Dyson Perrins, a businessman and book collector, the manuscript is now called **The Getty Apocalypse** after the J. Paul Getty Museum, which currently owns the document. Every page of this manuscript contains a short passage from the book of Revelation written in black ink, a colorful miniature, and commentary written in red ink by a Benedictine monk named Berengaudus. The scene rendered on this folio is from Revelation 19:20–21 and appears on the final page of the document.*

THE DEFEAT OF THE BEAST (CA. 1255–1260)

artist unknown

Current location: The J. Paul Getty Museum, Los Angeles, USA

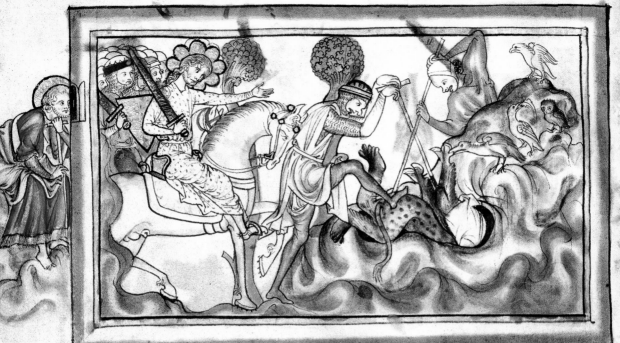

 t apprehensa est bestia
⁊ cum illa pseudo p̄-
pheta qui fecit signa
coram ipso quibz̄ sed-
uxit eos qui accepe-
runt characterem bestie qui ⁊ adoraūt
y̅maginem eius uiui missi sunt hii
duo in stagnum ignis ardentis sul-
phure ⁊ ceteri occisi sunt in gladio
sedentis sup equum qui p̄cedit de ore
ipsius ⁊ omnes aues saturate sunt
carnibz̄ eoꝝ.

H̅pense uidet bestia ⁊ pseudo ypliteus
h̅u illud umplebit q̄ dicitr̄ aple p̄ꝯ.
Que dn̅s xp̄s inficiet sp̄u oris sui ⁊ destruet
illustrate aduentꝰ sui. Si aute̅ sp̄u oris dn̅i
umficient; xp̅s y̅ pseudo ypypha eu̅ in stag-

nū missi sunt; ē ꝑt̄ iust̄oꝝ ⁊ ē ut̄a im-
pioꝝ. Iust̄ n̅o myg̅ne morte uacant uit̄ ui-
pioꝝ. Similit̄ ⁊ impii̅ uit̄am ust̄oꝝ morte est-
mant sunt i̅ militia dicūt̄ sūt· hii silq̄ꝯ̄
Alu̅ habuuit i̅ derisu ⁊ i̅ s̅uilitudine i̅p̄n̅-
stos nscensurt̄ uit̄a illoꝝ estimabat̄ i̅s̅ania ⁊
fine̅ illoꝝ sine hon̅e· dicitur̄ ē· ⁊ pseudo
ypliteu ē e̅ um missi sut̄ i̅ stagnū ig̅nis toꝝ ⁊
malitia sua uiui i̅ ea uidelit̄ usq̄ ad h̅sie̅ uit̄e
p̄seuerantes· Q̄d i̅ dn̅ dicitr̄ q̄ ceti̅ occisi sūt
i̅ gladio sedentis sup equu̅ interfectio̅n istoꝝ p
estusione potuer̄ stam sc̄ꝝ quoꝝ dextriua p̄r
p̄gladiu̅ oꝝ nomi̅ desig̅natur̄· uir̄tero xp̄o
uiuu̅ xp̄o ustusitabu̅t i̅ fidelcbz̄ eo q̄ doi̅me
impu̅ssuui̅ Atq̄ omnibus homi̅nubz̄ dociem
aute̅p̄iu̅ i̅mo̅ale deum̅ꝗ̄ exclamauer̅t
q̄d cō̅statet̄ pessima morte pempt̄um̅· At
ille ofundet̄ur· ⁊ thabescent i̅ uniquitatibz̄
suis.

And the beast was captured, and with it the false prophet who in its presence had done the signs by which he deceived those who had received the mark of the beast and those who worshiped its image. These two were thrown alive into the lake of fire that burns with sulfur. And the rest were slain by the sword that came from the mouth of him who was sitting on the horse, and all the birds were gorged with their flesh. (Revelation 19:20–21)

Many people view the book of Revelation as an *apokalypsis*, which means a "disclosure" or "revelation." It delivers a message of liberation and hope using symbols and metaphors. While it was not the last biblical book to be written, Revelation concludes the Christian canon with Jesus as a victor who vanquishes evil.

The opening verse of Revelation identifies the author as John, the "servant" of God. Traditionally, this John is believed to be the apostle John, the son of Zebedee and close friend of Jesus. However, authorship of the book has been questioned ever since the early church compiled the New Testament canon.

Following tradition, most pages of *The Getty Apocalypse* feature John looking on from the side. He appears next to paneled miniatures (illustrations) that occupy the topmost portion of the pages, while the text below each illustration records the corresponding passage from Revelation.

In the miniature titled *The Defeat of the Beast*, we see John, haloed and wearing a red robe, on the far left of the framed biblical vision. He watches

as a soldier and another man force the beast and the cloven-hoofed false prophet into the lake of fire while birds pick at their flesh.

According to Revelation 19:11–13, Jesus, who "is called Faithful and True," comes in judgment astride a white horse. He is described as having eyes "like a flame of fire, and . . . clothed in a robe dipped in blood." The artist has remained true to the apocalyptic vision by drawing Jesus, the conquering warrior-king, mounted on his steed defeating the beast and the false prophet. Although there is scholarly debate about the meaning of these symbols in the first century AD, most scholars believe they represented the Roman Empire and the priesthood of its religious system.

This illustration portrays Jesus as the incarnation of God's justice conquering evil. On the left of the panel, John peers through a tiny open door, irresistibly drawn to the vision of God's grace that plays out before him while equally terrified of a God with eyes aflame who burns his enemies alive in a lake of fire.

The Getty Apocalypse, viewed carefully, can be a visual meditation on some of the most compelling issues in life: love, forgiveness, justice, and judgment. The art helps us consider the tension between love and justice, and between mercy and judgment. On the one hand, most people value forgiveness and kindness, even in cases of certain crimes. But we also recognize the need to place limits on evil, especially in extreme cases, such as the Nazi-era Holocaust. Many biblical narratives, such as the story of Jonah, describe God's mercy and compassion, whereas others display his judgment against the evil that destroys cultures and generations.

Hildegard of Bingen was a German Benedictine abbess who wrote on theology, philosophy, biology, medicine, and poetry. She also composed hymns and liturgy that remain popular today. And she is known for her visionary and prophetic writings, as well as the illustrations she created to accompany them.

*In 1151, she completed a three-volume work titled **Scivias** (**Know the Ways**), which contained twenty-six visions about the Bible. The piece featured here is from her final visionary work titled **Liber Divinorum Operum** (**The Book of Divine Works**). This book contains ten cosmic visions that represent the culmination of her theological thought and the most mature artistic expression of her themes.*

*This piece, inspired by the biblical themes of creation (Genesis 1–2) and the cycles that occur in nature (Ecclesiastes 1:1–9, 3:1–8), is the recto (front) of the thirty-eighth folio leaf of **Liber Divinorum Operum**. This copy was completed after Hildegard's death, but it is based on her original designs. Depicting her fourth vision, it was completed on vellum with gold leaf and egg tempera.*

COSMOS, BODY, AND SOUL (13TH CENTURY)
Hildegard of Bingen (1098–1179)

Current location: Biblioteca Statale di Lucca, Lucca, Italy

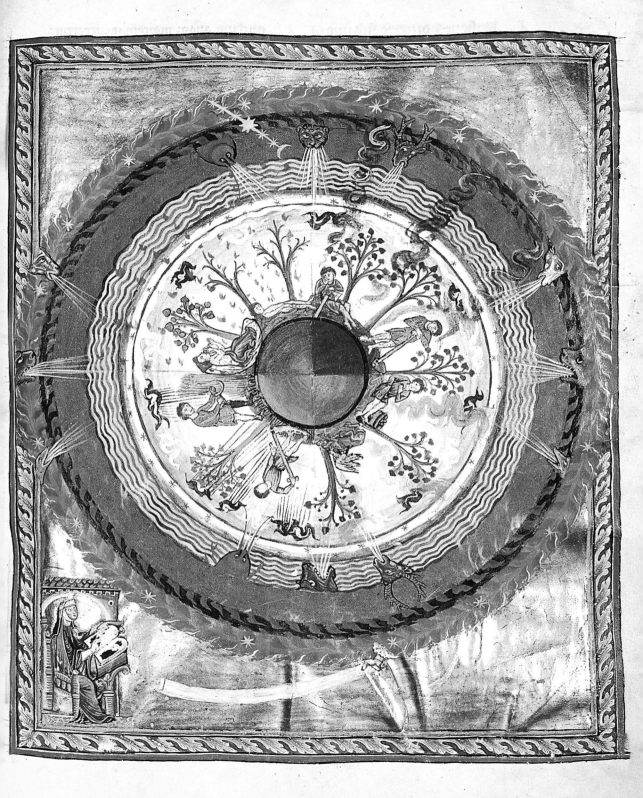

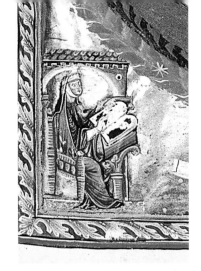

The sun rises, and the sun goes down, and hastens to the place where it rises. The wind blows to the south and goes around to the north; around and around goes the wind, and on its circuits the wind returns. All streams run to the sea, but the sea is not full; to the place where the streams flow, there they flow again. . . . What has been is what will be, and what has been done is what will be done, and there is nothing new under the sun. (Ecclesiastes 1:5–9)

The author of the book of Ecclesiastes—referred to in the opening verse of the book as "the Teacher"—begins his writing with an account of nature's cycles. The sun is described as forever rising and setting, the winds unceasingly blow south to north, and all streams flow to the sea. There is an endless repetition to the cosmos and to human life. The two are entwined in a cyclical dance of repeating seasons, joys, and sorrows.

This work of art reflects elements of the story of creation found in Genesis 1–2 along with the cyclical, repetitive nature of the cosmos found in Ecclesiastes 1. The painting demonstrates Hildegard's view on the interconnected relationship between humanity and the cosmos.

At the center of the image we see a globe divided into four equal parts representing the four seasons. The earth is enclosed in a firmament of water represented by the wavy blue circle. Outside this, we see a starry night sky enclosed by a red band of fire. The assorted beasts represent the wind blowing through the sky, and the men atop the center globe represent the stages of tilling, planting, tending, reaping, and resting. Hildegard herself can be seen in the lower left corner, seated and clutching a Bible with her eyes raised toward her own vision of creation.

Although many of Hildegard's visions were apocalyptic in nature, many scholars have noted that her theology and cosmology were holistic, that she emphasized the integrated nature of humanity and the cosmos. For Hildegard, humanity was a microcosm of the universe; the two were intertwined in what renowned Hildegard scholar Barbara Newman described as "the seamless web of being."*

In this piece, the cosmos, the body, and the soul are each entailed by the other as humanity harvests the earth within the creation. In an earlier writing on health and healing, Hildegard observed that humanity was bound to creation as "a flame is bound to fire."

Although we have a much more accurate view of the universe today, Hildegard's beautiful work of art enables us to pause and reflect on our own views of nature and humanity's relationship to it.

* Barbara Newman, *Sister of Wisdom: St. Hildegard's Theology of the Feminine* (Berkeley: University of California Press, 1987), 153.

Vincent van Gogh, the son of a minister in the Dutch Reformed Church, worked as a lay preacher in a poor mining district in western Belgium. In 1880 he moved to Brussels to study art at the Royal Academy. He eventually moved to Paris, where he encountered impressionism and neo-impressionism, and cultivated his own style of expressionism with its hallmark patchwork coloration and lyrical approach to line and form.

Before moving to Paris, van Gogh experimented with darker coloration, heavy line work, and a rapid painting technique. It was during this phase that he completed **Still Life with Bible**. *The Bible in the painting belonged to van Gogh's father, though it was not the van Gogh family Bible.*

Careful examination of the Bible's right-hand page header in the painting shows that it is opened to the book of Isaiah. The barely legible Roman numerals LIII on the far right-hand column reveal the chapter to be 53, which describes a servant who suffers in order to bring peace and healing (Isaiah 53:4–6). The book in the foreground is Émile Zola's novel **La joie de vivre** (**The Joy of Life**, *1883), a book about human suffering and disappointment.*

STILL LIFE WITH BIBLE (1885)
Vincent van Gogh (1853–1890)

Current location: Van Gogh Museum, Amsterdam, The Netherlands

Surely he has borne our griefs and carried our sorrows; yet we esteemed him stricken, smitten by God, and afflicted. But he was pierced for our transgressions; he was crushed for our iniquities; upon him was the chastisement that brought us peace, and with his wounds we are healed. (Isaiah 53:4–5)

Van Gogh's depiction of two memorable and influential books has led many people to wonder how Isaiah 53 and Zola's novel are related and why van Gogh would include them in this painting.

Although van Gogh was devoutly religious in his youth and even had experience preaching, as an adult he began to reject many of the beliefs of his father in favor of a religion of nature and beauty. It is possible that the extinguished candle sitting next to the Bible in the painting and Zola's novel in the foreground represent both the passing of van Gogh's father and his own rejection of his father's religion.

Commenting on the influence of Zola's novel in his life, in a letter to his sister Wilhelmina, van Gogh wrote, "If, on the other hand, one wants truth, life as it is, then there are, for instance, de Goncourt in *Germinie Lacerteux*, *La fille Eliza*, Zola in *La joie de vivre* and *L'assommoir*, and so many other masterpieces, all portraying life as we feel it ourselves, thus satisfying our need for being told the truth."* Perhaps van Gogh's inclusion of Zola's novel and the Bible opened to Isaiah 53 in this painting represents his desire to find meaning and truth in the midst of life's uncertainties and sufferings.

It is also possible that van Gogh painted *Still Life with Bible* as a visual commentary on the similarities he saw in the Bible's characters. The suffering servant of Isaiah 53 may have reminded him of a character in *La Joie de Vivre*—Pauline, an orphan who seeks to serve other people even while enduring great personal suffering.

Many people within the Christian tradition interpret Isaiah 53 as a prophecy about the suffering servant—believed to be Jesus—that leads to the salvation (or spiritual healing) of his followers. Jewish tradition teaches that Isaiah 53 refers to the plight of the Israelites while in Babylonian exile and describes the afflictions of an awaited messiah who would lead the nation to freedom.

In both religious interpretations of Isaiah 53, the central theme is suffering. Yet in both contexts, sorrows and afflictions are precursors to peace and healing. It could be said, then, that the two books depicted in van Gogh's *Still Life with Bible* represent a dichotomous theme of suffering and healing, or possibly suffering and joy.

By placing a well-worn copy of Zola's novel about suffering in front of a dust-covered Bible open to the song of the suffering servant, van Gogh was perhaps suggesting the need to continue retelling the story of suffering and the healing that follows in the cultural context of nineteenth-century France. In a similar way, his painting can help us to reflect on the relationship that exists between the moments of suffering and healing in our lives.

* Vincent van Gogh, *The Letters of Vincent van Gogh*, ed. Ronald de Leeuw and trans. Arnold Pomerans (New York: Penguin Books, 1996), 335.

Gerrit Dou studied under Rembrandt and became a master of the Dutch golden age. As he matured as an artist, he cultivated a skill for painting meticulous detail and the subtleties of light and shadow. However, by age thirty, Dou was nearly blind and had to use heavy glasses to continue his work.

*Dou's painting is reminiscent of Rembrandt's **An Old Woman Reading**. Dou's attention to minute detail is evident in the brushed marten fur collar of the old woman's coat, the delicately grooved wrinkles on her hand and eyelid, and the precise rendering of the book's text that makes it readable even in the painting.*

Compositionally, the picture plane is divided in two. The woman (who is probably Rembrandt's mother reading her lectionary) occupies the right half; the book, set off by the contrast of the dark background against its luminously pale white pages, occupies the left. The illuminated diagonal that runs from the top of the woman's head and down her eye line is completed with the tassel bookmark that dangles in the lower left corner and is mirrored by the fur trim on her coat. The result is an interesting two-sided picture plane that is complicated by a diagonal cross line.

OLD WOMAN READING (CA. 1631–1632)
Gerrit Dou (1613–1675)

Current location: Rijksmuseum, Amsterdam, The Netherlands

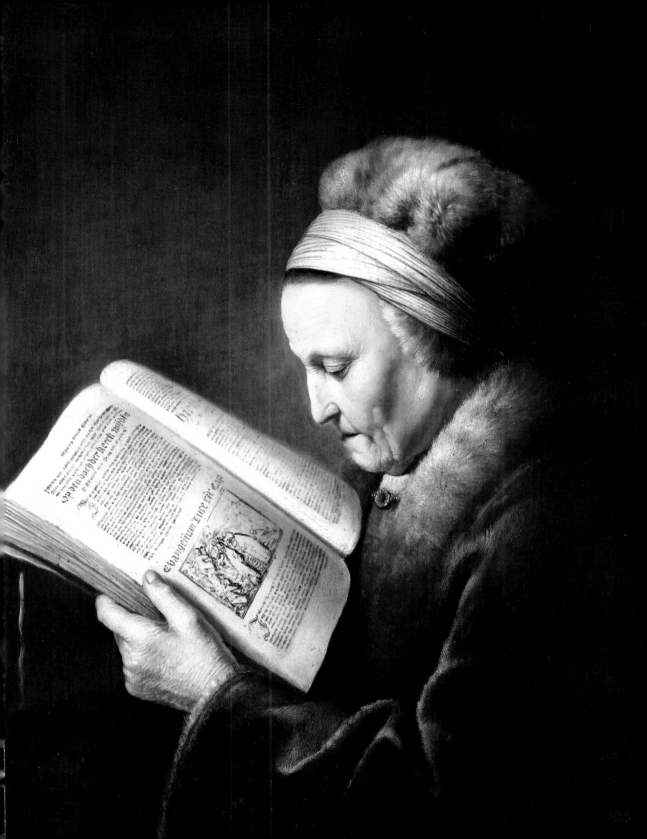

And Zacchaeus stood and said to the Lord, "Behold, Lord, the half of my goods I give to the poor. And if I have defrauded anyone of anything, I restore it fourfold." (Luke 19:8)

The old woman's wrinkled hand holds the lectionary open to the Gospel of Luke, chapter 19. This scene depicts the tax collector Zacchaeus in a tree trying to catch a glimpse of Jesus as he passes through Jericho. According to the text, Jesus tells him to come down from the tree and states that he must stay at Zacchaeus's house. When the people grumble about Jesus's choice of a host (tax collectors were disdained), Zacchaeus pledges half of his possessions to the poor.

The contrast between Zacchaeus's claim that he will give half of his possessions to the poor and the old woman's lavishly expensive fur-trimmed coat and gold-mounted amethyst broach suggests that the woman faces an inner conflict between giving to the poor and her love of wealth. She's studying carefully an admonition to give to the poor.

Scholars have generally interpreted Zacchaeus's declaration in two ways. Zacchaeus could have announced his intention to give to the poor as a way of defending his unpopular profession and the way he managed his accounts. It is also possible that his announcement to be generous to the poor expressed his sincere desire to change his ways and make amends for his cheating. In this case, his declaration is an admission of past guilt and an act of contrition and restitution.

Whether Zacchaeus is defending his customary practices or resolving to change his ways, his commitment to charity and restitution is commendable.

Charity gives out of abundance to meet the needs of others; restitution repairs damage or harm that has been inflicted. Both aim to improve, build, or restore relationships and community.

The painting reminds us that every person who accepts responsibility for mistakes has the opportunity to restore what has been broken. And anyone who wants to show generosity can, through charity, help the poor in need of food, shelter, and clothing.

*T*his elaborately carved marble sarcophagus was completed for Junius Bassus, a prefect of Rome who was among the first Roman governmental elites to convert to Christianity. Bassus died on August 25 in AD 359, establishing this work as one of the earliest examples of Christian art.

The sarcophagus is eight feet long and six feet tall. It consists of ten high-relief carvings on the front laid out in two rows. From left to right (starting at the top), the carvings depict the biblical stories of the sacrifice of Isaac, the arrest of Peter, Jesus with Peter and Paul, the arrest of Jesus, his appearance before Pilate (head missing), Job atop the dunghill, Adam and Eve, Jesus entering Jerusalem, Daniel in the lions' den, and Paul being led to execution.

If we focus on the portrayals of Jesus, he appears as a beardless young man dressed in the garb of a Roman philosopher. In the central panel, he sits on a throne clutching a scroll. His foot rests on the head of a pagan god, suggesting that the artist and/or Bassus viewed his new teachings as being greater than the older religious system.

SARCOPHAGUS OF JUNIUS BASSUS (AD 359)

artist unknown

Current location: Saint Peter's Treasury, St. Peter's Basilica,
Vatican City State

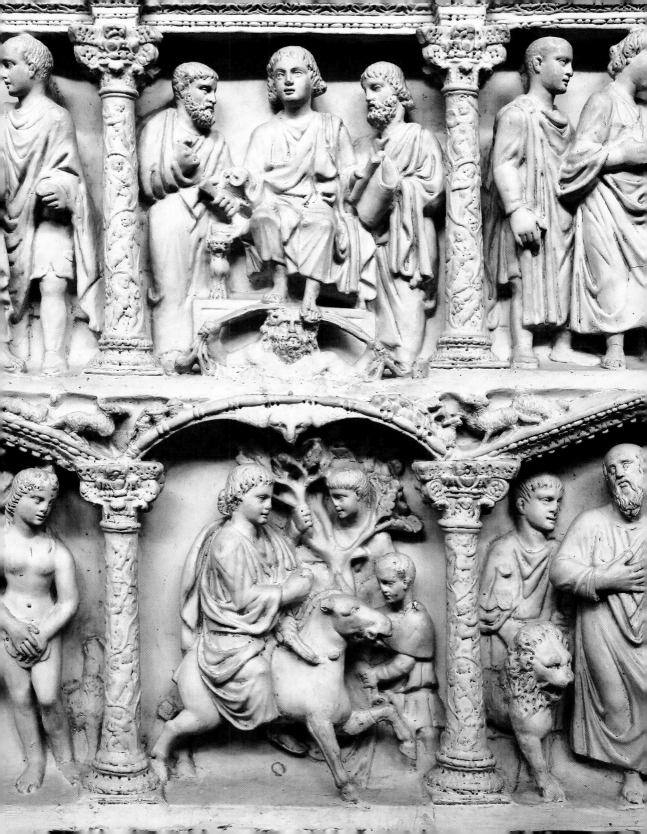

"A new commandment I give to you, that you love one another: just as I have loved you, you also are to love one another." (John 13:34)

A close look at this magnificent sculpture can help us reflect on how Jesus has been portrayed in different times and cultures. The artwork on the sarcophagus captures an extremely fluid moment in Christian history and offers one of the earliest glimpses of how Jesus was portrayed before the Byzantine era.

In the upper central panel of the sarcophagus, we find Jesus giving what is commonly called the *traditio legis* to Peter and Paul. Although these events do not occur in the Bible, John 13:34 describes the law that Jesus taught: "Love one another: just as I have loved you, you also are to love one another." We can imagine those words etched on the scroll he passes on to the two leaders of the early church.

First- and second-century Christians did not make images of Jesus. They usually used symbols such as grapes, an anchor, or a fish. It was not until the third and fourth centuries that Christians began to create images of Jesus. In these earliest depictions, Jesus is typically shown as a young man with short hair without a beard and wearing a robe, the common Roman dress and grooming for men at the time.

Later, during the Holy Roman Empire, artists depicted Jesus as a mighty ruler. This corresponds to the change in cultural circumstances in the fourth and fifth centuries when Christianity gained prominence and protections after Constantine.

As we see, artistic depictions of Jesus changed to reflect the cultural context. The *Sarcophagus of Junius Bassus* is remarkable because it predates traditional portrayals of Jesus and marks the origins of an ongoing negotiation about how people have perceived Jesus over time.

In his book *Visual Piety* (1997), David Morgan notes that when we see an image of Jesus—from da Vinci's painting *The Last Supper* to the rock opera *Jesus Christ Superstar*—we see "not a rendition of an actual, historical figure, but an interpretation of an ongoing tradition of imaging Jesus."* Because no one knows what the historical Jesus looked like, every image of Jesus's appearance is an imagined re-creation that is informed by previous images and the artist's cultural perspectives.

Examining the artistic renditions of Jesus over the centuries encourages us to reflect on our own culture's portrayals of Jesus.

* David Morgan, *Visual Piety: A History and Theory of Popular Religious Images* (Berkeley: University of California Press, 1997), 38.

Art Credits

· **pages 1,2**: God as Cosmic Architect (Credit: TheBiblePeople) · **pages 5,6**: The Creation of Adam (Credit: Age Fotostock/Alamy Stock Photo) · **pages 9,10**: Adam and Eve (Credit: Cleveland Art Museum) · **pages 13,14**: Adam and Eve (Credit: Bernard Gagnon/Commons.Wikimedia.org) · **pages 17,18**: The Death of Abel (Credit: Archivart/Alamy Stock Photo) · **pages 21,22**: Noah's Ark (Credit: Archivart/Alamy Stock Photo) · **pages 25,26**: The Tower of Babel (Credit: TheBiblePeople) · **pages 29,30** Melchizedek and Abraham: (Credit: Commons.Wikimedia.org) · **pages 33,34**: Scenes from the Story of Abraham (Credit: Commons.Wikimedia.org) · **pages 37,38**: Sacrifice of Isaac (Credit: Dover Images) · **pages 41,42**: The Dream of Jacob (Credit: Dover Images) · **pages 45,46**: Jacob Wrestling with the Angel (Credit: Prisma Archivo/Alamy Stock Photo) · **pages 49,50**: Jacob Receives the Bloody Coat of His Son Joseph (Credit: Peter van Evert/Alamy Stock Photo) · **pages 53,54**: Infant Moses in the Bulrushes (Credit: Godong/Alamy Stock Photo) · **pages 57,58**: The Israelites Resting after the Crossing of the Red Sea (Credit: Superstock/Everett Collection) · **pages 61,62**: Moses Breaking the Tablets of the Law (Credit: TheBiblePeople) · **pages 65,66**: The Punishment of Korah and the Stoning of Moses and Aaron: (Credit: TheBiblePeople) · **pages 69,70**: The Prophet Balaam and the Angel: (Credit: Commons.Wikimedia.org) · **pages 73,74**: The Testament and Death of Moses (Credit: Commons.Wikimedia.org) · **pages 77,78**: The Ark Passes Over the Jordan (Credit: Commons.Wikimedia.org) · **pages 81,82**: Samson and the Philistines (Credit: Commons.Wikimedia.org) · **pages 85,86**: Ruth in Boaz's Field (Credit: Commons.Wikimedia.org) · **pages 89,90**: The Shepherd David (Credit: Commons.Wikimedia.org) · **pages 93,94**: The Shade of Samuel Appears to Saul in the House of the Prophetess of Endor (Credit: Superstock/Everett Collection) · **pages 97,98**: David (Credit: Superstock/Everett Collection) · **pages 101,102**: Scenes from the Life of David (Credit: J. Paul Getty Museum) · **pages 105,106**: The Judgment of Solomon (Credit: Classic Paintings/Alamy Stock Photo) · **pages 109,110**: The Visit of the Queen of Sheba to King Solomon (Credit: Archivart/Alamy Stock Photo) · **pages 113,114**: Elijah and Elisha's Stories (Credit: Everett Collection) · **pages 117,118**: Joash Shooting the Arrow of Deliverance (Credit: Superstock/Everett Collection) · **pages 121,122**: Esther before Ahasuerus (Credit: Active Museum/Alamy Stock Photo) · **pages 125,126**: Job's Servants Are Slain, to the Manifest Delight of Satan (Credit: The National Library of France) · **pages 129,130**: Visions of the Hereafter (Credit: TheBiblePeople) · **pages 133,134**: Six-Winged Seraph (Credit: Image Partnership Ltd/Alamy Stock Photo) · **pages 137,138**: Tree of Jesse (Credit: Alamy) · **pages 141,142**: Ezekiel (Credit: Commons.Wikimedia.org) · **pages 145,146**: Ezekiel's Vision (Credit: Dover Images) · **pages 149,150**: The Story of Daniel and the Three Youths in the Fiery Furnace (Credit: Commons.Wikimedia.org) · **pages 153,154**: Jonah Swallowed by the Whale (Credit: Everett Collection) · **pages 157,158**: Rest on the Flight into Egypt (Credit: Commons.Wikimedia.org) · pages **161,162**: The Feeding of the Five Thousand; Jesus Walking on the Water (Credit: J. Paul Getty Museum) · **pages 165,166**: The Baptism of Christ (Credit: Jozef Sedmak/Alamy Stock Photo) · **pages 169,170**: Christ of St. John of the Cross (Credit: Dover Images) · **pages 173,174**: Christ Enthroned, leaf from the Book of Kells (Credit: Jozef Sedmak/Alamy Stock Photo) · **pages 177,178**: The Workshop of the Evangelist Luke (Credit: Masterpics/Alamy Stock Photo) · **pages 180,182**: Christmas Night (Credit: Commons.Wikimedia.org) · **pages 185,186**: Presentation of Jesus (Credit: World History Archive/Alamy Stock Photo) · **pages 189,190**: Christ on the Sea of Galilee (Credit: Dover Images) · **pages 193,194**: Parable of the Good Samaritan (Credit: The Artchives/Alamy Stock Photo) · **pages 197,198**: Christ in the House of Martha and Mary (Credit: Dover Images) · **pages 201,202**: Christ Cleansing the Temple (Credit: Niday Picture Library/Alamy Stock Photo) · **pages 205,206**: The Last Supper (Credit: Commons.Wikimedia.org) · **pages 209,210**: Ecce Homo (Credit: Dover Images) · **pages 213,214**: The Disciples Peter and John Running to the Sepulchre on the Morning of the Resurrection (Credit: Peter Horree/Alamy Stock Photo) · **pages 217,218**: Death of Sapphira (Credit: World History Archive/Alamy Stock Photo) · **pages 221,222**: Angel of the Revelation (Credit: Commons.Wikimedia.org) · **pages 225,226**: The Defeat of the Beast (Credit: J. Paul Getty Museum) · **pages 229,230**: Cosmos, Body, and Soul (Credit: Everett Collection/Mondadori Portfolio) · **pages 233,234**: Still Life with Bible (Credit: Commons.Wikimedia.org) · **pages 237,238**: Old Woman Reading (Credit: FineArt/Alamy Stock Photo) · **pages 241,242**: Sarcophagus of Junius Bassus (Credit: Lanmas/Alamy Stock Photo)

museum of the Bible

Experience the Book that Shapes History

Museum of the Bible is a 430,000-square-foot building located in the heart of Washington, D.C.—just steps from the National Mall and the U.S. Capitol. Displaying artifacts from several collections, the Museum explores the Bible's history, narrative and impact through high-tech exhibits, immersive settings, and interactive experiences. Upon entering, you will pass through two massive, bronze gates resembling printing plates from Genesis 1. Beyond the gates, an incredible replica of an ancient artifact containing Psalm 19 hangs behind etched glass panels. Come be inspired by the imagination and innovation used to display thousands of years of biblical history.

Museum of the Bible aims to be the most technologically advanced museum in the world, starting with its unique Digital Guide that allows guests to personalize their museum experience with navigation, customized tours, supplemental visual and audio content, and more.

For more information and to plan your visit, go to museumoftheBible.org.

Dr. J. Sage Elwell is Associate Professor of Religion and Art at Texas Christian University and the author of one other book and a number of academic and popular articles. He publishes and teaches in the areas of theology of culture, suffering and embodiment, digital technology, modern art, atheism, and humanism. As an artist he works in digital media, photography, sculpture, and book art. His academic and artistic work, as well as his work as cohost of the podcast thesacredprofane, can be found at sageelwell.com.

Dr. Corinna Ricasoli is an Italian art historian and attained her Ph.D. from the School of Art History and Cultural Policy, University College Dublin, Ireland. She has worked at the Musée du Louvre, Paris, and has frequently been invited to guest lecture at several European institutions. She holds research associateships at the UCD Humanities Institute of Ireland and at the Vatican Apostolic Library (Cabinet of Prints & Drawings), where she is drawing up a complete catalog of Giovanni Battista Piranesi's prints for publication. She is currently Consultant Curator of Fine Arts, Museum of the Bible, Washington DC.